Hawai'i 24/7 is the sequel to *The New York Times* bestseller *America 24/7* shot by tens of thousands of digital photographers across America over the course of a single week. We would like to thank the following sponsors, the wonderful people of Hawai'i, and the talented photojournalists who made this book possible.

KAUNAKAKAI, MOLOKA'I
At the venerable Kapuāiwa coconut grove planted by King Kamehameha V in the 1860s, Elizabeth Tollefsen dances to "Wahine 'Ilikea," Dennis Kamakahi's classic song about a Moloka'i waterfall.
Photo by Richard A. Cooke III

LONDON, NEW YORK, MUNICH, MELBOURNE, and DELHI

Created by Rick Smolan and David Elliot Cohen

24/7 Media, LLC
PO Box 1189
Sausalito, CA 94966-1189
www.america24-7.com

First Edition, 2004
04 05 06 07 08 10 9 8 7 6 5 4 3 2 1

Published in the United States by
DK Publishing, Inc.
375 Hudson Street
New York, NY 10014

DK Publishing, Inc. offers special discounts for bulk purchases for sales promo-
tions or premiums. Specific, large-quantity needs can be met with special
editions, personalized covers, excerpts of existing guides, and corporate
imprints. For more information, contact:

Special Markets Department
DK Publishing, Inc.
375 Hudson Street
New York, NY 10014
Fax: 212-689-5254

Cataloging-in-Publication data is available
from the Library of Congress
ISBN 0-7566-0051-0

Printed in the UK by Butler & Tanner Limited

First printing, October 2004

WAIKIKI, O'AHU
Surfer girl: Kehaulani Lee demonstrates
what Hawaiians have known for centuries—
longboards aren't just for boys.
Photo by Warren Bolster, Getty Images

HAWAI'I 24/7

24 Hours. 7 Days.
Extraordinary Images of
One Week in Hawai'i.

Created by Rick Smolan and David Elliot Cohen

DK Publishing

About the America 24/7 Project

A hundred years hence, historians may pose questions such as: What was America like at the beginning of the third millennium? How did life change after 9/11 and the ensuing war on terrorism? How was America affected by its corporate scandals and the high-tech boom and bust? Could Americans still express themselves freely?

To address these questions, we created *America 24/7*, the largest collaborative photography event in history. We invited Americans to tell their stories with digital pictures. We asked them to shoot a visual memoir of their lives, families, and communities.

During one week in May 2003, more than 25,000 professionals and amateurs shot more than a million pictures. These images, sent to us via the Internet, compose a panoramic yet highly intimate view of Americans in celebration and sadness; in action and contemplation; at work, home, and school. The best of these photographs, more than 6,000, are collected in 51 volumes that make up the *America 24/7* series: the landmark national volume *America 24/7*, published to critical acclaim in 2003, and the 50 state books published in 2004.

Our decision to make *America 24/7* an all-digital project was prompted by the fact that in 2003 digital camera sales overtook film camera sales. This techno-logical evolution allowed us to extend the project to a huge pool of photographers. We were thrilled by the response to our challenge and moved by the insight offered into American life. Sometimes, the amateurs outshot the pros—even the Pulitzer Prize winners.

The exuberant democracy of images visible throughout these books is a revela-tion. The message that emerges is that now, more than ever, America is a supersized idea. A dreamspace, where individuals and families from around the world are free to govern themselves, worship, read, and speak as they wish. Within its wide margins, the polyglot American nation manages to encompass an inexplicably complex yet workable whole. The pictures in this book are dedicated to that idea.

—*Rick Smolan and David Elliot Cohen*

American nightlight: More than a quarter
of a billion people trace a nation with incandes-
cence in this composite satellite photograph.
Photo by Craig Mayhew & Robert Simmon, NASA
Goddard Flight Center / Visions of Tomorrow

Aloha 'Aina

By Curt Sanburn

The key to understanding everything about Hawai'i is to keep in mind that the archipelago is the newest and most temporary bit of land on Earth. Its growth and demise are simultaneous. You can watch both: Acres of docile lava ooze from Kīlauea's fissures, making the half-million-year-old Big Island bigger. Meanwhile, heavy rains stain Kaua'i's nearshore waters the rust red color of its volcanic soils, melting that 5-million-year-old island back into the sea. The bittersweet life-and-death drama of these islands is evident and stirs sympathetic human emotions. Essentially, that's what "aloha" is: an enduring, pervasive affection that cloaks these awesome yet tender islands in sweet perfume.

Okay, so the weather's not bad, either. It's never too hot and never too cold, the trade winds bless us, and the sunsets unleash unimaginable colors in the western sky every night at 6. Hurricanes are rare. There are no poisonous insects or barbed plants—or snakes. For the here and now, Hawai'i is, indeed, Paradise Found.

Over the last millennium, a million people or so have found Hawai'i and now call it home. We've built stone terraces and irrigation systems, freeways and beige subdivisions, malls, universities, and prisons to manage our numbers. And what about the 7 million strangers who show up every year to savor the paradise they've been promised their whole lives? For them we publish "Hidden Hawai'i" guidebooks; build obscenely luxurious resorts, scenic lookouts, and golf courses; and post "Danger: Killer Waves" signs.

Now that sugarcane and pineapple have shrunk down to boutique businesses, the 50th state's economy is completely dependent on tourism and U.S. military spending, both subject to faraway forces. The high costs of living combined with low-wage service jobs make it tough to get by. Two and three generations—call 'em 'ohana—jam together in old bungalows, cinder block walk-up apartments, or "affordable" new townhomes sprawling across abandoned sugarcane fields. "No need!" is the cheerful refrain: No need air conditioning, no need heat, no need a fancy car. No can afford—no need.

The other key to understanding Hawai'i is to accept the distinction of the Polynesians who found and named these islands. Historically, the Hawaiian people warmly welcomed others and spread their koko (blood) around. Today Hawaiians and part-Hawaiians are the third-largest ethnic group in this most polyglot of states, behind haole (Caucasians) and Japanese Americans.

Since the U.S.-backed overthrow of the Hawaiian Kingdom in 1893, and after two centuries of dispossession and displacement, the state and federal governments are finally grappling with their obligations to the Hawaiian nation. Meanwhile, Hawaiian cultural practice—land stewardship, spirituality, health care, music, dance, sport—has energized every corner of these cosmopolitan islands.

What goes around, comes around. The unique triumph of aloha 'aina, love for the land, will be the lasting legacy of the living islands.

CURT SANBURN *is senior editor of the America 24/7 States Project. He was formerly managing editor of the* Honolulu Weekly.

HONOLULU, O'AHU
A quintet of future nurses adds up to one wide smile. Queenie Retuta, Noemi Oviedo, Rochelle Lyn Valdez, Janah Pacheco, and Layna Gaustad just received their bachelor's degrees from the Hawaii Pacific University School of Nursing.
Photo by Dennis Oda, Honolulu Star-Bulletin

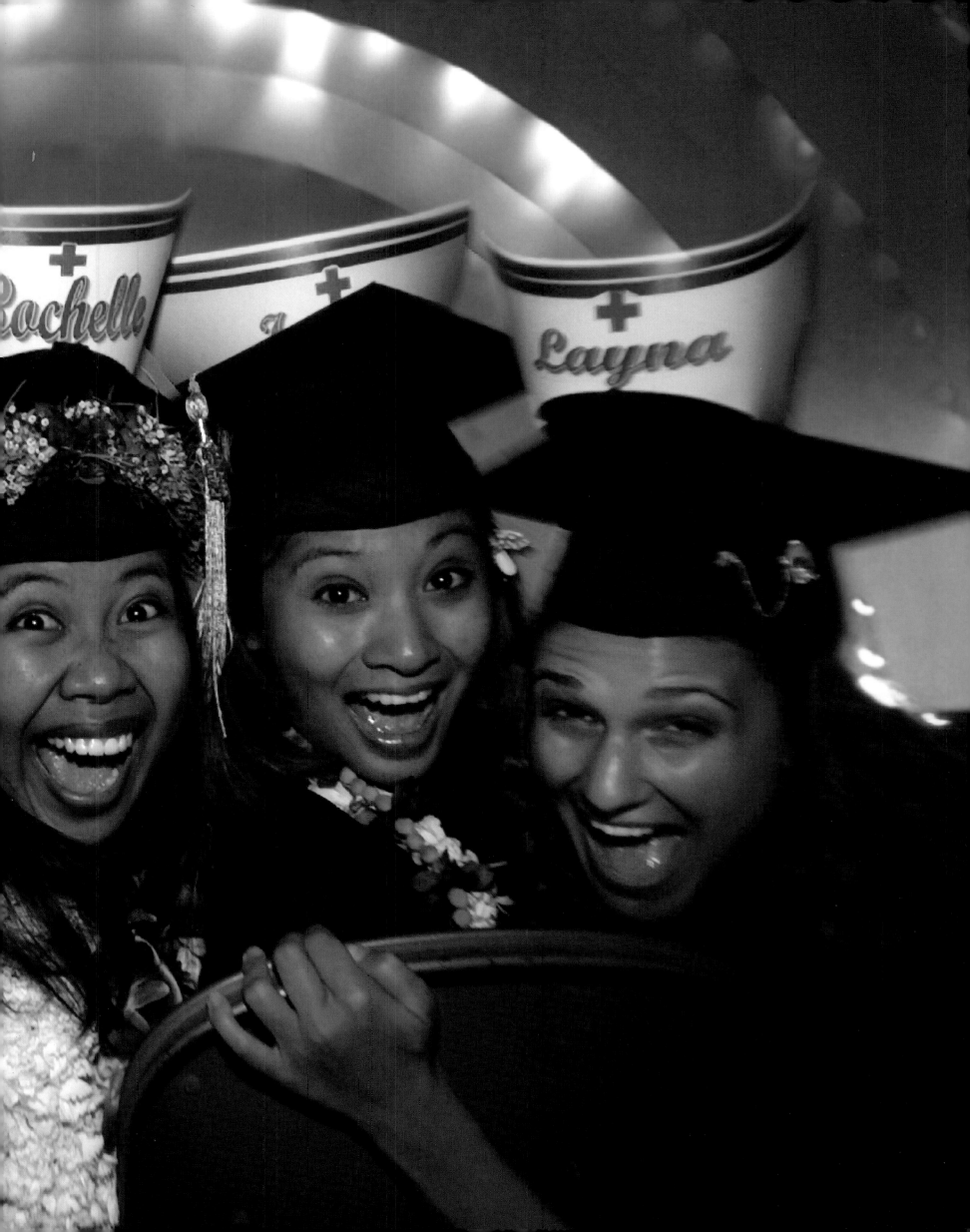

HAWAI'I VOLCANOES NAT'L PARK, HAWAI'I
Chain of Craters Road ends abruptly at the
scene of a 1995 lava incursion, part of the
ongoing eruption that began in 1983 from
vents along Ki lauea volcano's east rift zone.
Since then, seven miles of park road, whole
forests, scenic towns, and beaches have
been buried. A path of yellow reflectors
guides hikers across the brittle lava.
Photo by G. Brad Lewis

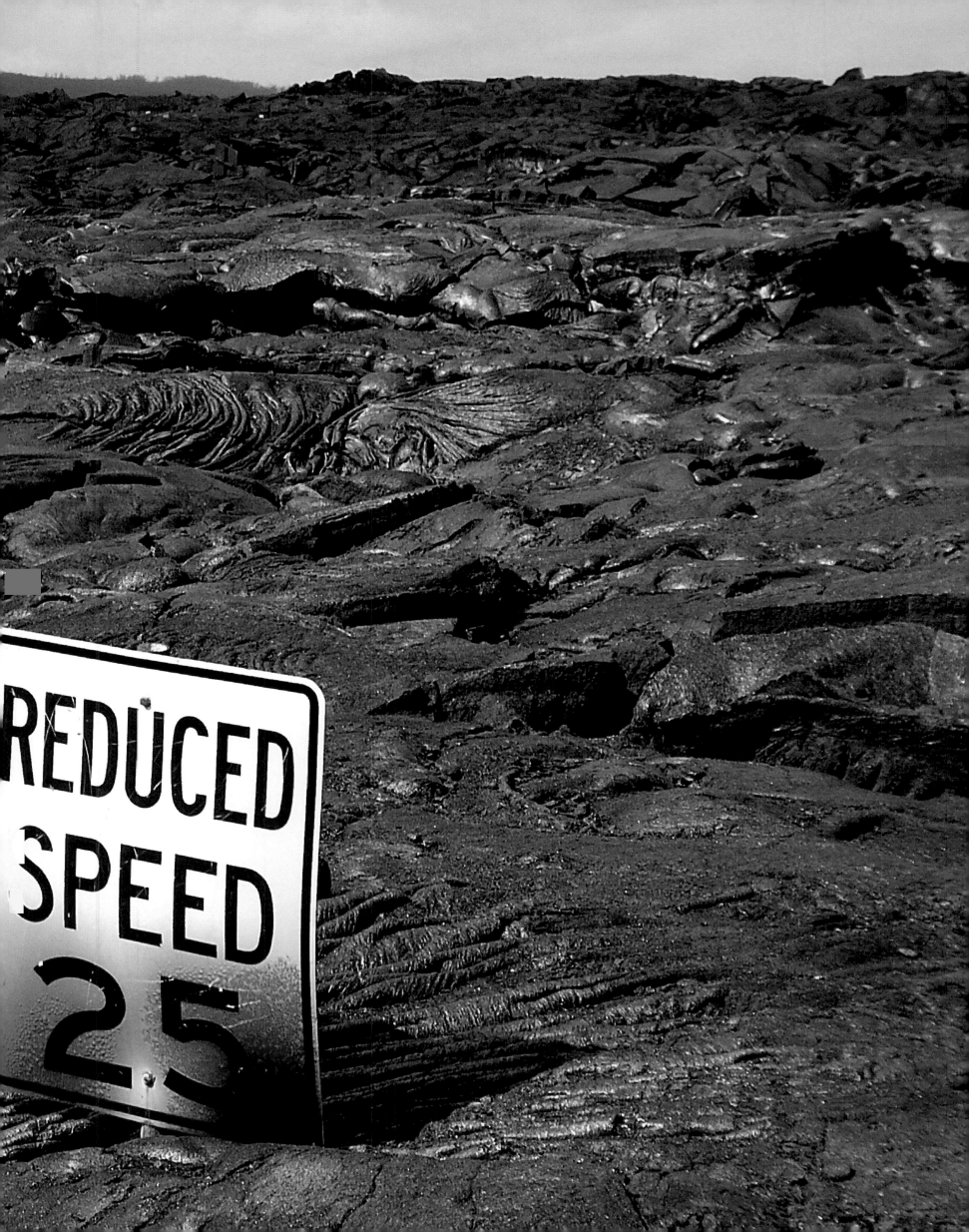

MAUNAWILI VALLEY, O'AHU
Kua'ana Watson gets a lift to a community work day at a taro field from his uncle, Keohokalani Lewis. The traditionally patterned geometric tattoo around Lewis's wrist protects him from bad energy, he says. The work along his forearm symbolizes navigation through life.
Photo by Brett Uprichard,
Honolulu Publishing Company

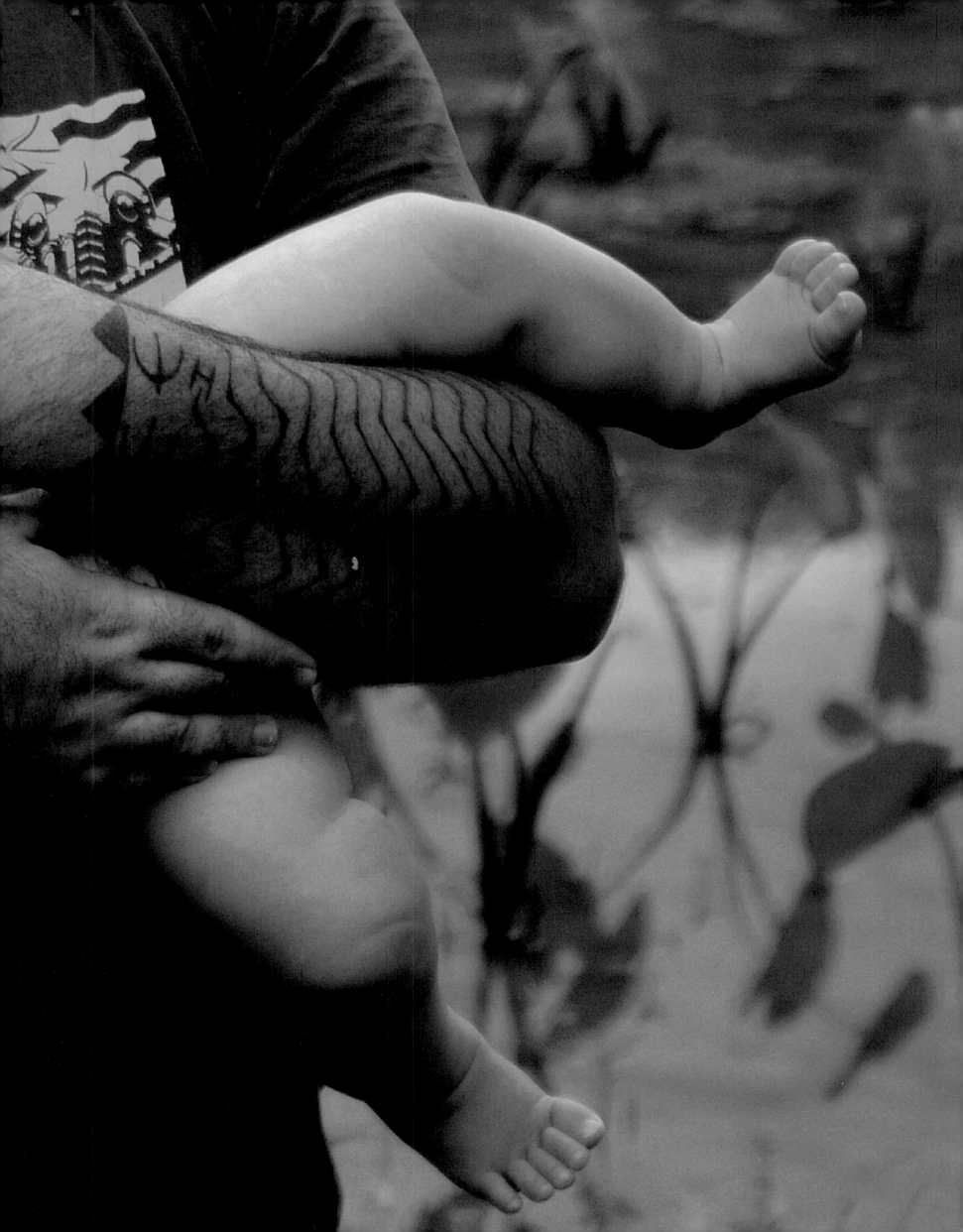

HONOLULU, O'AHU
May 15, 2003, 7:22 p.m.: Zel Boddie takes a swim at the King Manor Apartments on South King Street. Temperature, 79 degrees; humidity, 60 percent; NE tradewinds, 14 mph; surf, 4 to 6 feet on the eastside, 2 to 4 feet on the south; sunset, 19 minutes ago. Forecast: more of the same.
Photo by Jeff Widener

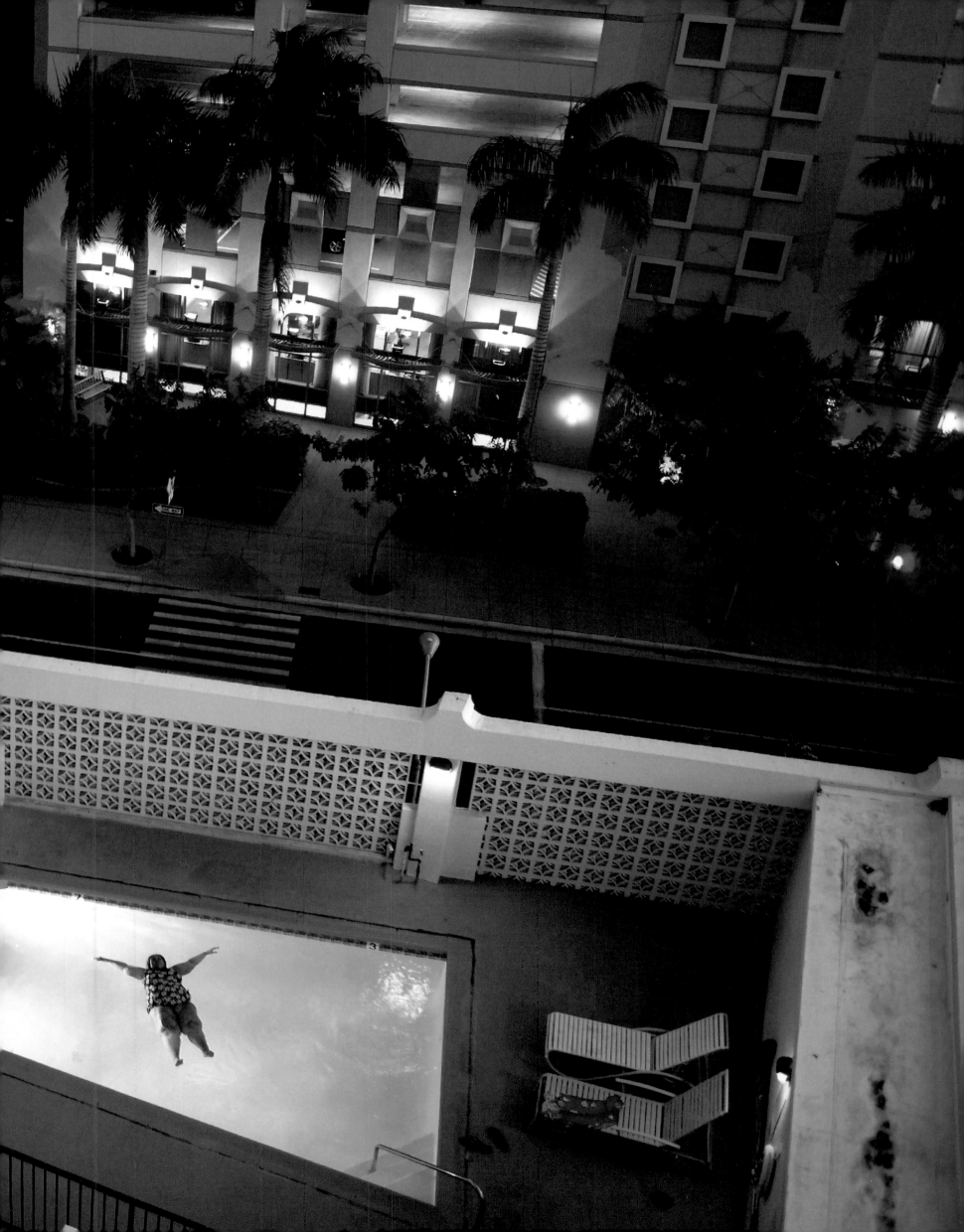

KAILUA BEACH, Oʻahu
One of the most honored hula troupes in the state is Hālau Na Mamo O Puʻuanahulu, under the direction of kumu hula Sonny Ching. Dancers Kalehua Etrata, Kauʻi Ramos, Jennifer Oyama, and Pomaikaʻi Krueger express an ancient Hawaiian chant.
Photo by Dennis Oda, Honolulu Star-Bulletin

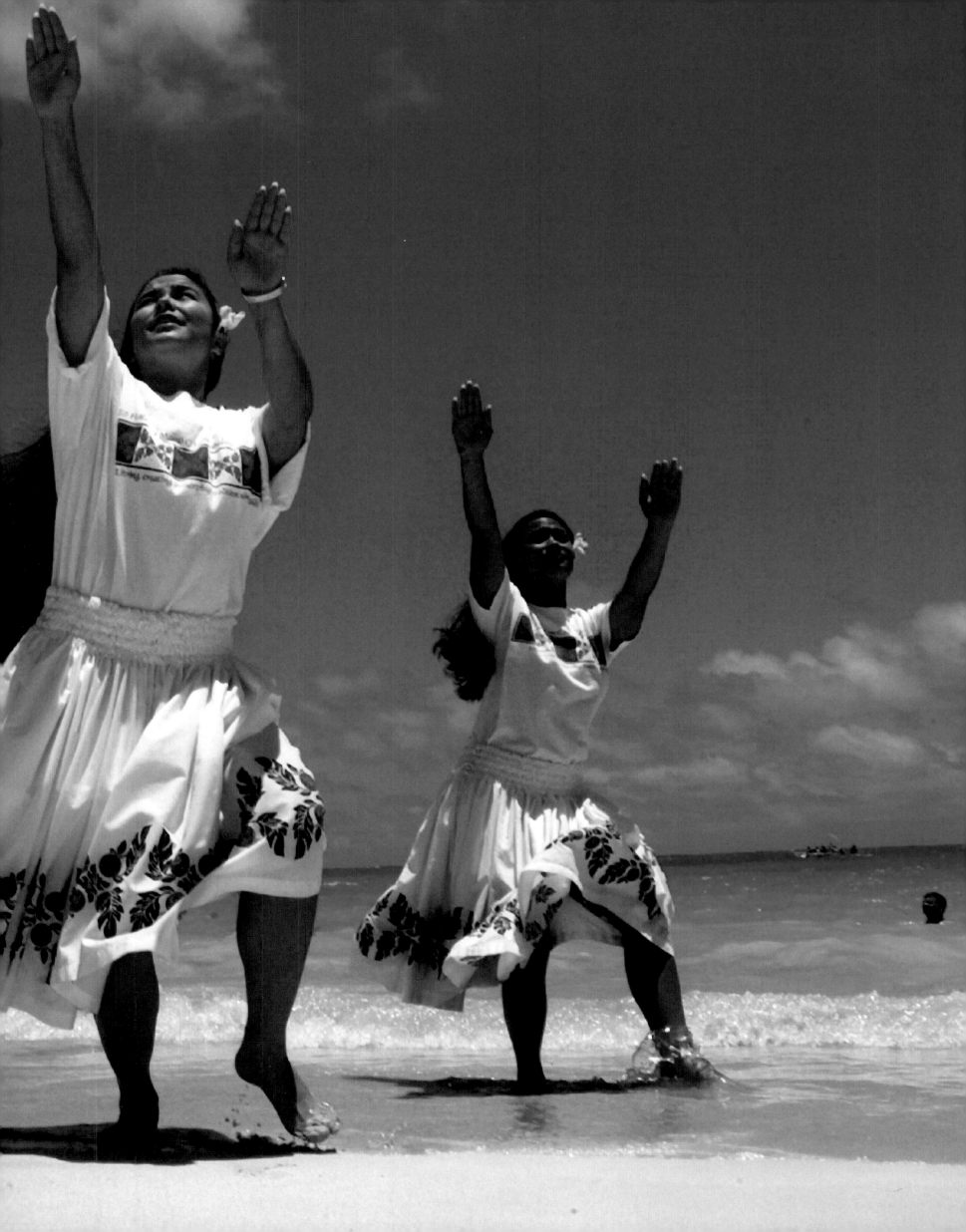

HONOLULU, O'AHU
Month-old Keoe Hoe is named for the star Vega, called Keoe in Hawaiian. The star is part of the celestial summer triangle sailors rely on for navigation. Parents Kealoha Hoe and Moana Doi are crew members of the voyaging canoe *Hokule'a* and have sailed through the Marquesas Islands with help from Keoe's light.
Photo by Monte Costa

Hearth & Home

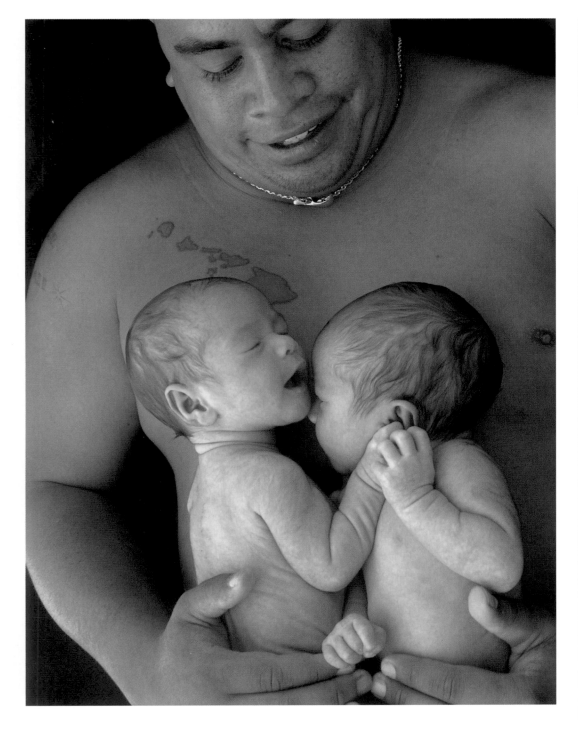
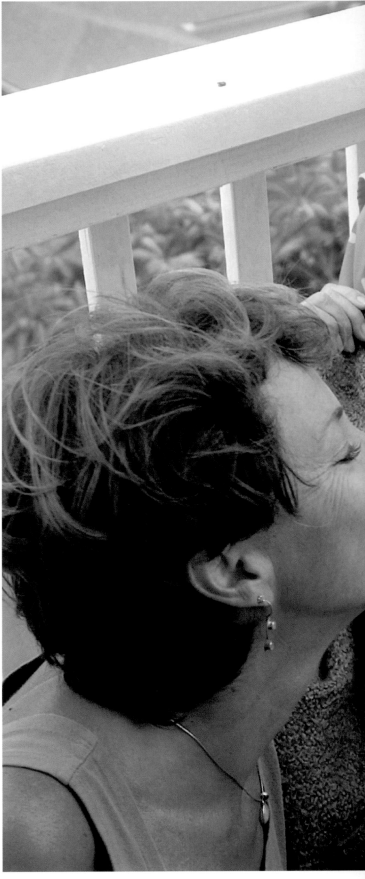

HEʻEIA OʻAHU
Kelii Wagner poses for a family portrait with his newborn babies at home in Heʻeia, on Oʻahu's windward side. Kelii and his wife Cindy's identical twins, ʻAulani and Kainani, were born April 30. Their heritage is Hawaiian, Japanese, African American, Irish, and German.
Photos by Brett Uprichard,
Honolulu Publishing Company

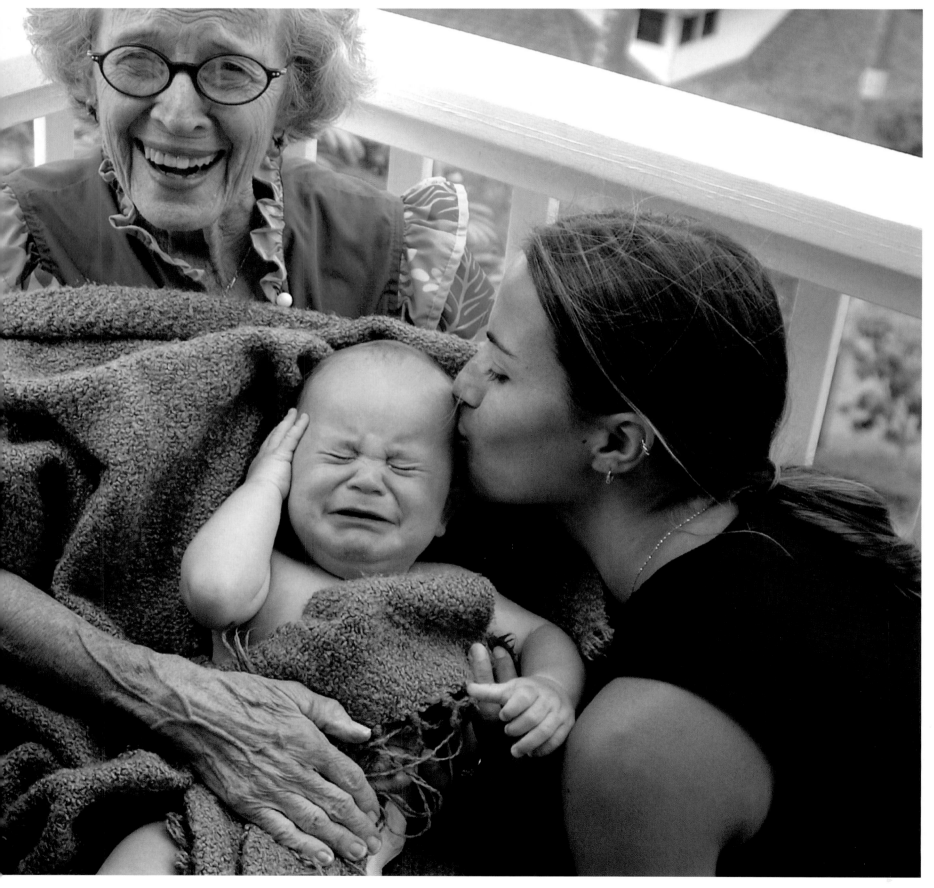

LANIKAI, O'AHU

A Lanikai matriarchy: Petty Floyd and her family moved from Poplar Bluff, Missouri, to this lānai in Lanikai in 1958. Now, four generations live under one roof in harmony—unless it's teething time. Petty's daughter Nori Floyd keeps smiling while granddaughter Sarah Perry comforts her son Kaden Wolfley, the household's only male.

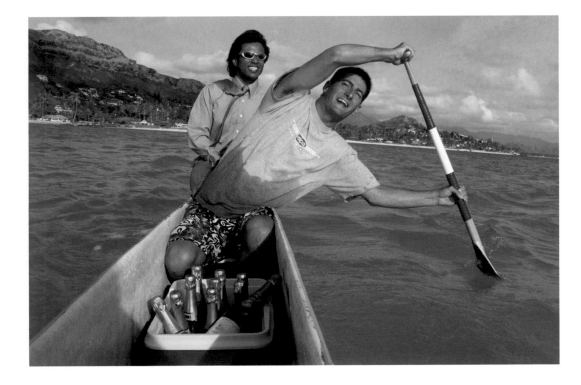

KAILUA, O'AHU

Get him to the offshore islet on time: Tad Tucker paddles bridegroom Robert Myint to his wedding on an island off Lanikai beach. After the ceremony, Myint and his bride, Angelina Campos, plan to toast one another and their guests with champagne, and then swim back to Lanikai.

Photos by Sergio Goes

NA MOKULUA, OʻAHU

The bride, groom, and guests took seven outrigger canoes to this sandy getaway beach. Here in the blazing morning sun, 38-year-old Robert Myint was wedded to Angelina Campos, 34. The couple gives a salute before their swim back to Oʻahu. Love is crazy.

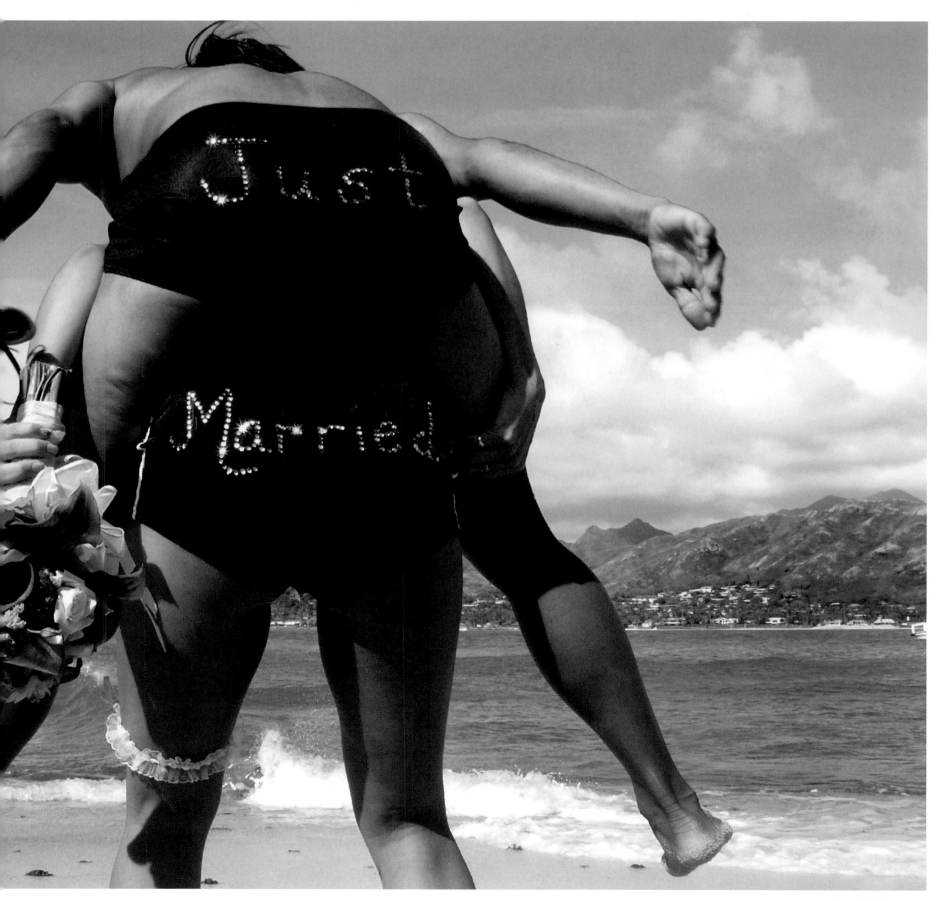

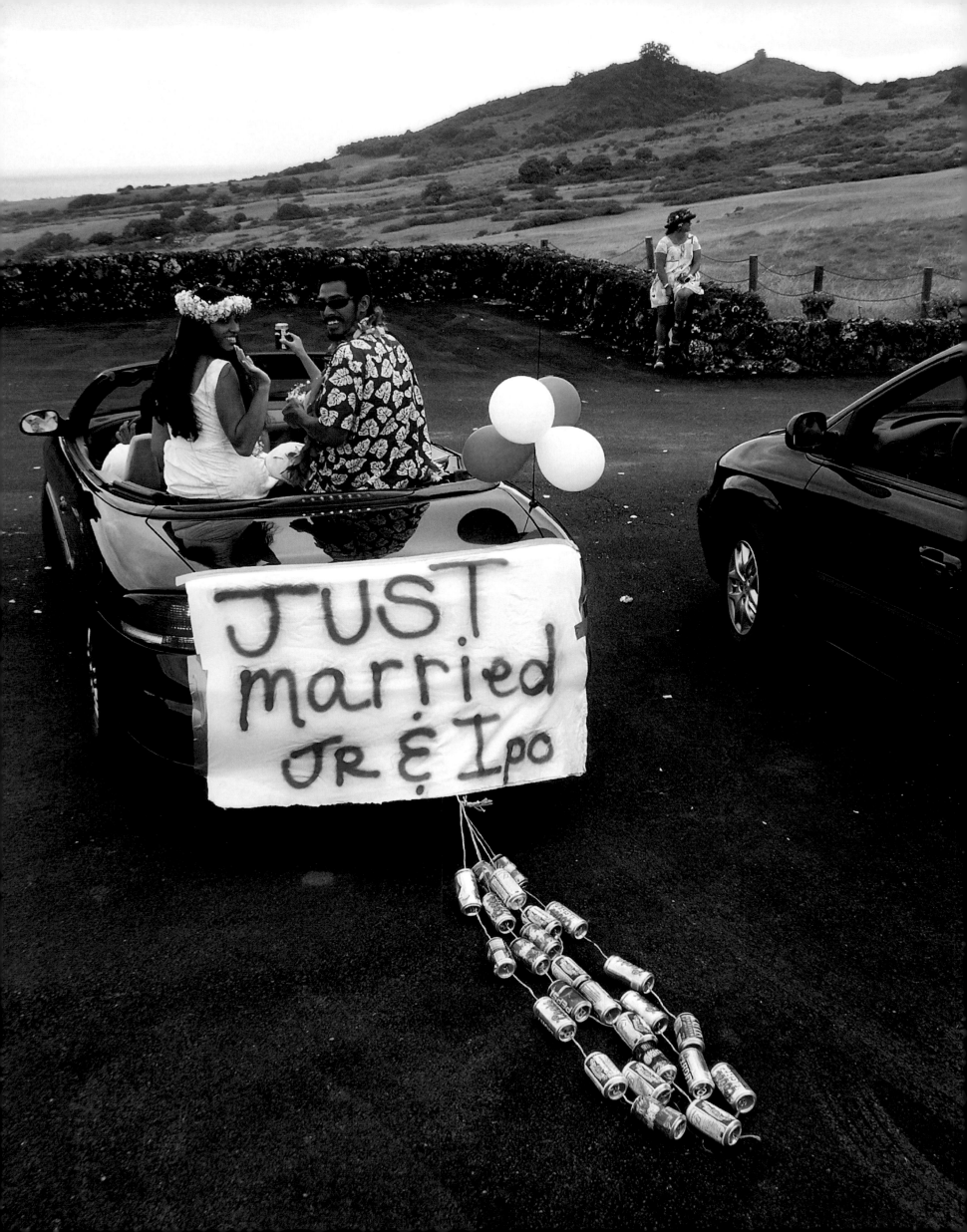

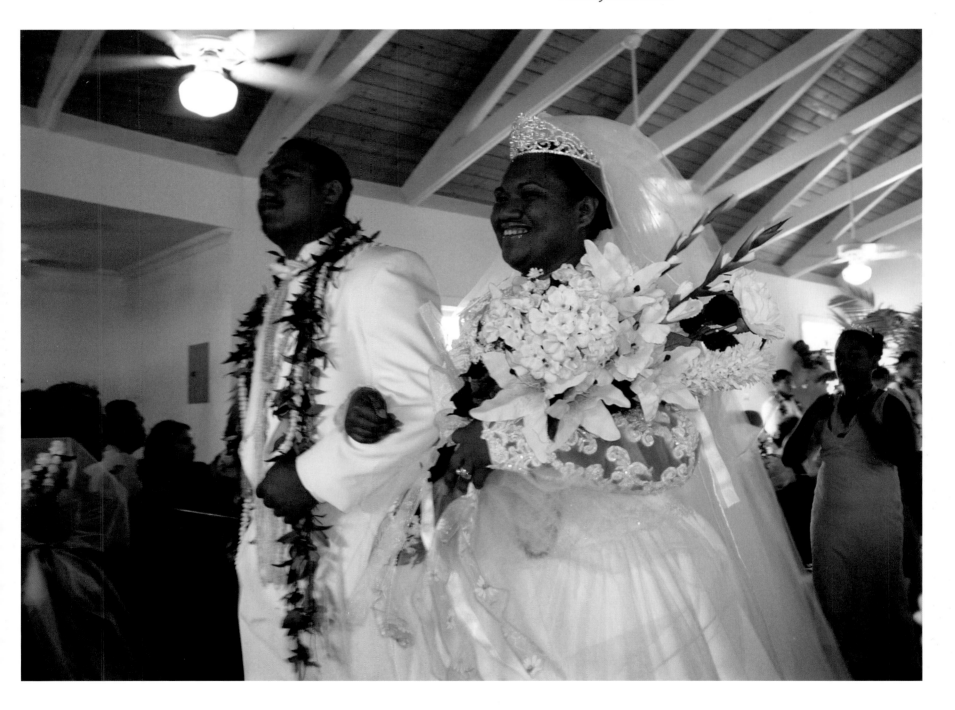

HĀNA, MAUI

Ipo and JR, Pepsi in hand, drive away from the hill-top setting of their wedding after the ceremony. A honeymoon? No need. Every day in sleepy, rainy, end-of-the-road Hana (pop. 709) is an idyll. Plus, who in Hawai'i can really afford a honeymoon? And where would you go?

Photo by Michael Gilbert

WAIMEA, KAUA'I

Full-blooded Hawaiians Georgiana Nawai Kanahele Kahale and husband Allen Kaleionalani Kahale leave Waimea Hawaiian Church after their wedding ceremony. The couple is from Ni'ihau, where a strict Christian code forbids contact between men and women before marriage. Allen and Georgiana broke this taboo, and she was banished to Kaua'i for five months. The story ends happily.

Photo by Sabra Kauka

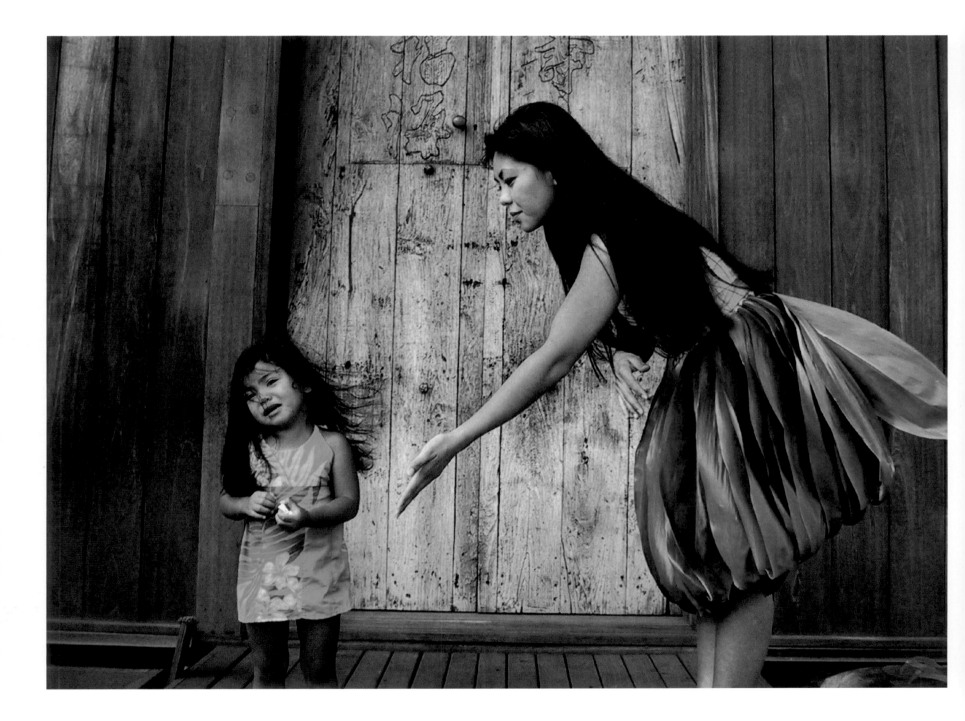

KALĀHEO, KAUAʻI

Two-year-old Taira Abreu likes to ride horses with her father in the valleys of Kauaʻi. She does not—repeat, NOT!—want to dance hula like her mom, Brandee, a member of Hālau Ka Lei Mokihana ʻO Leinaʻala. At a hula photo session, the gentlest gesture of supplication was to no avail.

Photo by Bruna Stude

WAIMĀNALO, O'AHU

Sara Caires, 19, spritzes Leviosa after training at the Waimanalo Polo Club. Caires moved to the islands with her mother from Nice, France, at age 7. They've returned to Europe for visits, but Hawai'i is home. "The ocean is so close to the mountains," she says. "I ride in the morning and surf in the afternoon. It's the best of both worlds."

Photo by Sergio Goes

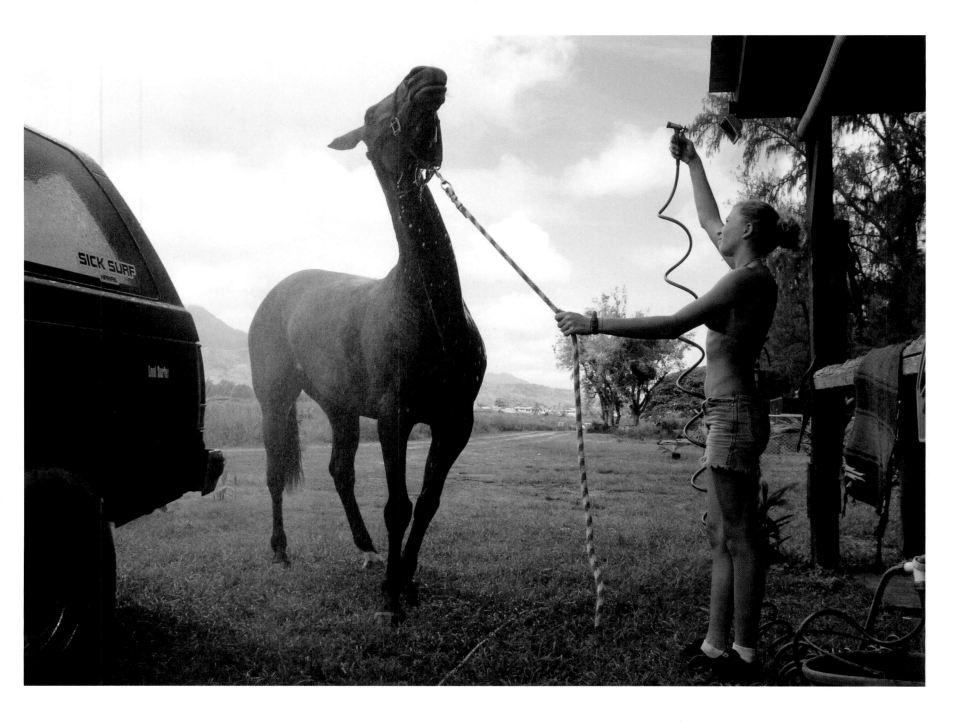

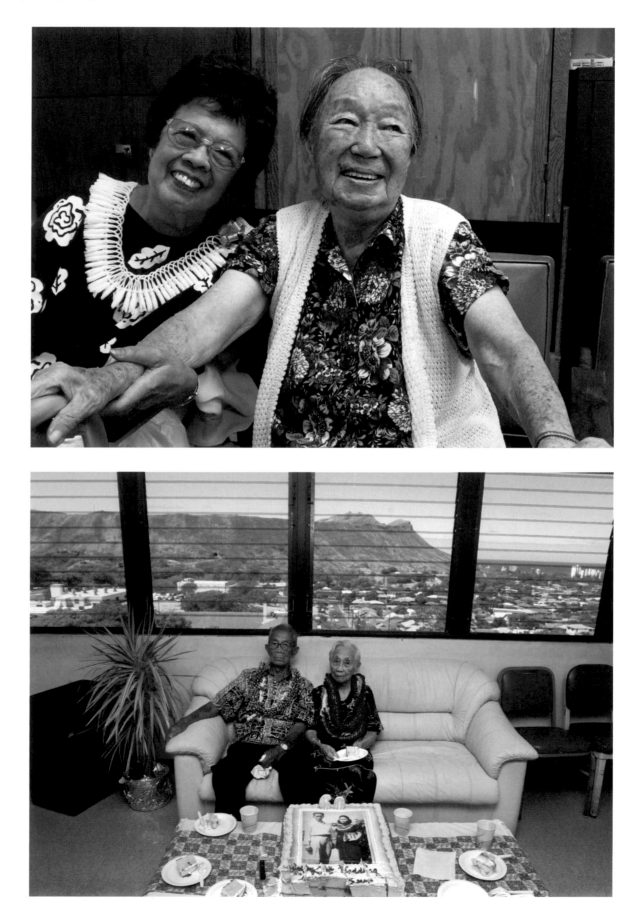

HONOLULU, O'AHU

The Lanakila Multi-Purpose Senior Center began 35 years ago with separate "clubs" for Japanese, Hawaiian, Portuguese, Korean, Okinawan, Chinese, and Filipino elders who clung to their cultural practices. Now elders socialize across borders. Sally Chun, 77 (Hawaiian, Chinese, Filipino, Spanish), clings to Annie Lee, 91 (Korean).

Photo by Phil Spalding

HONOLULU, O'AHU

Benny Marquez, 99, catches the bus from Kalihi three times a week to visit his wife Florentina, 95, who lives at the Lē'ahi Hospital Nursing Home in Kaimukī. Married 60 years, Benny says he and Florentina don't have many problems, because he always lets her have her way.

Photo by Jeff Widener

KAULUWAI, MOLOKA'I

Renaissance woman: a nurse, an artist, a photographer, a teacher, a business woman—there isn't much Bronwyn Cooke hasn't done. Her focus now is the Hui Ho'olana arts and healing retreat she founded with her husband on Moloka'i.

Photo by Richard A. Cooke III

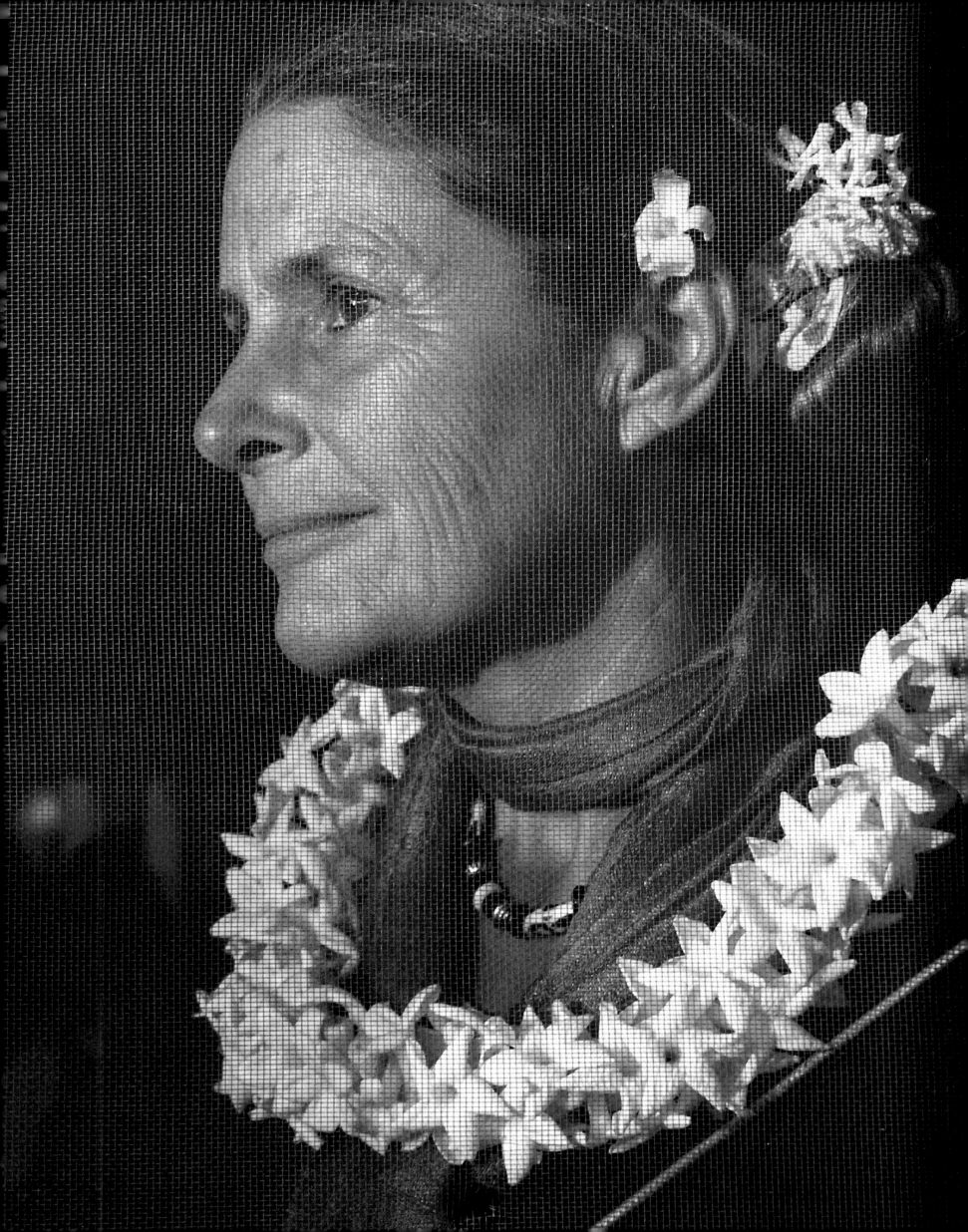

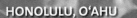

HONOLULU, O'AHU
Art Pacheco works hard during the week. He commutes by plane to Maui, where he supervises the construction of an $18 million waste treatment plant. On weekends, he takes it easy—usually a round of golf followed by some pool time. "Of course, I gotta finish my 'honey-do' projects before I get in the pool," he avers.
Photo by Brett Uprichard,
Honolulu Publishing Company

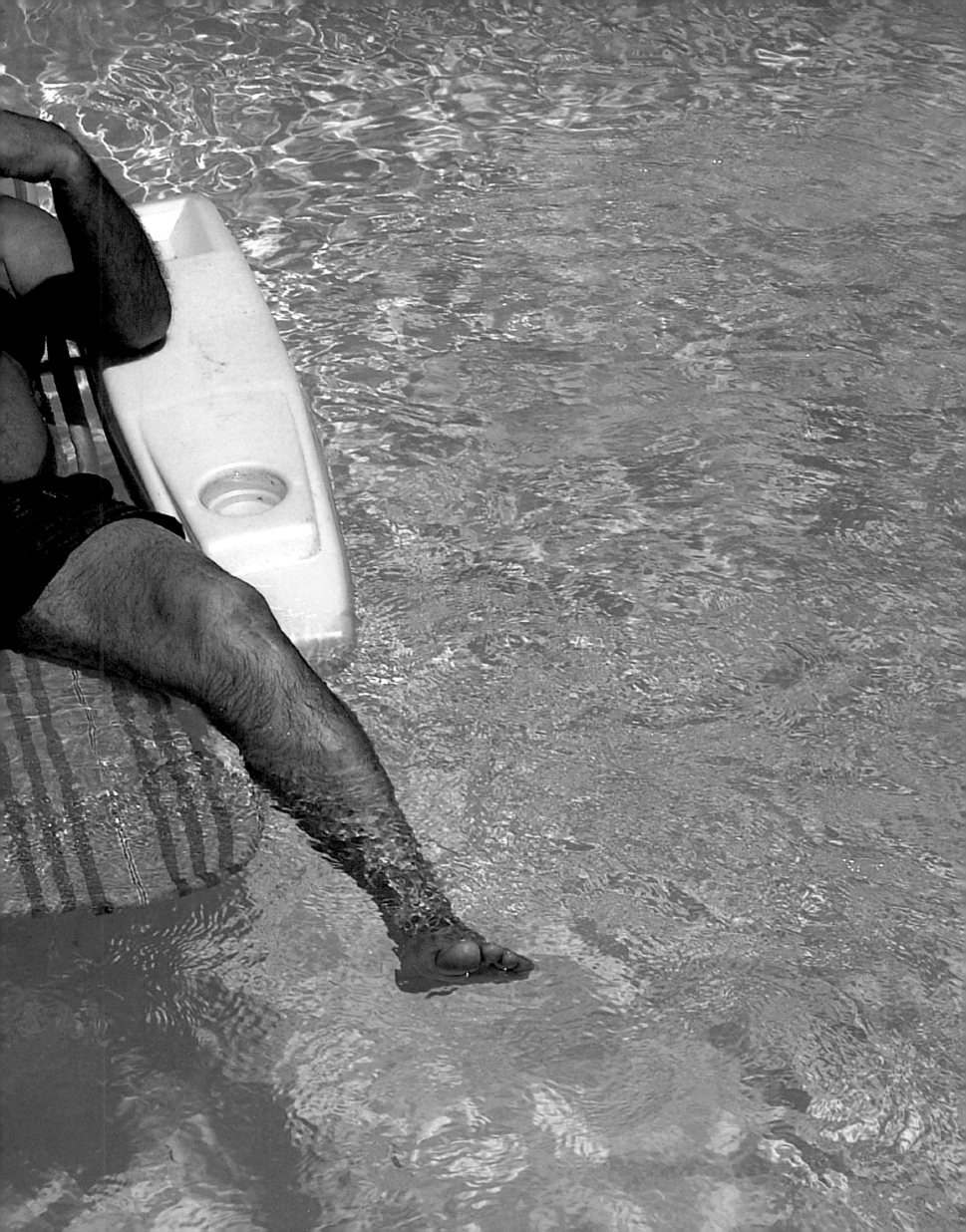

PEARL HARBOR, HAWAI'I
After the nuclear-powered attack submarine USS *Louisville* docks at Pearl Harbor, Jessica Jarrett, her son Will, and daughter Hayley search the crowd for dad, Executive Officer Andrew Jarrett. The sub was deployed for eight months in the Persian Gulf and was part of the U.S. invasion of Iraq, firing Tomahawk missiles to support ground troops.
Photos by George F. Lee, Honolulu Star-Bulletin

PEARL HARBOR, HAWAI'I
His wife Jeanette (holding sign) and family frien Diane Thompson welcome Machinist Mate Chie Tom Vatter home. Vatter is the *Louisville*'s senio enlisted man, or chief of the boat. "I'm the go-t guy when there's a problem among the boat's enlistees," says the 18-year veteran.

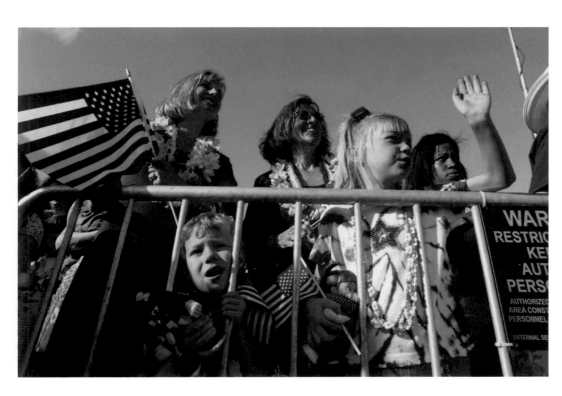

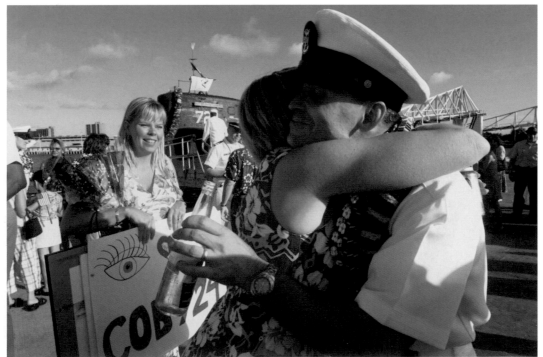

PEARL HARBOR, O'AHU
"Coming home is a pretty special feeling," says the *Louisville*'s commander Michael Jabaley. The 21-year veteran of the U.S. Navy greets wife Jeanette and Christian, one of their six kids.

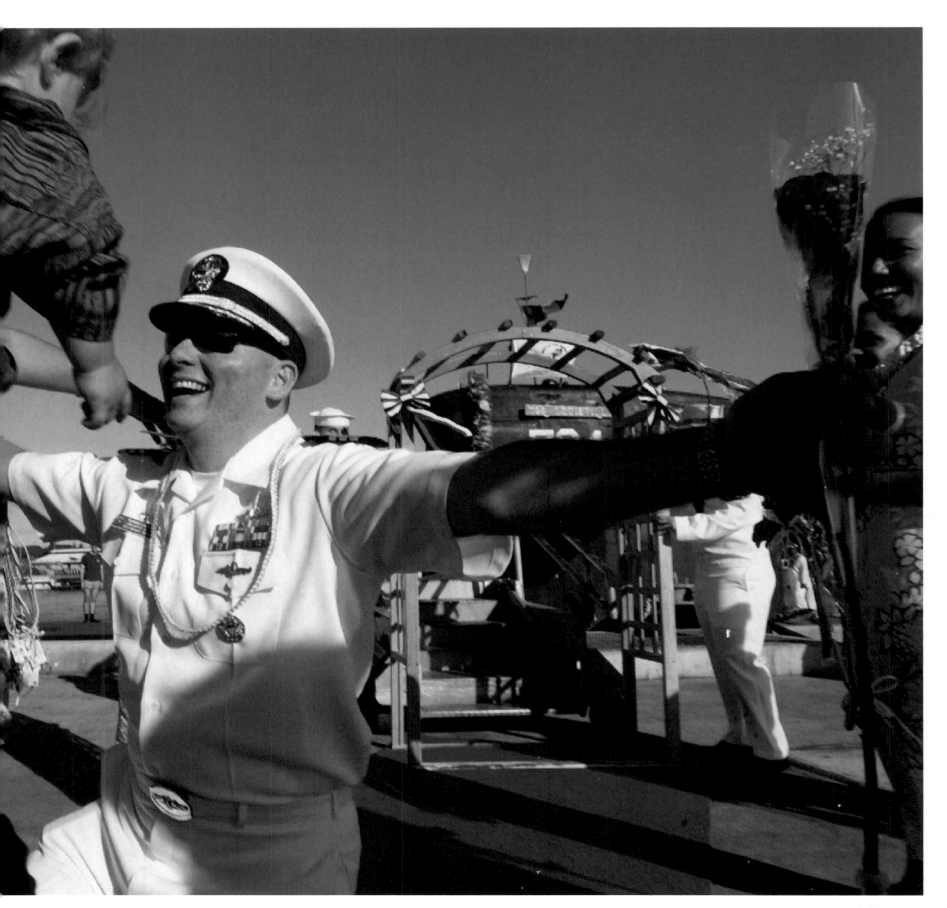

HONOLULU, O'AHU

Jacqueline Tran speaks English and her parents' native Vietnamese. She spends afternoons after school at her family's restaurant, Pho Pacific, in Honolulu's Mō'ili'ili neighborhood. Her mother cooks at the restaurant and her father manages it—on the two days he's not working as a cook at someone else's restaurant.

Photo by Deborah Booker, Honolulu Advertiser

HONOLULU, OʻAHU

Mango madness! In their Kaimukī yard, Liz and Emma Laliberté gather ripe fallen mangoes before the fruit flies get ʻem. Neighbor Gabriel Goes heads back to his house with his hand-selected breakfast.

Photo by Sergio Goes

KĪLAUEA, KAUAʻI

Kawena Alohilani Kawaihalau crowns herself with a lei of palapalai (*Microlepia strigosa*). The fragrant fern is the plant of Laka, goddess of hula and the forest.

Photo by David S. Boynton

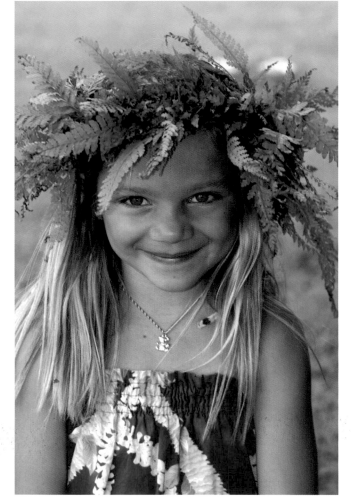

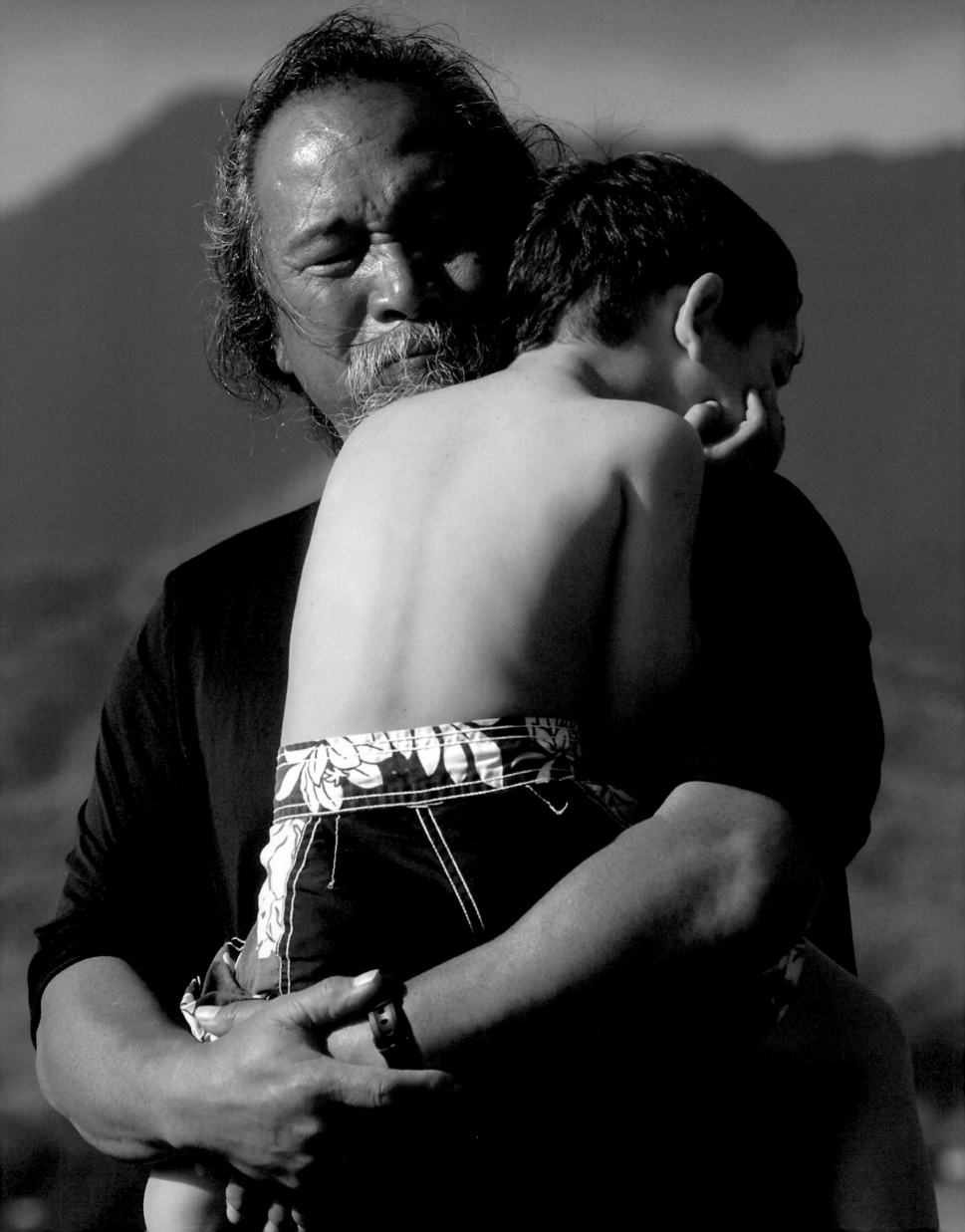

HAKIPU'U, O'AHU
Community activist Calvin Hoe and his grandson Kahiwa attend a ceremony welcoming the voyaging canoe *Hokule'a* to Hakipu'u, the family's ancestral land at Kāne'ohe. "It was a proud moment," Hoe says. One son was captain, and another (Kahiwa's dad) led the welcoming chants.
Photo by Monte Costa

HONOLULU, O'AHU
Two dads and their kids: Photographers Sergio Goes (with Gabriel) and Greg Laliberté (with Emma) chill at Kaimana beach, Honolulu's most urbane beach hangout.
Photo by David Ulrich,
Pacific New Media, University of Hawai'i

HONOLULU, O'AHU
Three plus one: Air Force Master Sergeant John Rosati and his wife Kelly pose in Kaka'ako Waterfront Park with their children Daniel and Anna, hours after Anna's adoption into the family became final. Director of Hawai'i's Family Forum, Kelly Rosati lobbies against same-sex unions, sex education in public schools, and birth control.
Photo by Phil Spalding

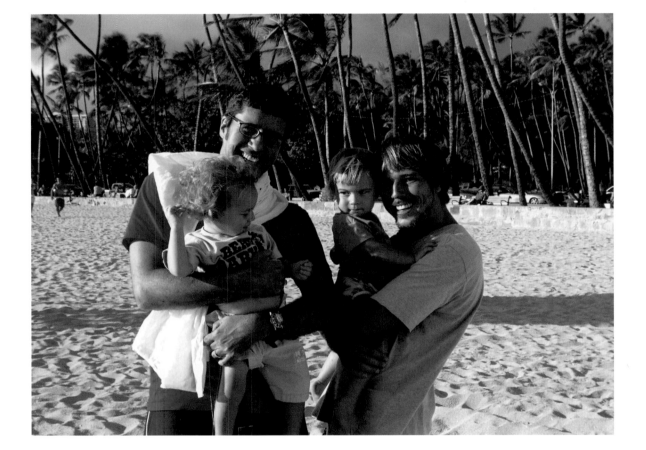

Playing footsie: Lucy Young-Oda has just given 7-month-old Zoe a bath and is kissing her feet when dad, photographer Dennis Oda, hears the gurgling and squealing. He's photographed Zoe every day of her life.
Photo by Dennis Oda, Honolulu Star-Bulletin

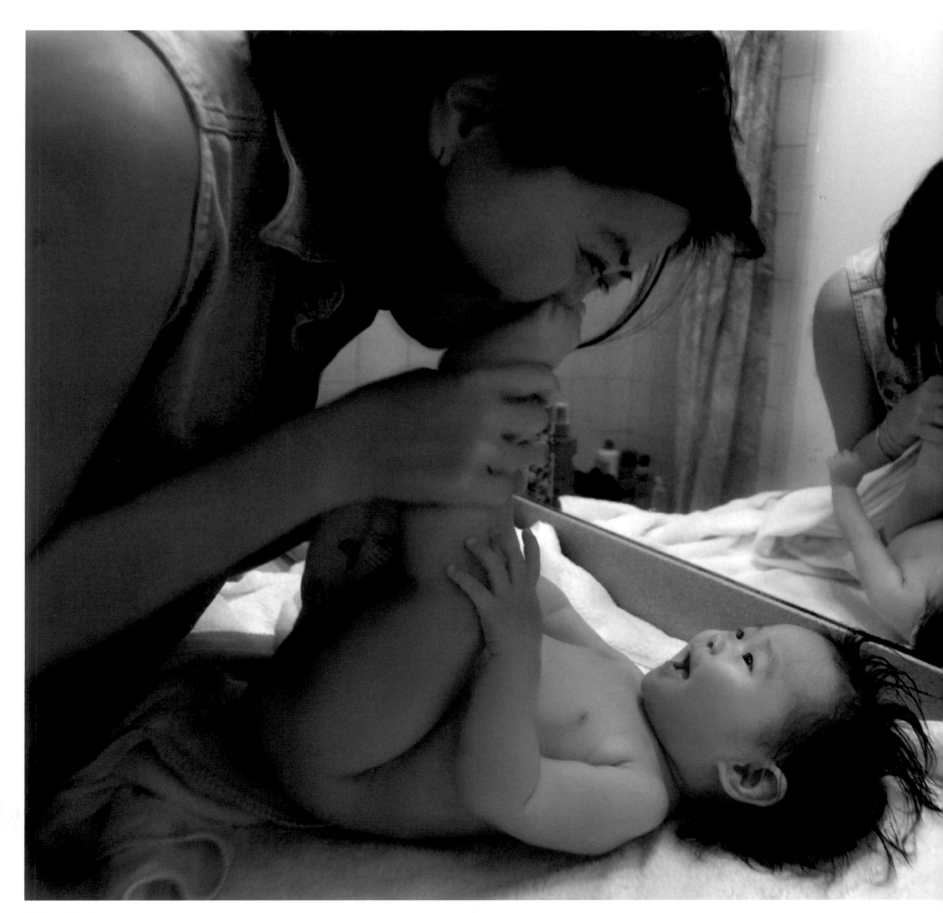

HONOLULU, O'AHU
Cristina and Tony Costa, outside their Honolulu fixer-upper, await the birth of their first child. Hawai'i-born Tony, who sells commercial fishing gear, met Cristina over the phone; she worked in her native Mexico for a company that did business with him.
Photo by Monte Costa

KULA, MAUI
Stephanie Hufford leads a ballet class for tiny princesses at the Alexander Academy in Kula (pop. 2,000). The 14-year-old has been home-schooled her whole life and plans to attend college in California—majoring in math, not dance—by the time she turns 16.
Photo by Randy Hufford, www.visualimpact.org

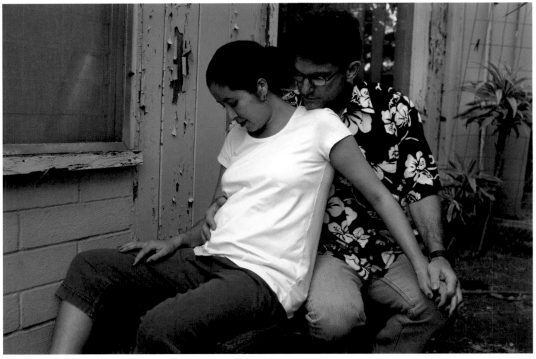

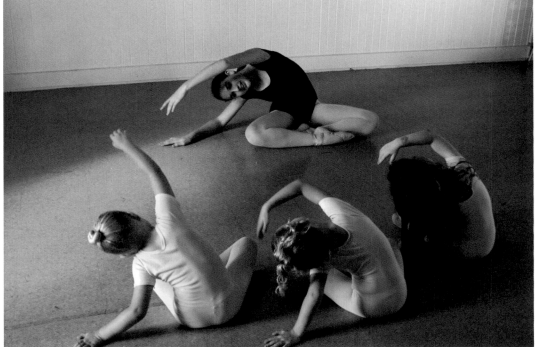

The year 2003 marked a turning point in the history of photography. It was the first year that digital cameras outsold film cameras. To celebrate this unprecedented sea change, the *America 24/7* project invited amateur photographers—along with students and professionals—to shoot and, via the Internet, submit digital images. Think of it as audience participation. Their visions of community are interspersed with the professional frames throughout this book. On the following four pages, however, we present a gallery produced exclusively by amateur photographers.

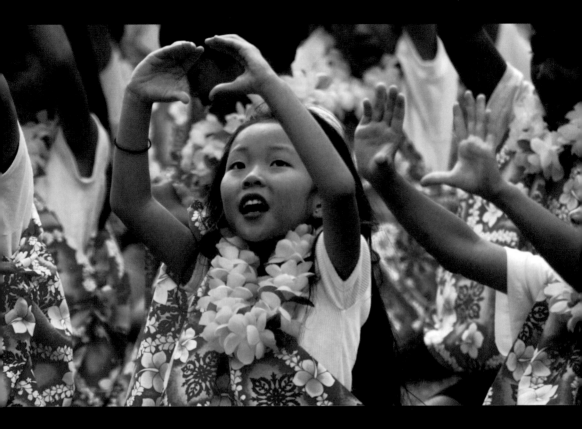

HONOLULU, O'AHU At this point in the hula, says Megan Ishii, her kindergarten class at Mānoa Elementary School sings the word "melemele" (yellow) and forms the sun. *Photo by Warren Ishii*

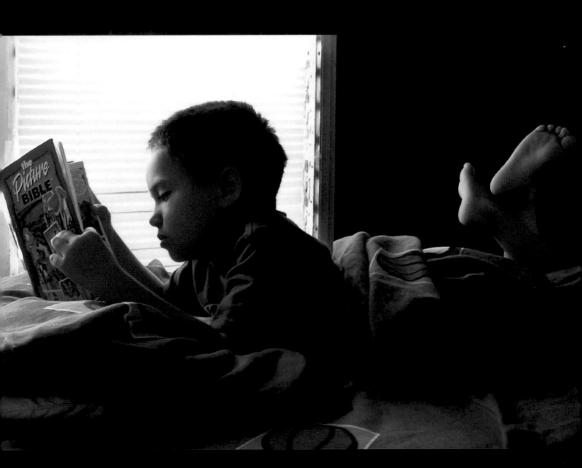

AIEA, O'AHU Every morning Malik Estrella-Clark, 6, reads from his comic book of Bible stories. His goal: to read

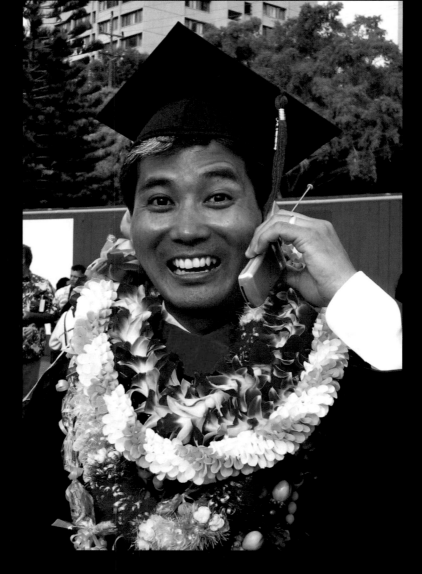

HONOLULU, OʻAHU Architect Troy Miyasato decided to go back to school for an MBA. He calls a buddy after receiving the degree from the University of Hawaiʻi at Mānoa. *Photo by Michelle Clark*

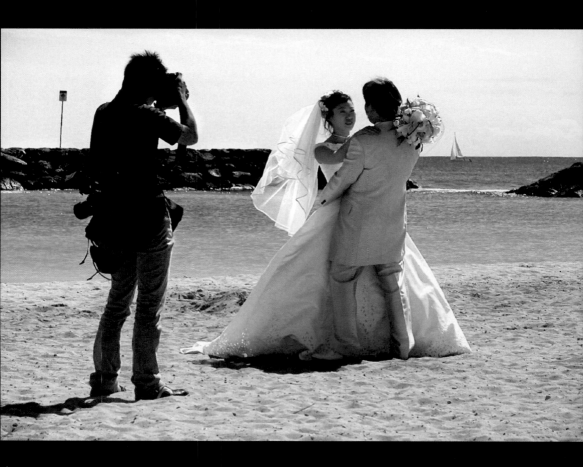

HONOLULU, OʻAHU Japanese tourists pose for wedding pictures on the man-made beach at Magic Island in Ala Moana Beach Park. In 2002, 23,900 Japanese couples came to Hawaiʻi to exchange their vows. *Photo by Eric Sawchuk*

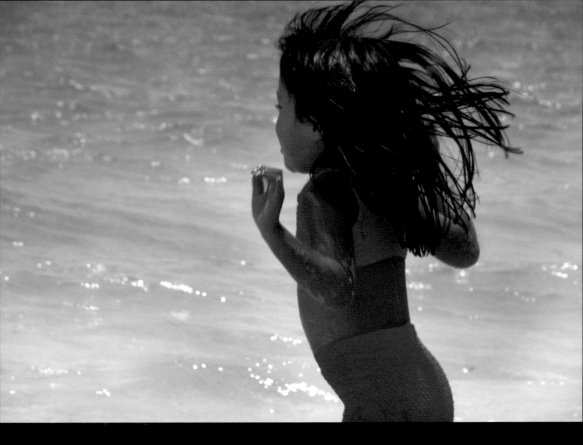

MĀKAHA, OʻAHU Malia Brooks plays at the water's edge on Mākaha beach. The famous surf spot is also the leeward side's favorite family spot. ***Photo by Linda Mascaro***

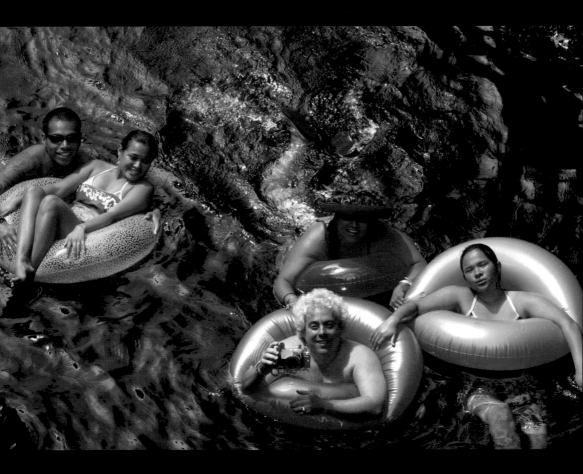

KEʻANAE, MAUI The Bright family and photographer Michael Gilbert look up toward the waterfall that spills into Ching's Pond in East Maui. ***Photo by Greg Davidge***

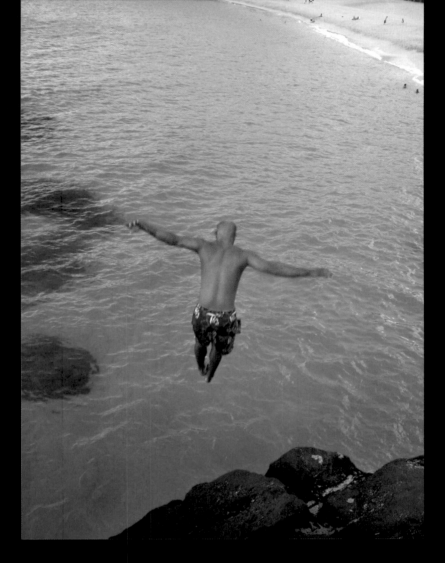

WAIMEA, OʻAHU Depending on the season, Waimea bay has great snorkeling, diving, surfing, and bodysurfing. For those with luʻau feet, the climb up "Jump Rock" for the trip back down is its own reward.
Photo by Lisa Devlin

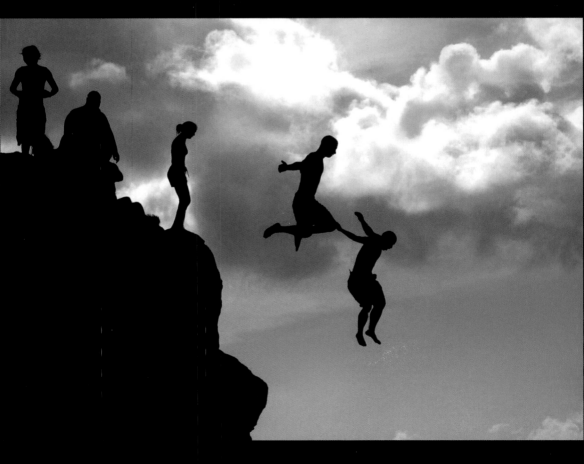

WAIMEA, OʻAHU When the bay is flat during the summer, kids line up for the 20-foot leap.
Photo by Brian Bozlee

KĀNE'OHE, O'AHU
Topsy-turvy: High above the Ko'olau ridge, pilot Hank Bruckner executes a "half roll to inverted" in his 1984 CAP-10B plane. The re-tired Air Force officer (who had a nonflying job) teaches acrobatic flying and participates in local air shows.
Photo by Jeff Widener

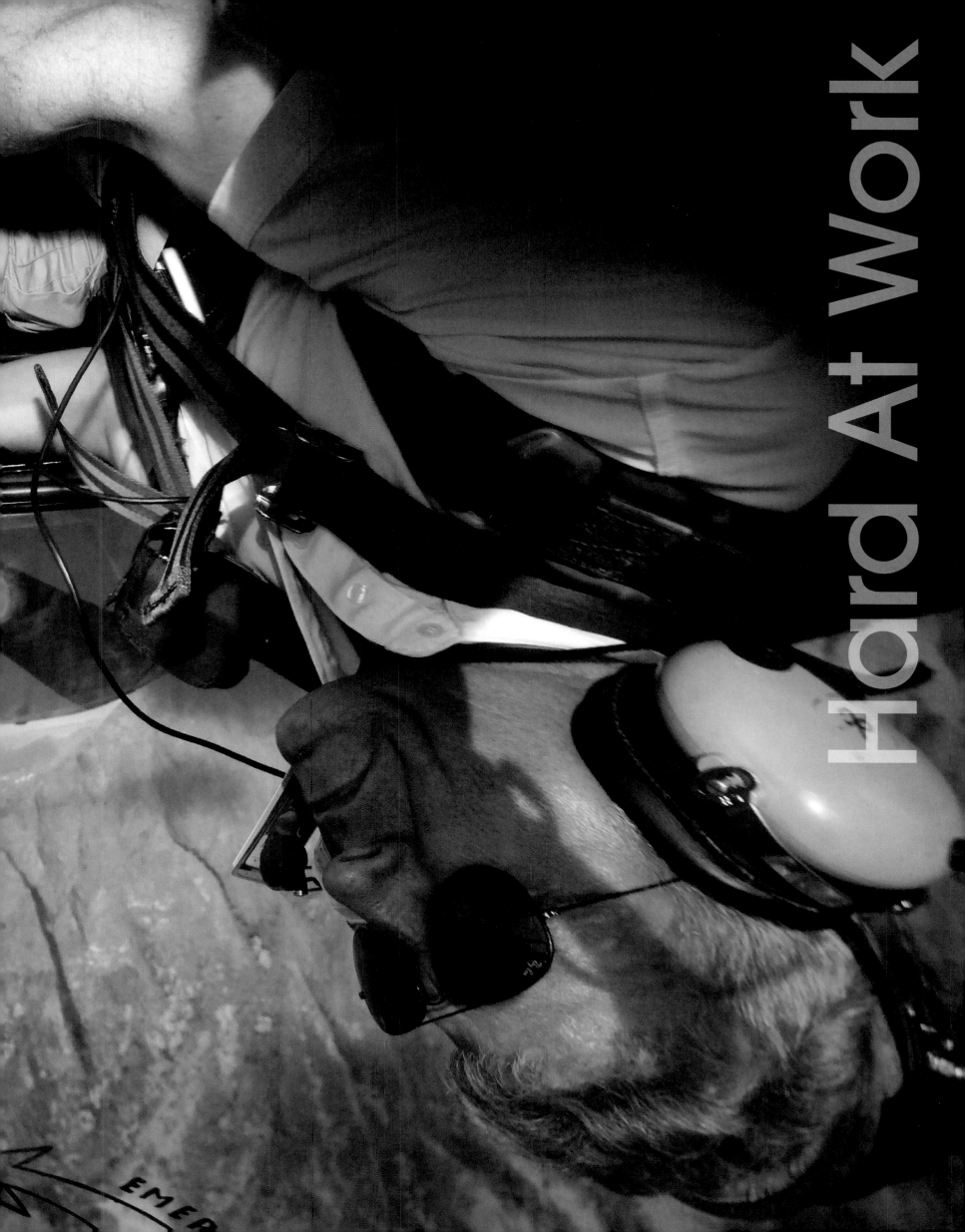

Hard At Work

HONOLULU, O'AHU
Tamaru Colombel of Tahiti competes at the 11th Annual World Fireknife Championship. Sponsored by the Mormon-run Polynesian Cultural Center, the event attracted 46 contestants from as far away as the Cook Islands and Florida. The crowd-pleasing dance derives from the Samoan martial tradition of brandishing burning torches.
Photo by Deborah Booker, Honolulu Advertiser

HONOLULU, O'AHU
On an open-air, floodlit stage at Waikīkī beach, a coed hula hālau performs for tourists. Kealohilani Gardner, 5, is making her performance debut.
Photo by Deborah Booker, Honolulu Advertiser

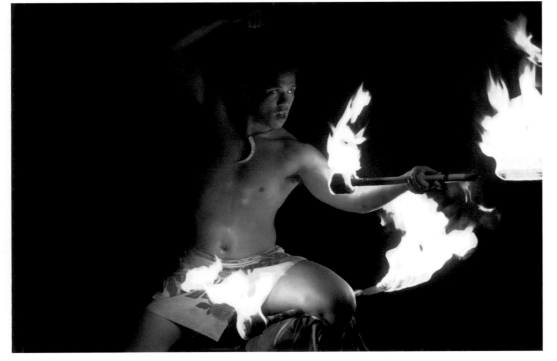

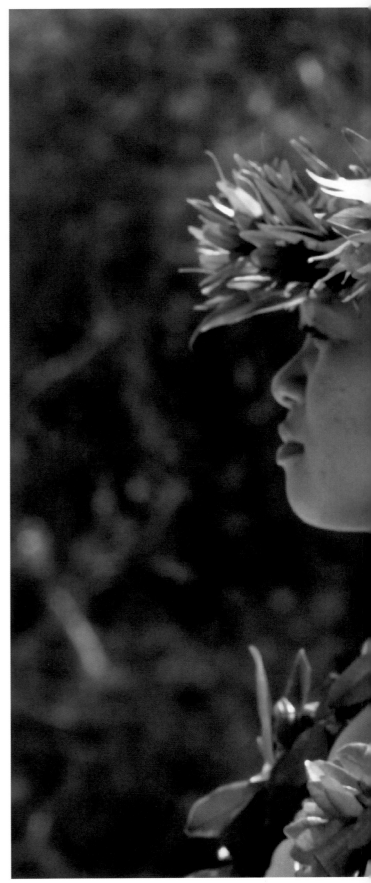

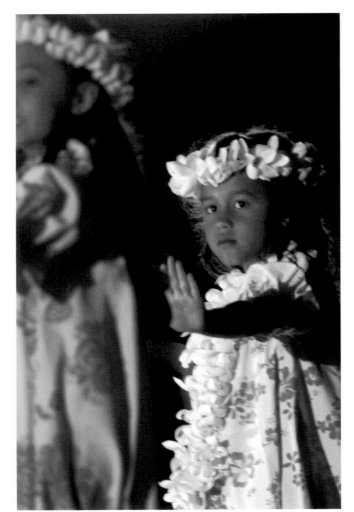

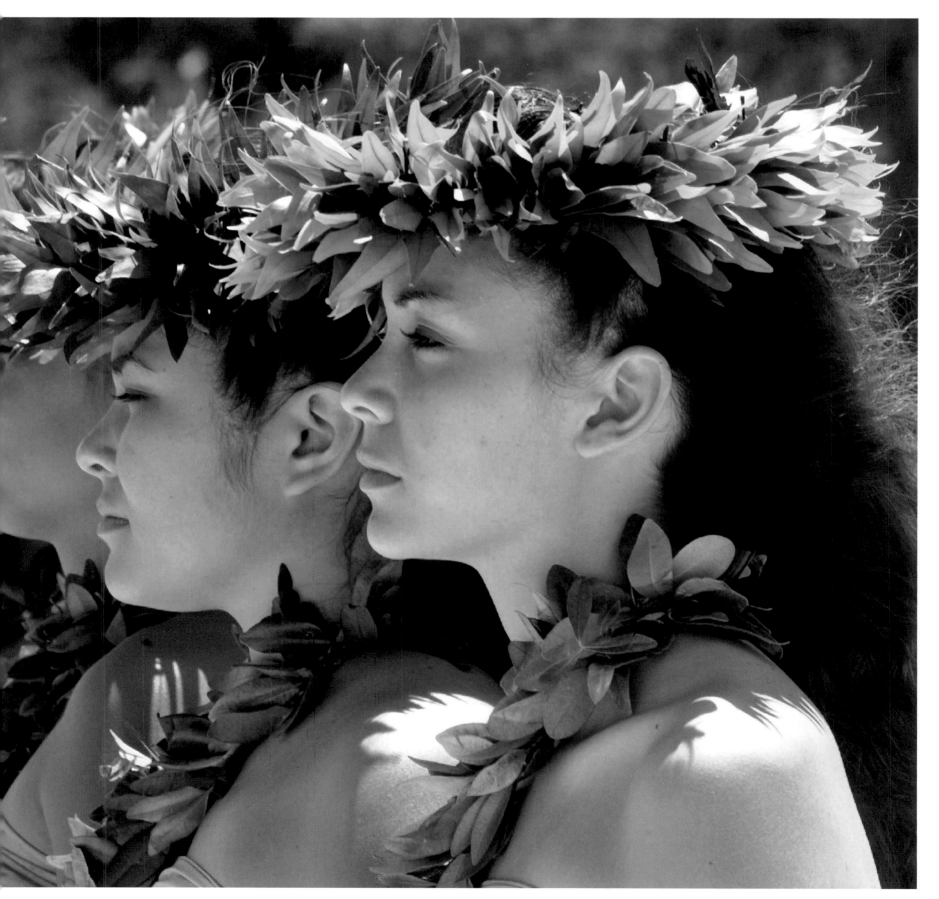

KAILUA, O'AHU
Traditional haku lei top off the outfits of Kalehua Etrata, Pomaika'i Krueger, Jennifer Oyama, and Kau'i Ramos. The quartet are hula dancers with Sonny Ching's Hālau Na Mamo O Pu'uanahulu.
Photo by Dennis Oda, Honolulu Star-Bulletin

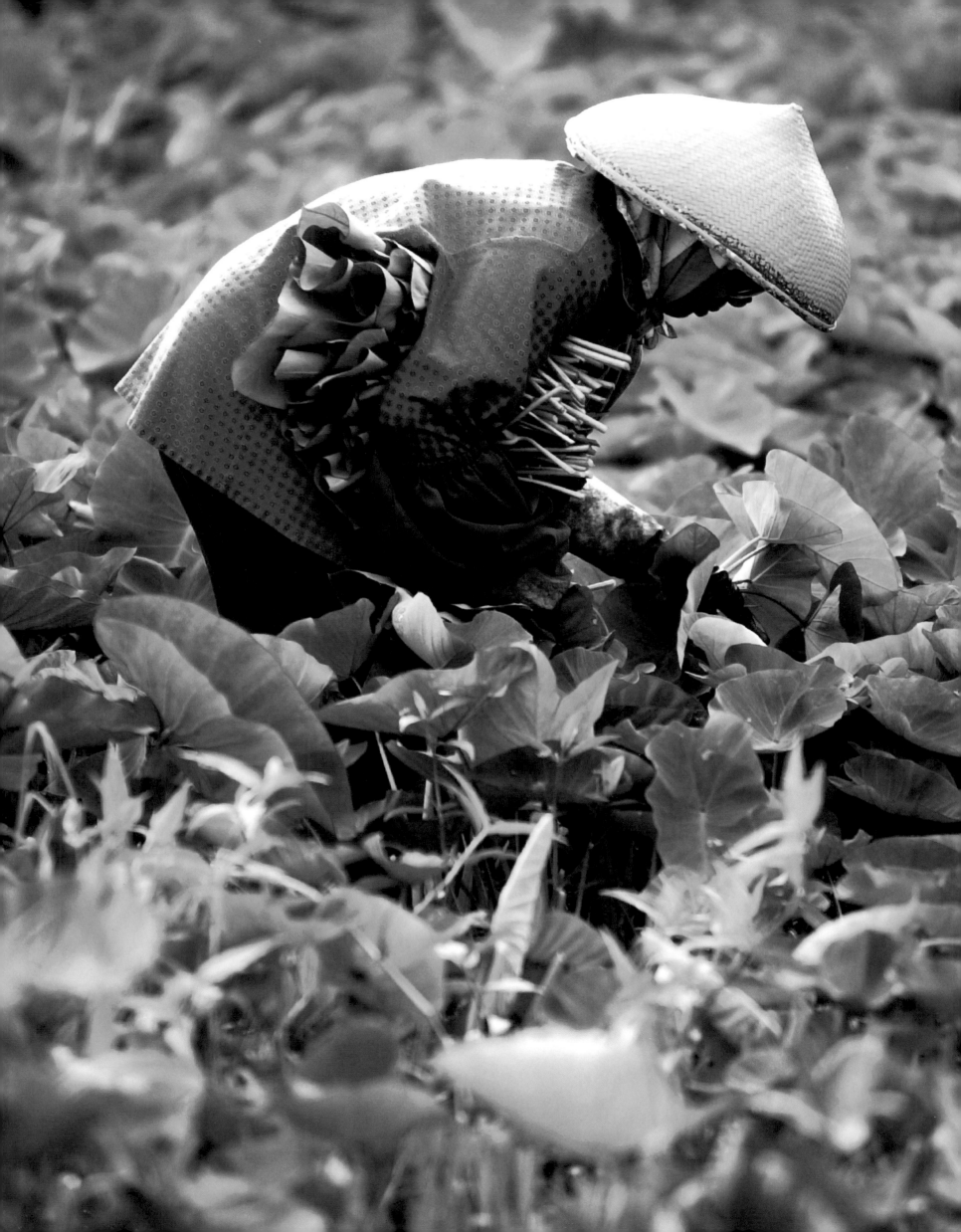

Twenty workers pick taro leaves for Wong's Products in Green Valley. The Wongs began farming taro in the 1950s. Later, they switched to the variety of taro with the tenderest leaves, which are essential greens for laulau, a favorite Hawaiian pork dish.
Photo by Deborah Booker, Honolulu Advertiser

Before entering a loʻi, or taro field, for a day of work, Naiʻa Watson always says a prayer. She is definitely Hawaiian, she says: part Hawaiian, Chinese, French, Portuguese, German, and so on.
Photo by Brett Uprichard, Honolulu Publishing Company

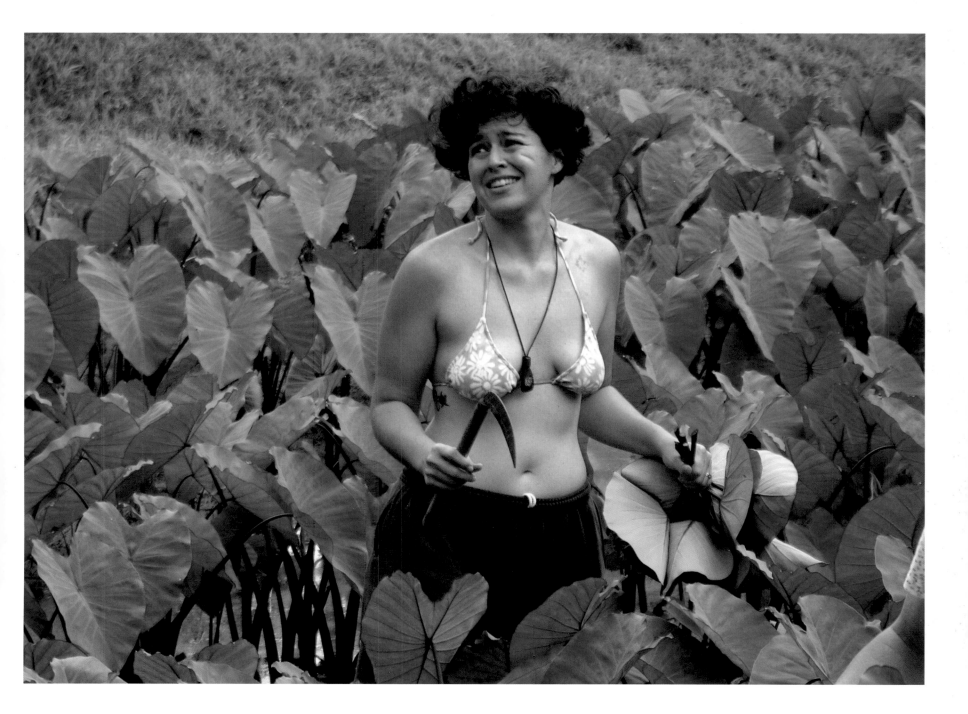

HONOLULU, O'AHU

The Moana Hotel, circa 1901, was the first resort hotel on Waikīkī. In a nod to its late-Victorian beginnings, afternoon high tea is served on the hotel's waterfront lānai—with white gloves, no less. Waiter Florencio Supnet pours. For years, the "Hawai'i Calls" radio show was broadcast around the world from the Moana's lānai.

Photos by Deborah Booker, Honolulu Advertiser

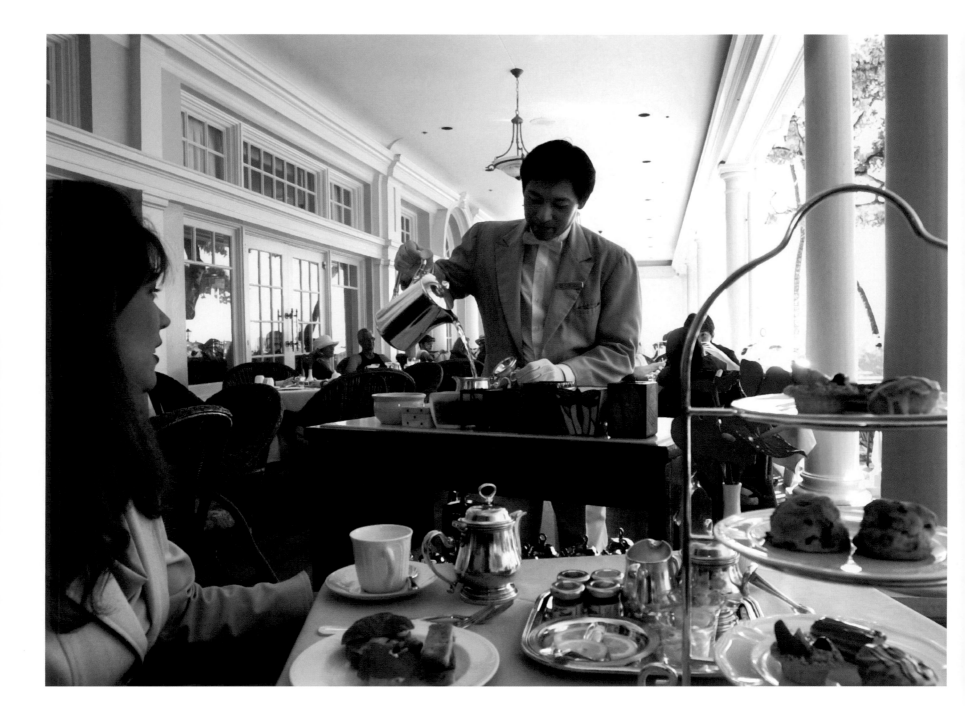

HONOLULU, O'AHU

Shangri La, the Diamond Head estate of the late tobacco heiress Doris Duke, shimmers with her Islamic art collection. Estate caretaker turned tour guide Jin De Silva, 75, is a native of Sri Lanka with a master's degree in welding technology. He says he treated Duke like a mother and that her 1993 death left a vacuum that tourists' daily questions help fill.

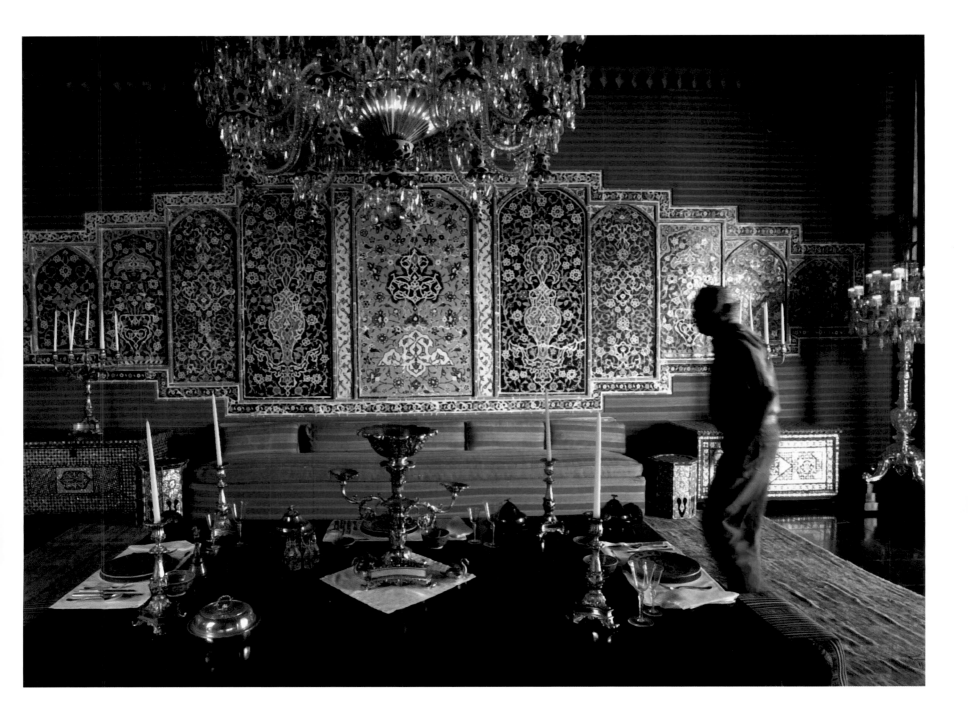

PEARL HARBOR, O'AHU
Twice a year, volunteers clean up the oily waters around the sunken hulk of the USS *Arizona* and its visitor-clogged memorial. Catches of the day include disposable cameras, plastic lei, hats, sunglasses, and hotel-room key cards.
Photo by Brett Uprichard,
Honolulu Publishing Company

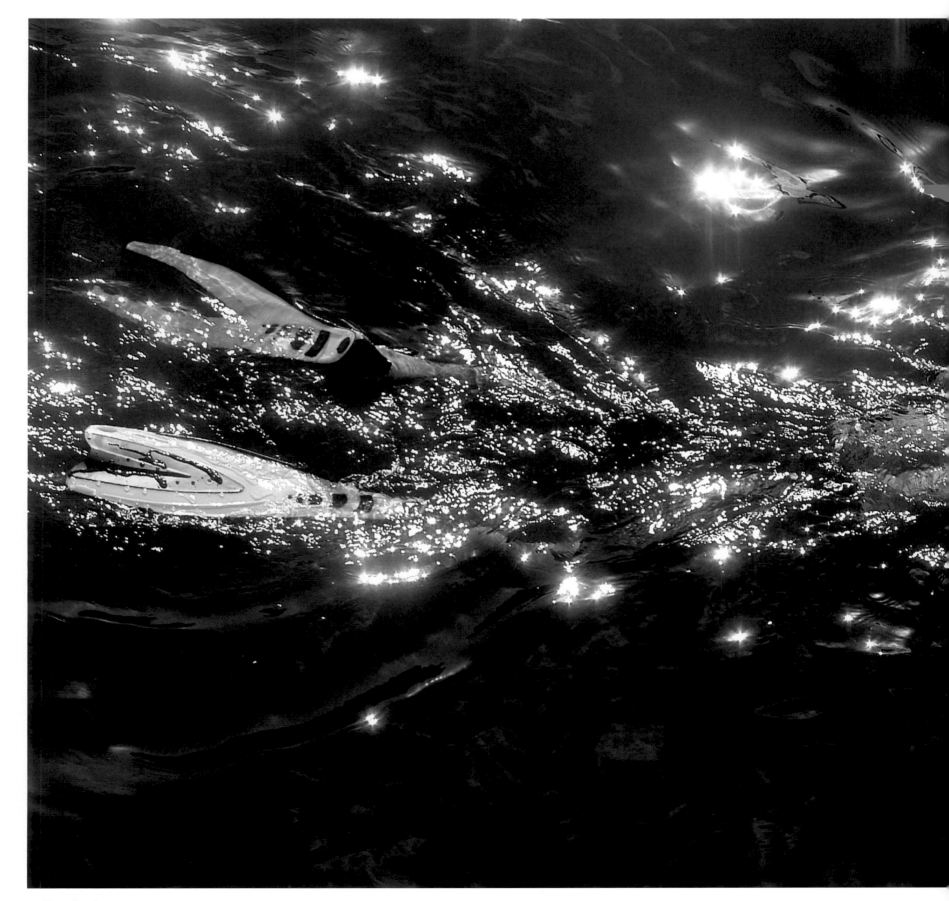

KEAWA NUI, MOLOKA'I

Joshua Kalua and Hano Naehu collect 'ama'ama (mullet) from the ancient Keawa Nui fishpond, one of many on Moloka'i. The pond's 2,000-foot-long rock wall, built on the shallow reef in about 1500, encloses a pasture for fish. Abandoned in the late 19th century, the ponds are slowly recovering productivity through community labor and state and federal grants.

Photo by Richard A. Cooke III

MO'OMOMI BEACH, MOLOKA'I

Take only what you need. From the beach at Mo'omomi, Mac Poepoe casts his net for moi. A leader on Moloka'i, Poepoe and his family are using education and peer pressure to enforce the unwritten code of mauka-to-makai stewardship that once guided the Hawaiians. The goal is to restore district ecologies and thus improve the chances for subsistence economies on Moloka'i.

Photo by Richard A. Cooke III

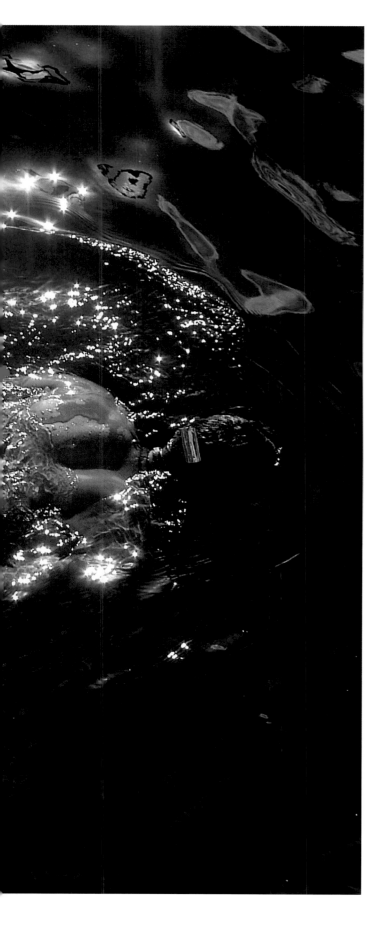

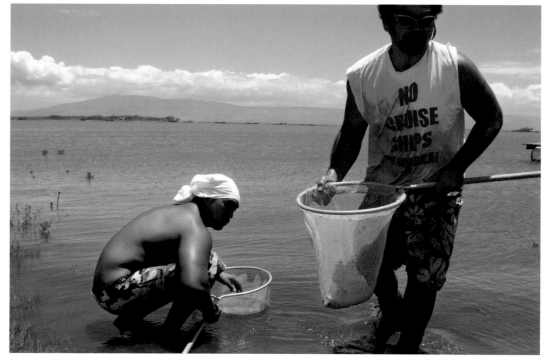

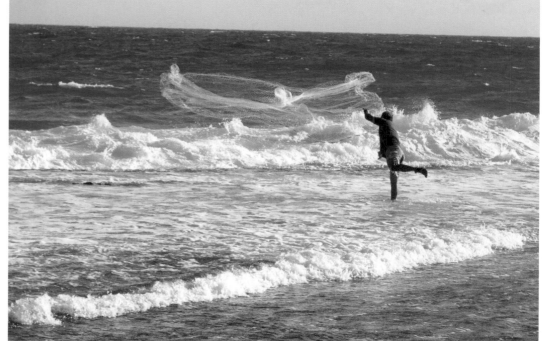

KAUNAKAKAI, MOLOKA'I

In 1993, Dr. Emmett Aluli and fellow activists
finally forced the U.S. Navy to turn over the small,
dry island of Kaho'olawe to eventual Hawaiian
control. Since World War II, the island had been
used as a bombing range. "In our work to heal the
island, we work to heal the soul of our Hawaiian
people," said Aluli after the historic victory.
Photo by Richard A. Cooke III

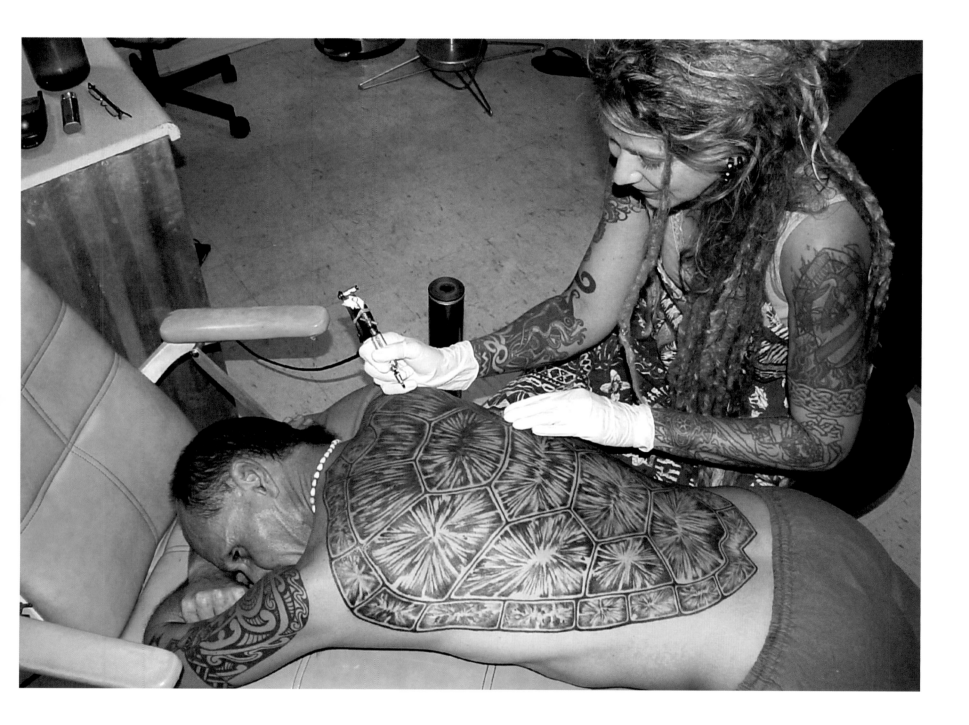

PĀHOA, HAWAI'I

"He got the tattoo fever," says Nancy Bolton of customer Michael Tillo. To bring attention to Hawai'i's threatened honu, or green sea turtles, Tillo is having a turtle carapace recreated on his back. Bolton, a native of Indiana, moved to the Puna district of the Big Island after a stint in the tattoo parlors of Venice Beach, California.
Photo by Tim Wright

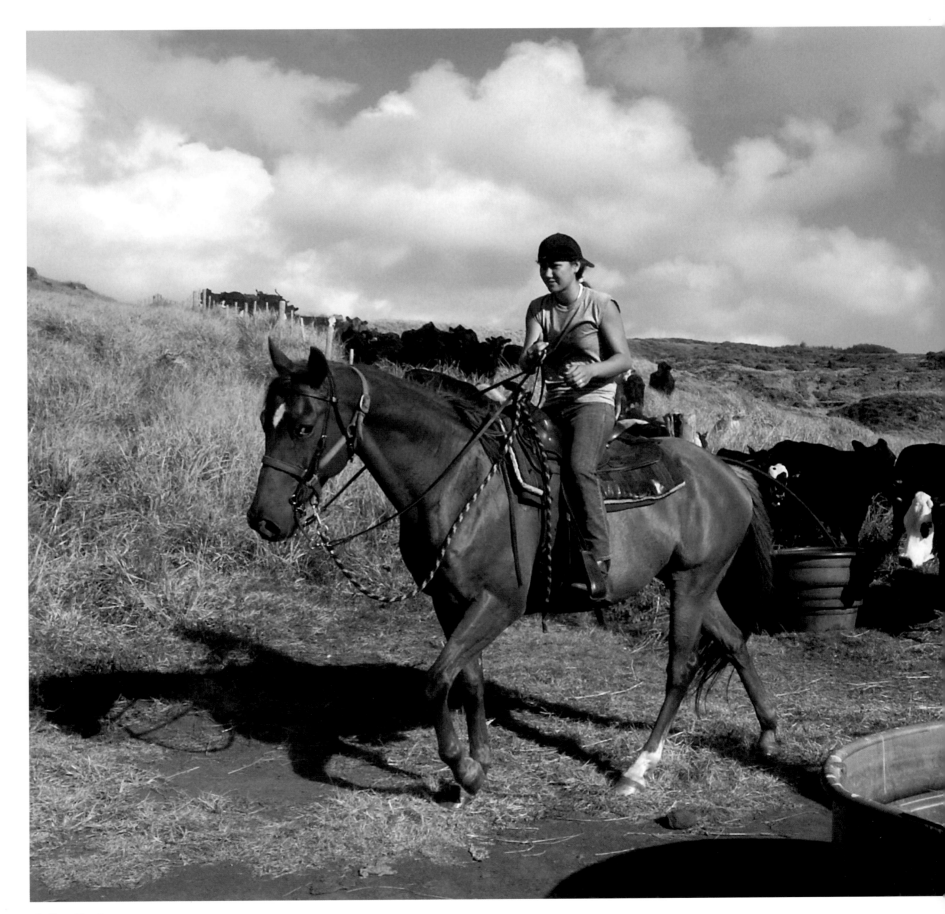

HĀLAWA, MOLOKAʻI
Kathy Coelho works at the Puʻu O Hoku ranch on the east end of Molokaʻi every summer. Pitching in to mend fences and manage a herd of Brangus (a cross between a Brahman and an Angus), the part-time paniolo also leads trail rides on the 14,000-acre property.
Photo by Richard A. Cooke III

HILO, HAWAI'I

Gertrudes Namnama arrived from the Philippines 13 years ago and has worked at Big Island Candies ever since. Her current job is dipping macadamia shortbread cookies into chocolate. On weekends, the mother of five boys works at a market, selling produce she and her husband grow.

Photo by Tim Wright

HONOLULU, O'AHU

University of Hawai'i at Mānoa student Mary Puaonaonaoka'awapuhi Stibbard helps thatch a traditional hale using native pili grass. This hale pili is in an area of the campus set aside for Hawaiian studies, Stibbard's major.

Photo by Val Loh

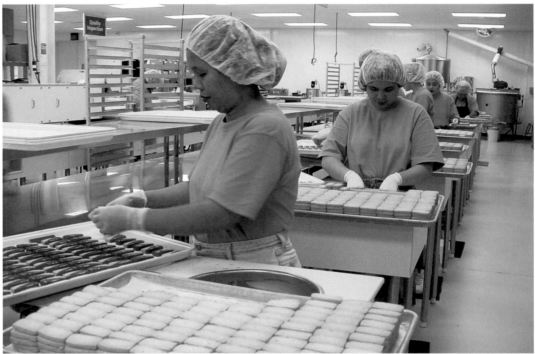

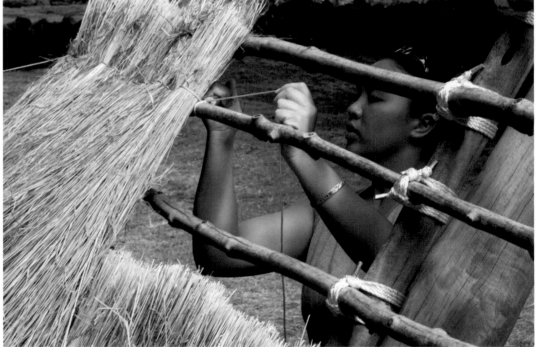

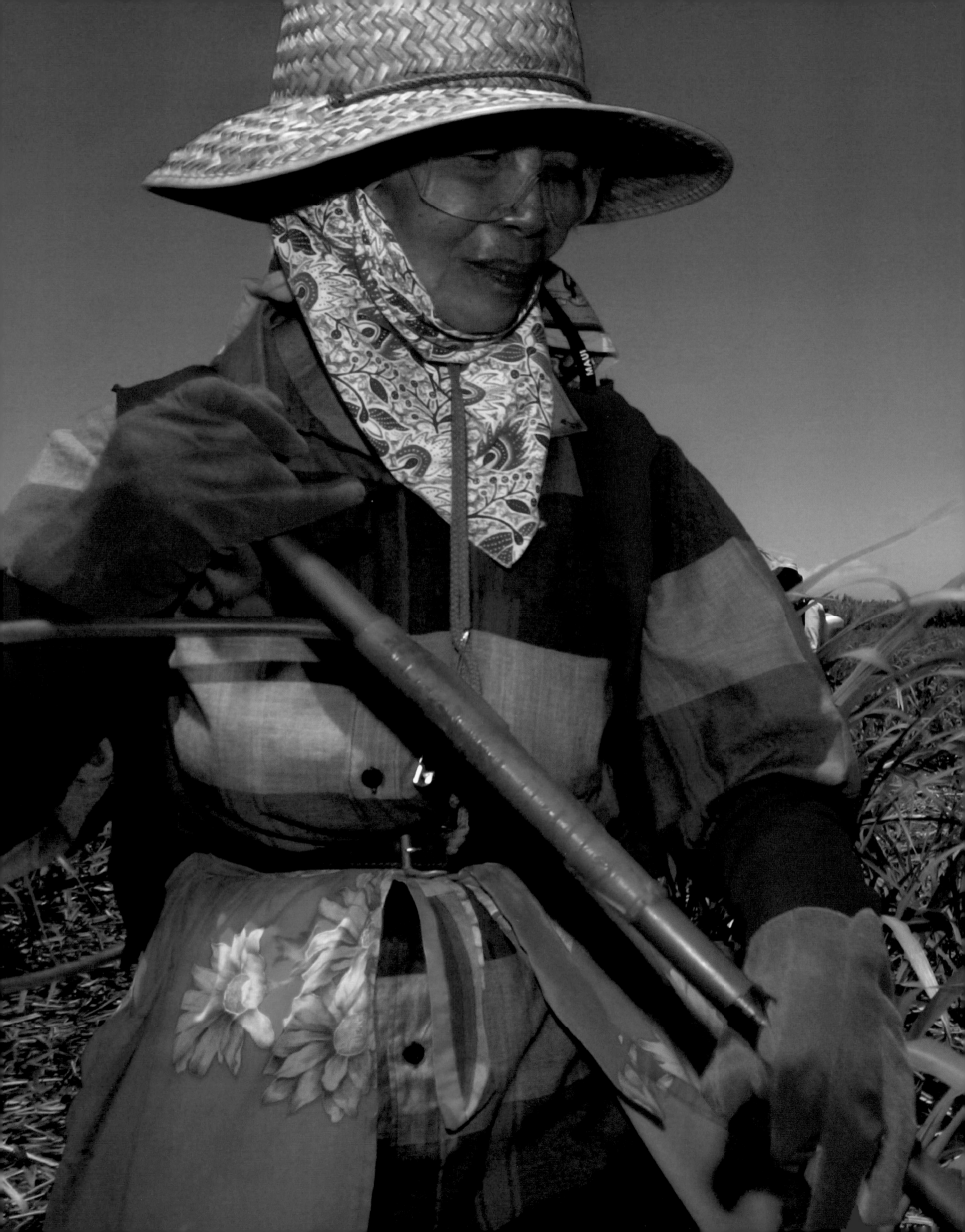

PU'UNENE, MAUI
On the Hawaiian Commercial & Sugar Company's 37,000-acre central Maui plantation, Adelindes Rumbaoa works the young cane in field no. 708. The company employs 900 people on Maui and produces 200,000 tons of raw sugar annually.
Photo by Ron Dahlquist

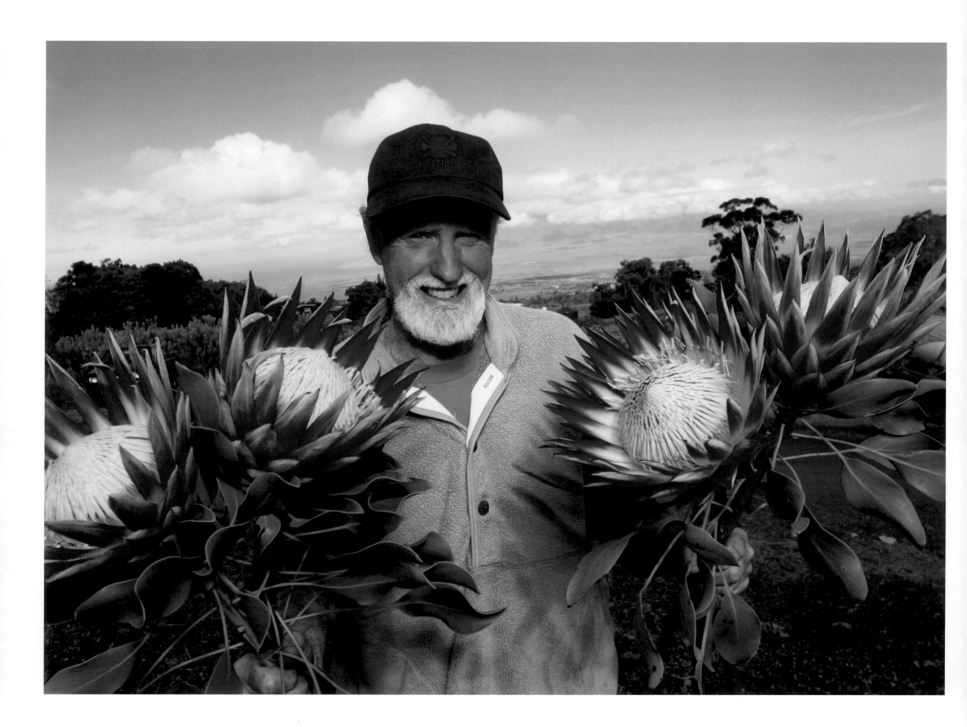

KULA, MAUI

Jim Heid, owner of Kula Vista Protea Farm, displays his signature King protea. A recognized protea expert, Heid crossbred the predominantly pink flower to develop a unique and vibrant red. His 80-acre farm sits at 3,200 feet on Haleakalā, where the soil and climate are similar to the flower's native habitat in South Africa.

Photos by Ron Dahlquist

KULA, MAUI

The Pincushion protea harvest is a delicate affair. Gregario Baoit carefully picks the prickly, easily damaged blooms. The Pincushion is one of many varieties grown at Kula Vista Protea Farm. Nearby, the University of Hawai'i's New Cultivar Research Program supports Maui flower growers by coming up with new protea hybrids.

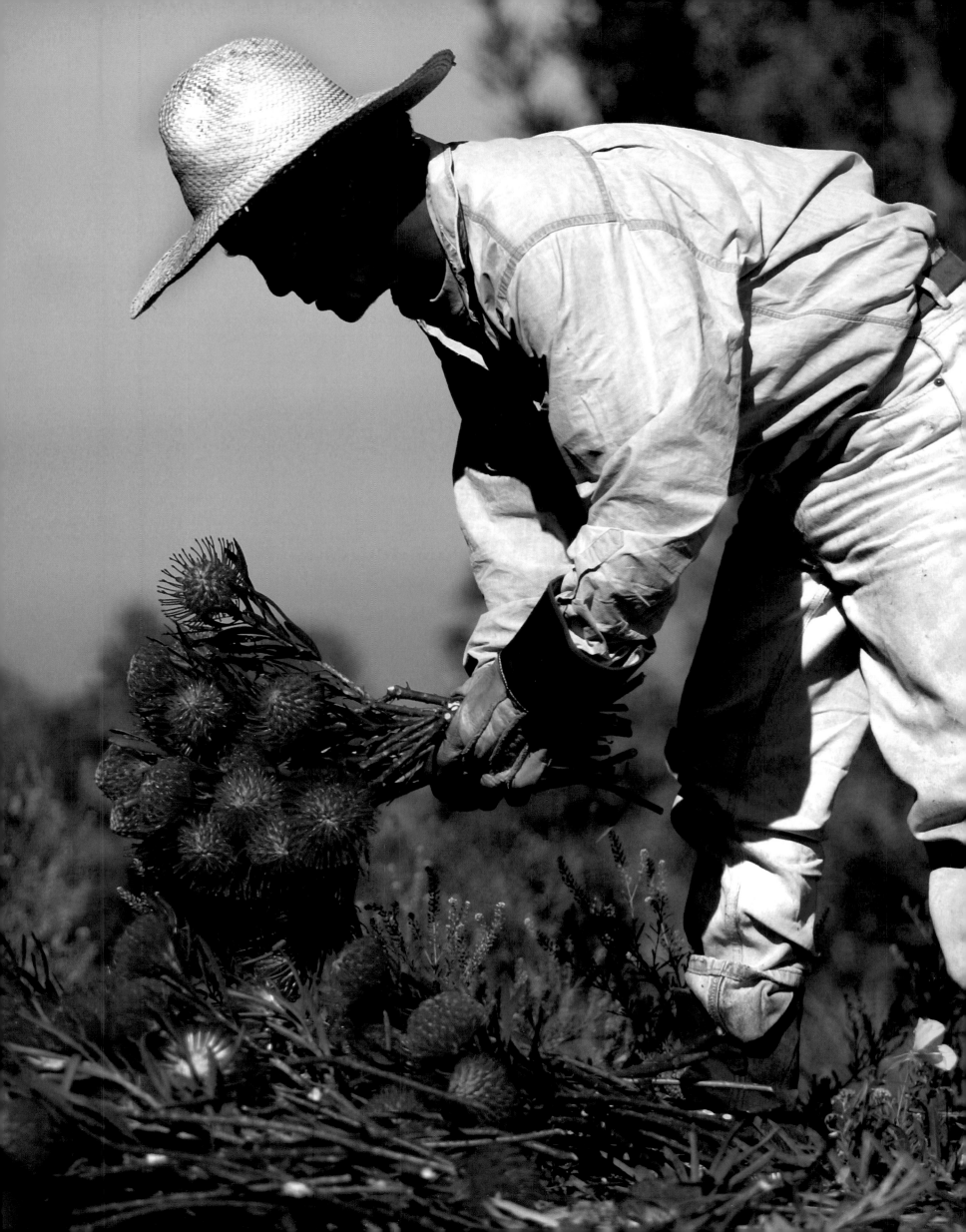

HONOLULU, O'AHU

Dr. Moria Amjadi studies an X ray of a cracked
tooth. The Hawai'i-born, Persian-American
Amjadi is a specialist in prosthodontia, a branch
of dentistry devoted to tooth restoration and
replacement, jaw problems, and post-oral-cancer
reconstruction.
Photo by Linda Gomez Carr

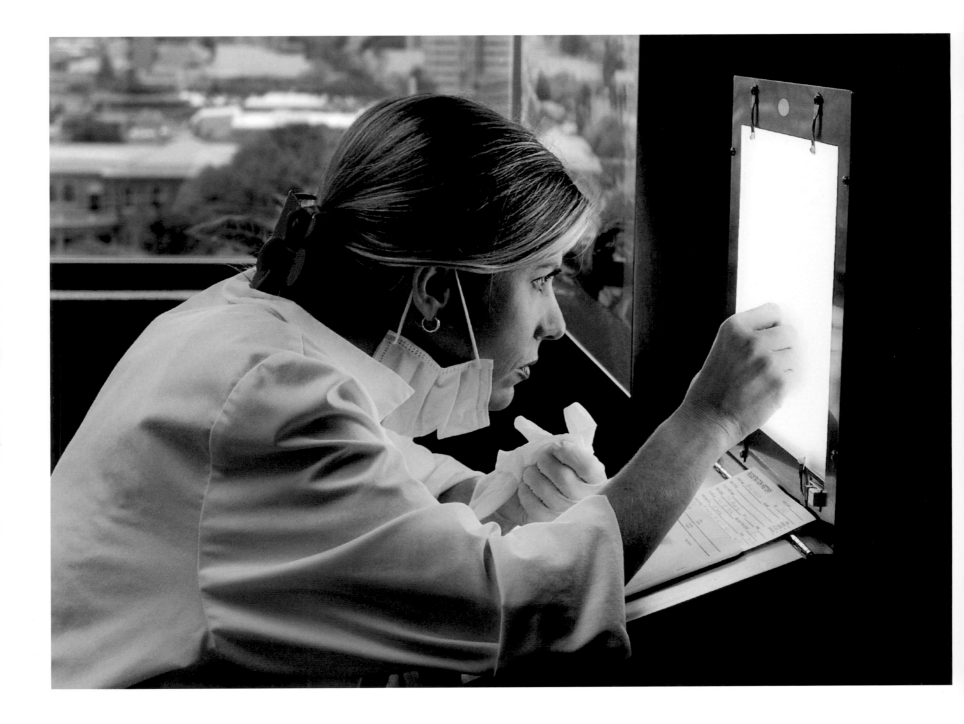

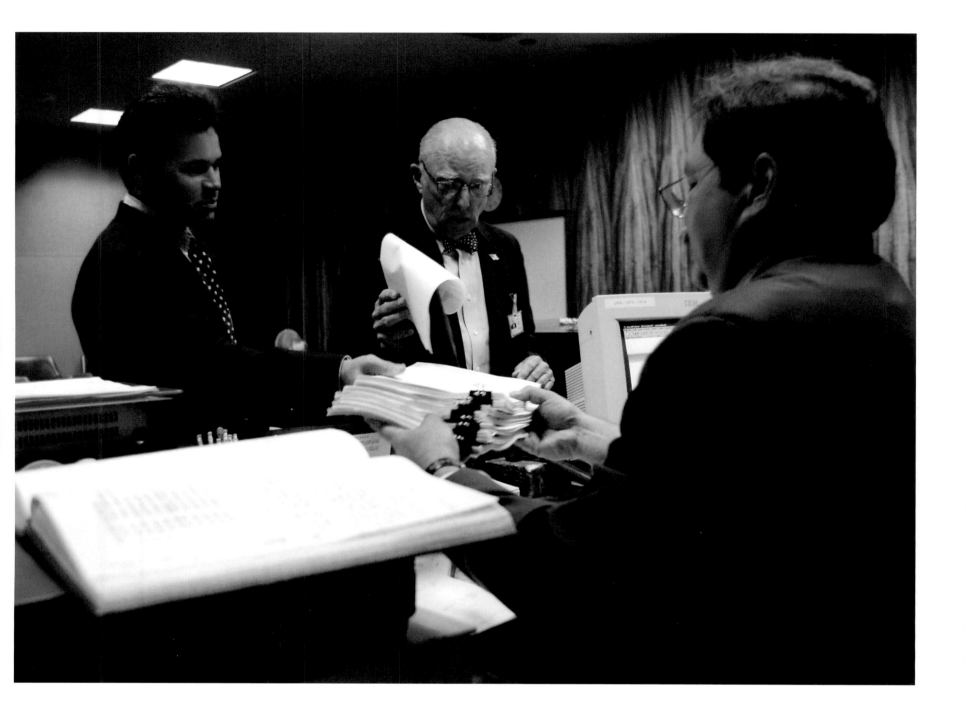

HONOLULU, O'AHU
Between hearings in the state's criminal division, lawyer Michael Healy, ret red Navy Captain Charles B. Crockett (who volunteers his time), and State Circuit Court Clerk Alden Kau review paperwork. They're in the courtroom of Judge Michael A. Town, a civil servant respected as fair and compassionate, who is especially committed to helping young people.
Photo by Monte Costa

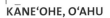

KĀNEʻOHE, OʻAHU
At the Marine Corps air base, Aviation Mechanic First Class Justin Taylor works on a Seahawk helicopter. Some 15,000 people live on the base—about half of them Marines, the other half dependents.
Photo by Dennis Oda, Honolulu Star-Bulletin

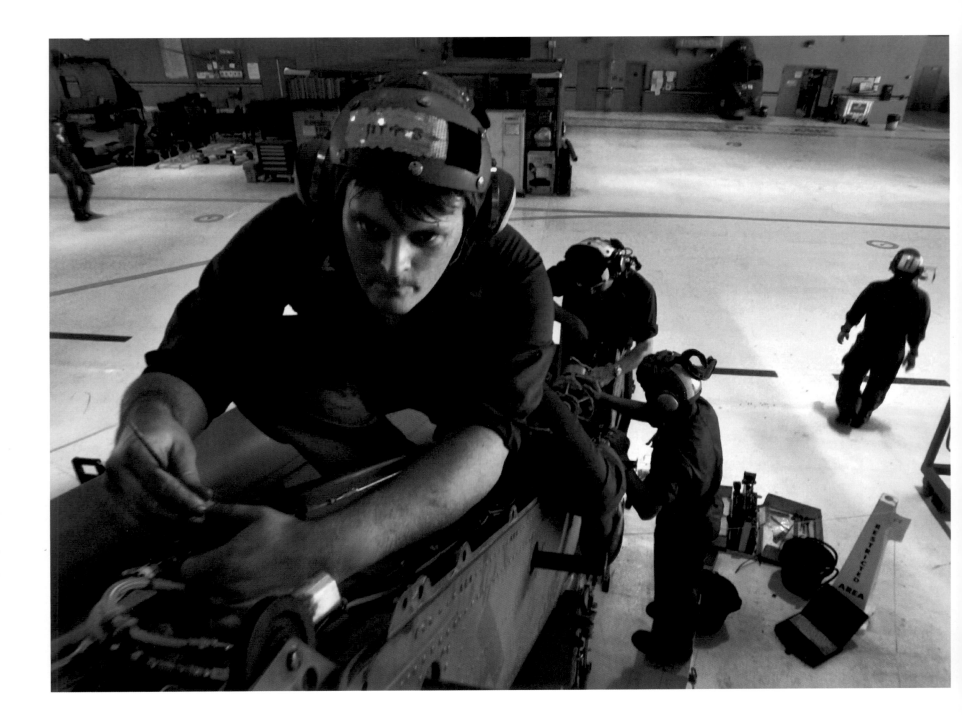

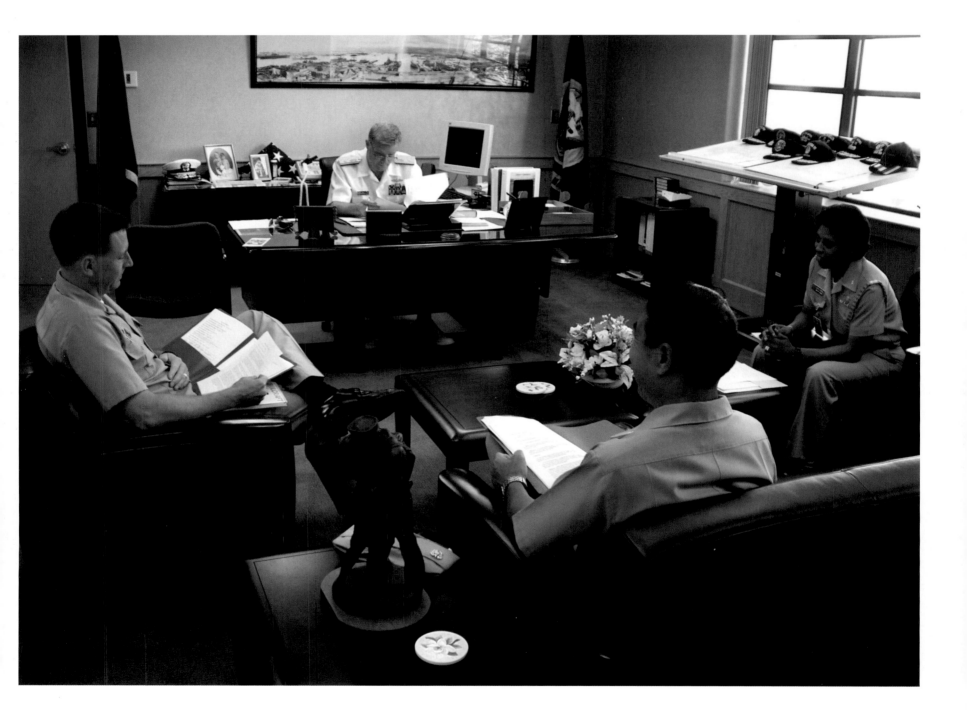

PEARL HARBOR, OʻAHU
Rear Admiral Bernard J. McCullough III (center),
Commander of the U.S. Navy Region Hawaii and
Surface Group Middle Pacific, conducts a meet-
ing with senior staff members. The business of
the hour: updating housing inventory.
Photo by Sergio Goes

PEARL HARBOR, O'AHU
At the U.S. Navy Dive School, sailors warm up before heading to the tank at the back of the room. There are roughly 30 active-duty warships and submarines in Hawai'i. Each vessel must carry trained divers who can work in the water for up to 10 hours at a stretch.
Photo by Sergio Goes

KĀNEʻOHE, OʻAHU

Camouflaged in a ghillie suit, Marine Sgt. Justin Taylor of the Scout Sniper Platoon awaits Hawaiʻi Governor Linda Lingle's visit to the Kāneʻohe Marine base. The military is under pressure from Hawaiian activists to scale back its live-ammunition training exercises on state-owned lands. But in her speech at the base, the Republican governor said the training helps ensure troops' readiness and safety.

Photo by Deborah Booker, Honolulu Advertiser

SCHOFIELD BARRACKS, OʻAHU

During a 25th Light Infantry Division exercise, Specialist Ryan Addis uses AN/PVS-7D night-vision goggles that would allow him to spot a human 200 yards away on a moonless, cloudy night.

Photo by Lucy Pemoni, Associated Press

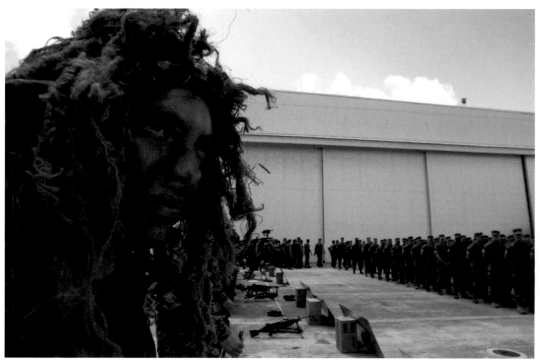

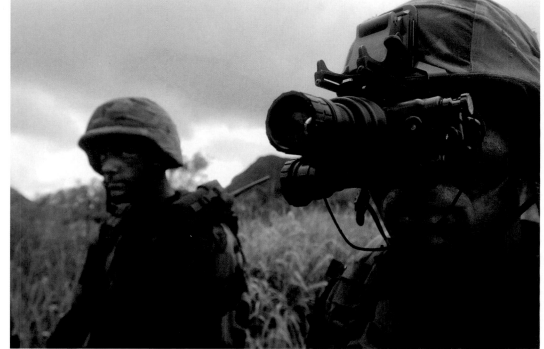

KĀNEʻOHE, OʻAHU

University of Hawaiʻi students measure a black tip reef shark at the Hawaiʻi Institute of Marine Biology. Declining shark populations have led university scientists to conduct a captive-growth study to find out why. Turning the shark on its back puts it into a sleeplike state, making tagging and tissue sampling easier.

Photos by Daniela Stolfi

WAIMĀNALO, OʻAHU

Sea lions at Sea Life Park, 15 miles from Waikīkī Makapuʻu Point, open wide for fishy snacks. The well-trained pinnipeds know to expect feeding five times a day—twice by trainers and thrice tourists.

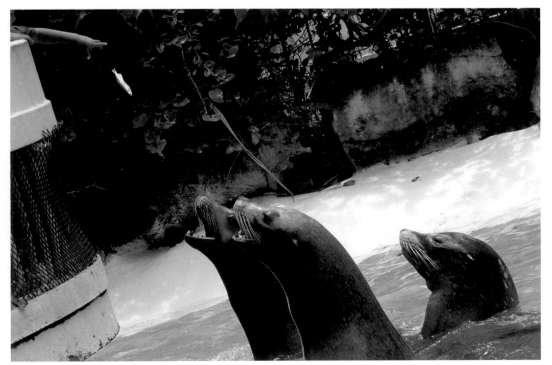

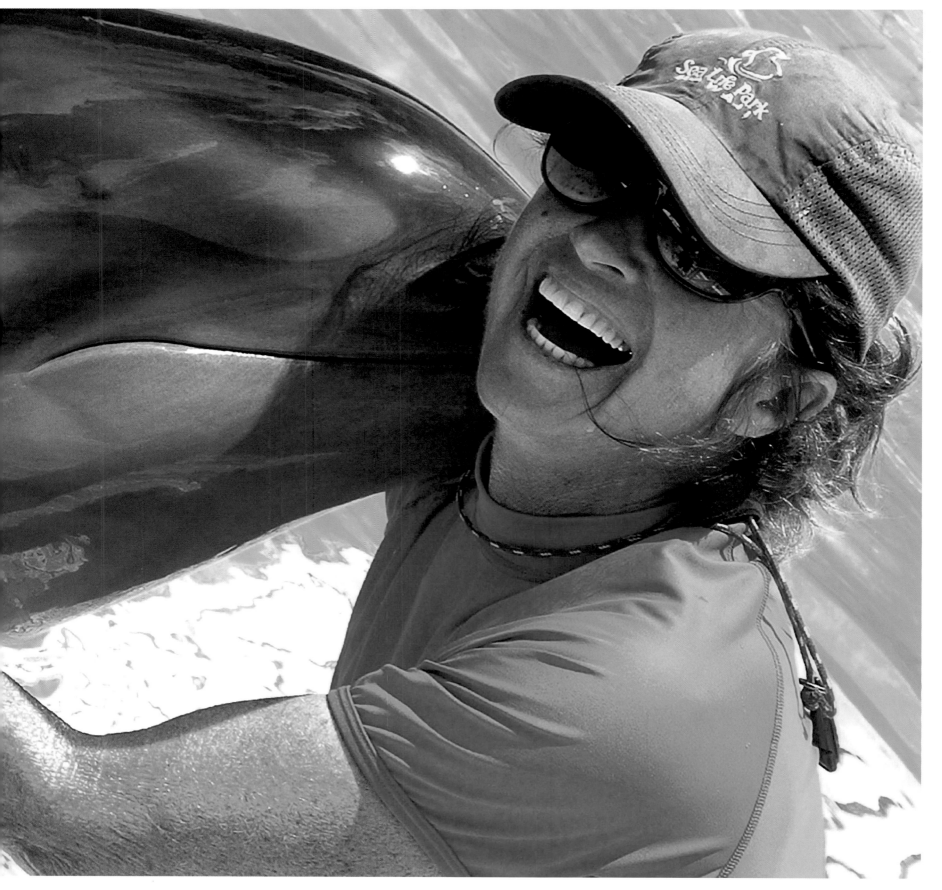

WAIMĀNALO, O'AHU
With trainer Kiana Pugh, Kekaimalu, the world's first known "wholphin," celebrates her birthday at Sea Life Park. Eighteen years ago her mother Punahele, a bottle-nosed dolphin, gave birth to the gray, snub-nosed beauty. Puzzled trainers quickly realized Punahele had been carrying on a torrid affair with her roommate, I'anui Hahai, a one-ton false killer whale.

LĀNAʻI CITY, LĀNAʻI

The island of Lānaʻi, marketed to the world as "Hawaiʻi's Private Island," has one jail cell. And it meets all federal standards, which means it has a bed, sink, toilet, fire alarm, intercom, and light. Officer Kim Masse and Lieutenant Chad Viela work out of the Lānaʻi City police station, under the jurisdiction of Maui County. "This is a pretty quiet district," Viela says.

Photo by Jeff Widener

KAMALŌ, MOLOKAʻI

Boat makers for 35 years on Oʻahu, Rae Young and Kirk Clarke relocated to Molokaʻi in 1994. They yearned for the simple, sweet lifestyle they remembered from the 60s—before mass-market tourism. They found it on Molokaʻi. "We call it Molokaʻi style," Young says. "People take the time to enjoy family and friends and their surroundings."

Photo by Richard A. Cooke III

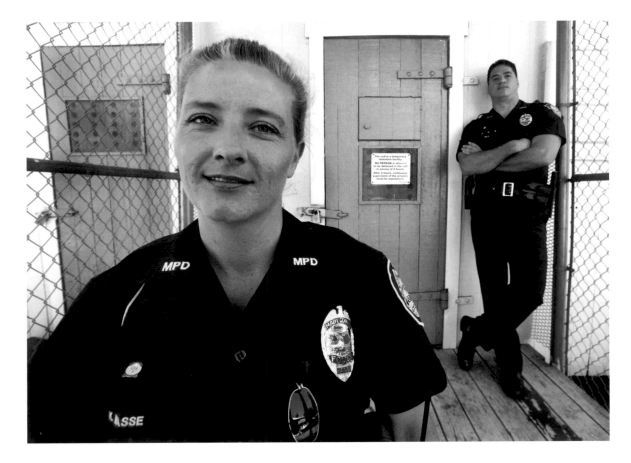

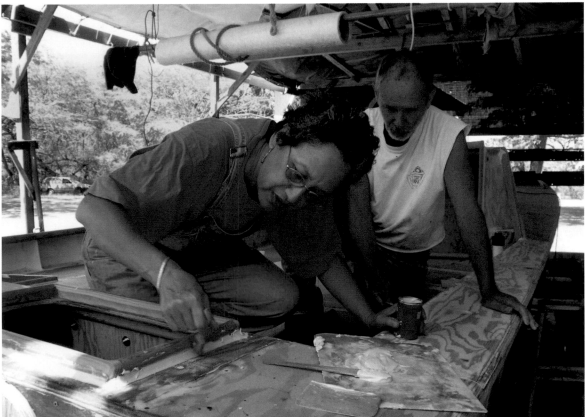

MĀKAHA, OʻAHU

Longtime lifeguard for the City & County of Honolulu Dean Marzol watches over swimmers and surfers on Oʻahu's leeward beaches. The former professional body-boarder has seen it all during his 11-year career, including a shark attack. Two hundred City & County lifeguards report to work at some of the most beautiful, and turbulent, beaches in the world.
Photo by Sergio Goes

HONOLULU, OʻAHU

Lei, originally strung from leaves, feathers, shells, and blossoms by Polynesian settlers, have become the ubiquitous symbol of Hawaiʻi, and rare is the occasion for which the sharing or wearing of a flower garland is not appropriate. Chinatown's Maunakea Street bustles with competitive lei sellers like Martina at Kapena's Leis & Flowers.
Photo by Sergio Goes

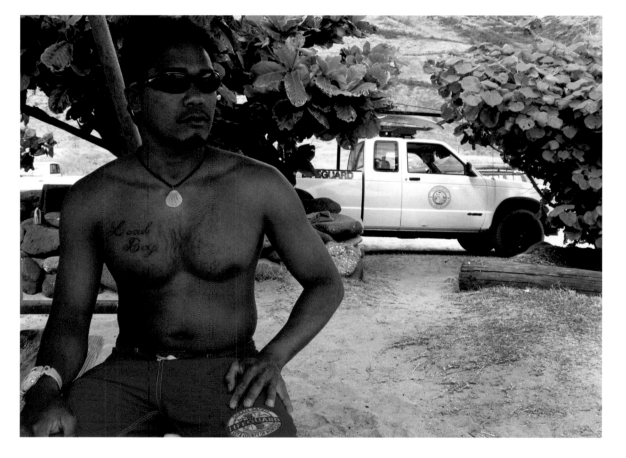

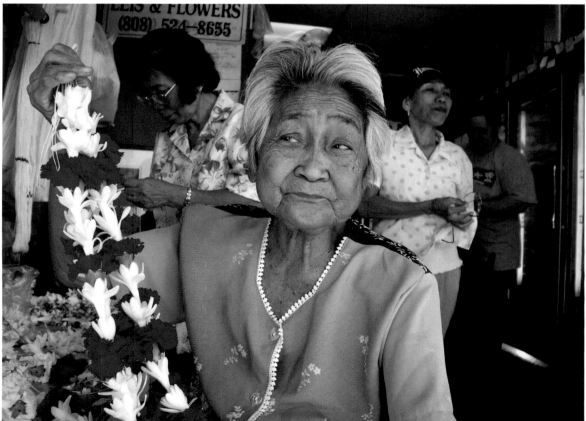

HALEAKALĀ NATIONAL PARK, MAUI
After descending on Sliding Sands Trail into this otherworldly crater, a horseback tour group crosses a cinder desert. The erosional depression at the summit of the 10,023-foot mountain is 3,000 feet deep, 7.5 miles long, and 2.5 miles wide.
Photo by Ron Dahlquist

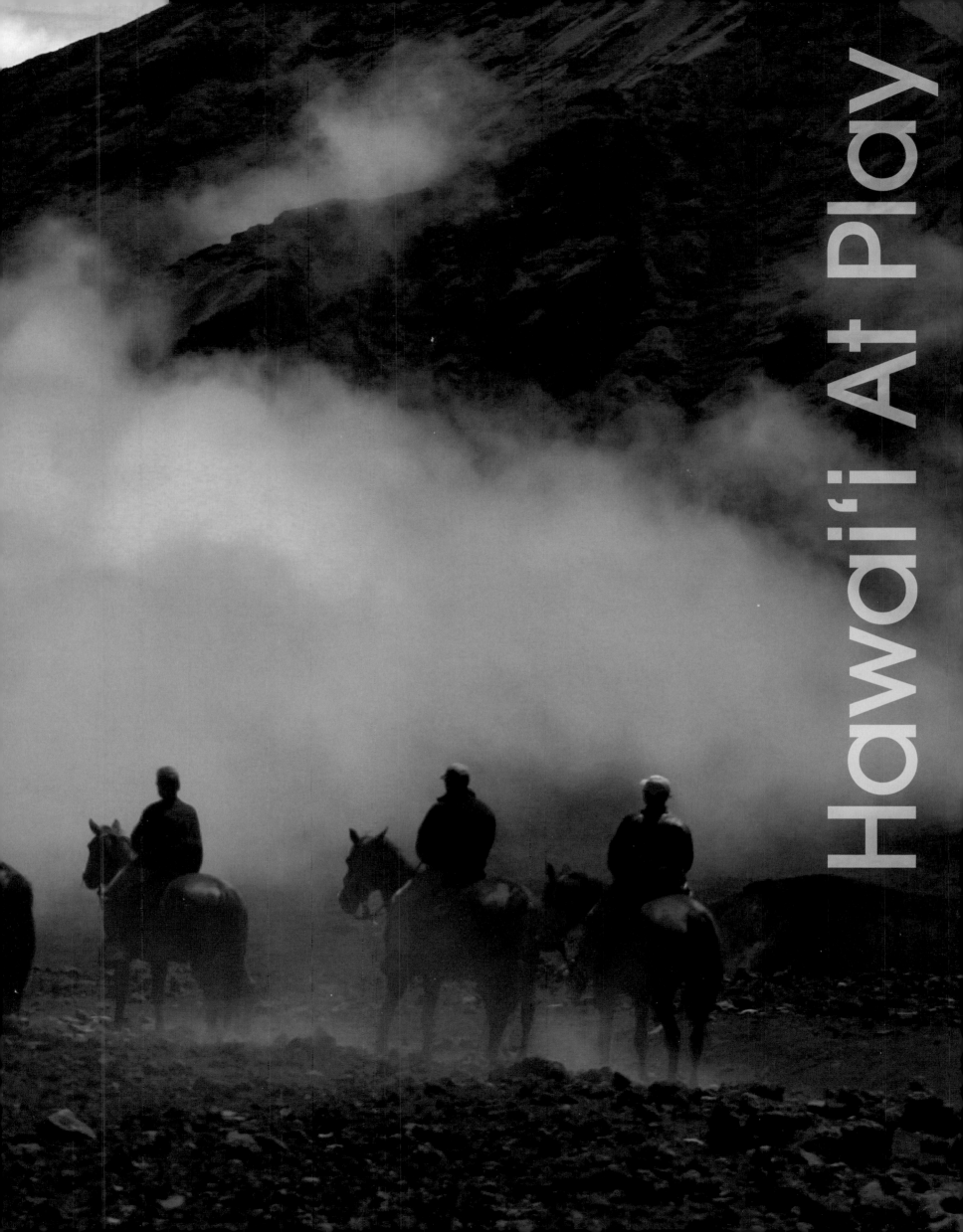

Hawai'i At Play

LAHAINA, MAUI
Dancers perform a fast-paced Tahitian number for an audience of 500. Started by four friends in 1986, the waterfront Old Lahaina Lu'au has prospered selling Hawaiian dance and food (slightly modified) to visitors. "It began as a lark," says partner Michael Moore. "We never thought we'd be here 18 years later."
Photo by Michael Gilbert

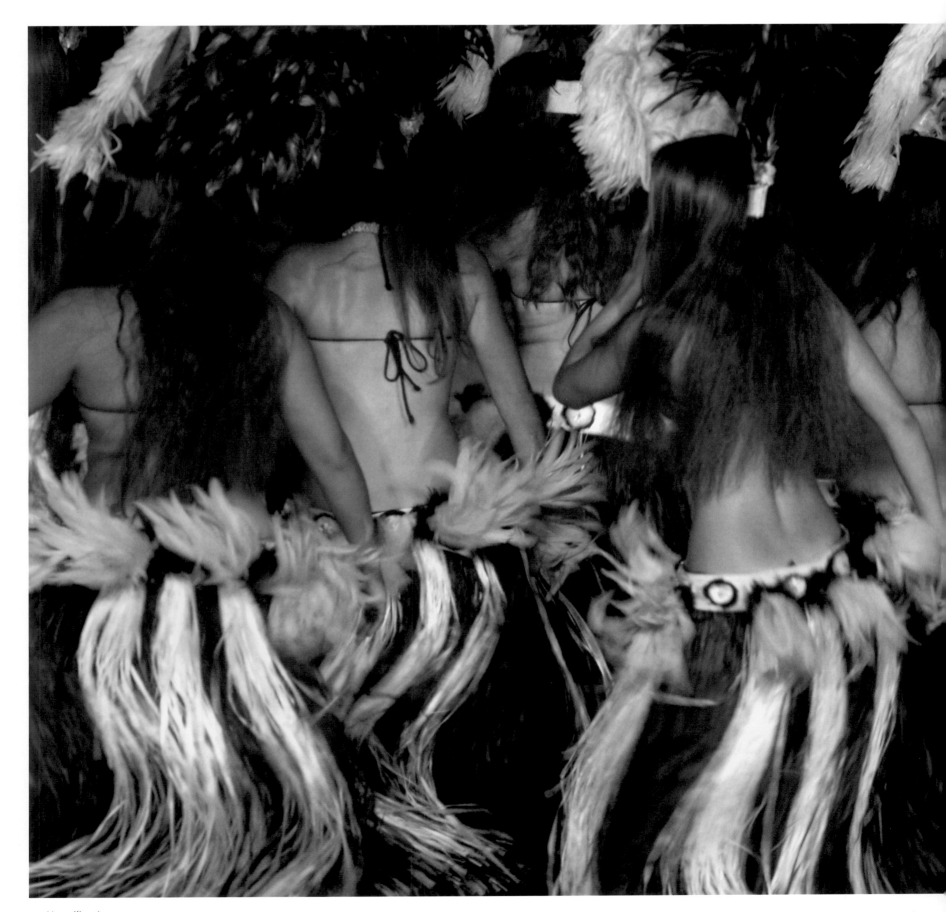

HONOLULU, O'AHU

A few clues point to the probability that this woman has just arrived on Waikīkī: She's wearing shoes on the beach and lugs a camera and tote bag. Give her 24 hours and, no doubt, she'll be as barefoot and unencumbered as the other visitors on day two.

Photo by Deborah Booker, Honolulu Advertiser

HONOLULU, O'AHU

Cowabunga! Leaping into Waikīkī's breaking waves off the Kapahulu pier—or groin, as it's called—is almost a rite of passage for Honolulu kids.

Photo by Val Loh

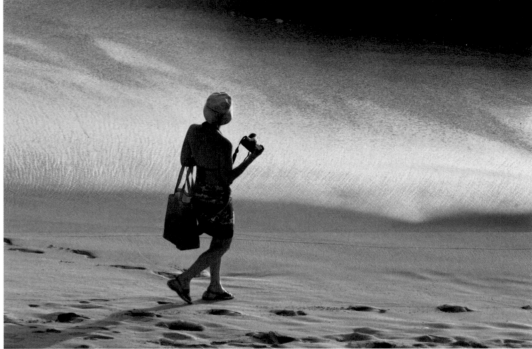

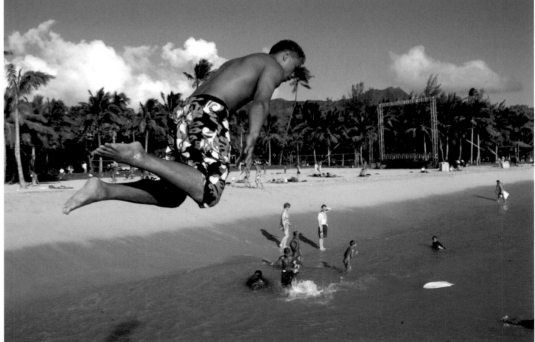

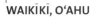

WAIKĪKĪ, OʻAHU

Hang eight: Decked out with a life preserver and special sunglasses to filter out UV rays, Ted E Bear manages a moment of balance on his own Body Glove boogie board.
Photo by Julie McBane

PĀKALĀ, KAUAʻI

On the west side, cattle rancher Bob Farias, Jr., considers the surf before paddling out on his 10-foot Dick Brewer board. The 33-year-old's tattoos imprint all the things he holds dear—his god, his family, the island, and his people.
Photo by David S. Boynton

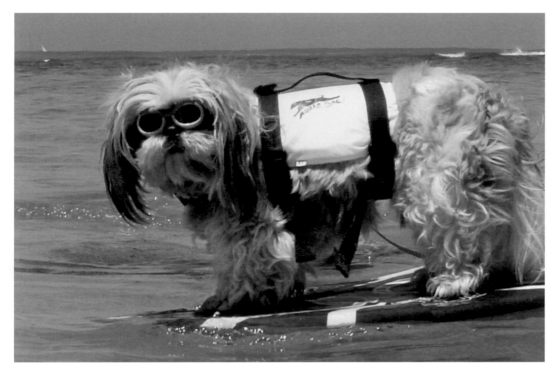

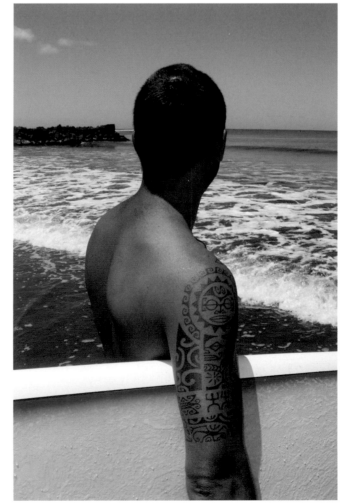

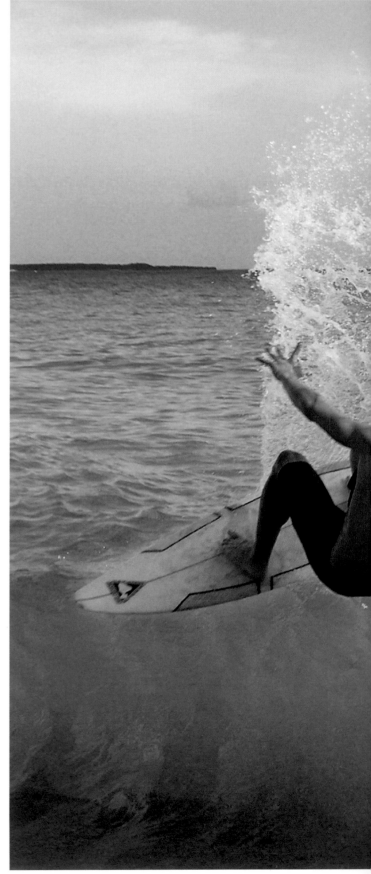

MĀKENA, MAUI

In the slap-you-down shorebreak at Mākena, a skimboarder is all tensile grace as he thrashes the lip of his wave. On the southward horizon: the thin black line of Cape Kina'u, created by the most recent lava flow on Maui, circa 1790.

Photo by Michael Gilbert

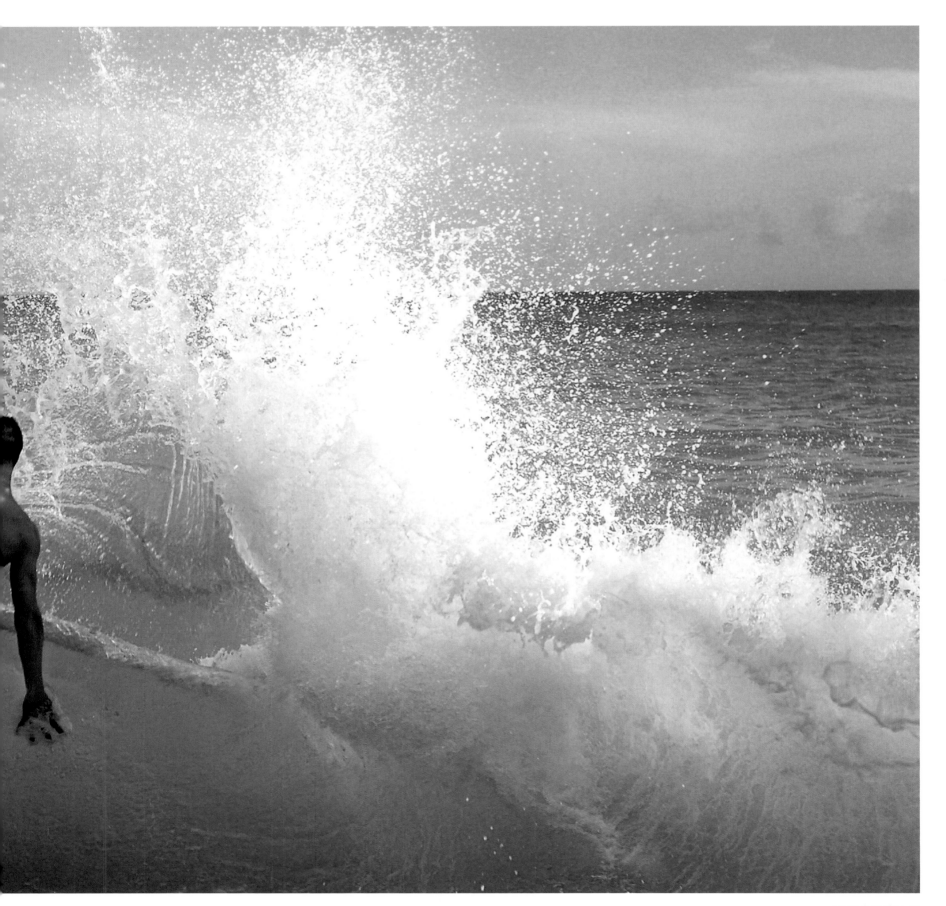

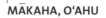

MĀKAHA, O'AHU

Buffalo surfer: When he isn't riding his long-board, famed water man and patriarch Richard "Buffalo" Keaulana promotes proper respect for the ocean. In 1977, he started Buffalo's Big Board Surfing Classic, a competition that revived the graceful art of Hawaiian-style surfing. Between Buffalo, his six children, and 10 grandchildren, the Keaulana clan owns more than 100 surfboards.
Photo by Sergio Goes

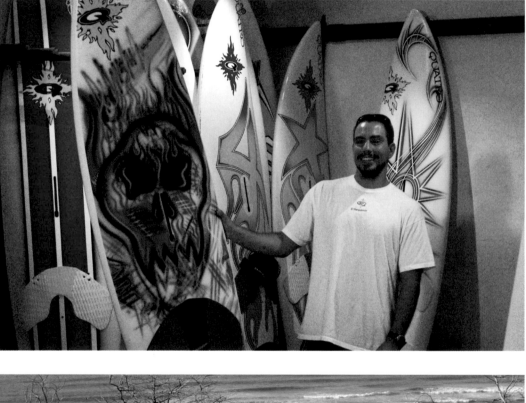

HAʻIKŪ, MAUI
Quatro International, co-owned by Lalo Goya, cranks out about 600 custom windsurfing boards each year. Argentina-born Goya grew up surfing on Maui and took up windsurfing after high school. But he still owes much to his surfer background: Laid-out bottom turns followed by strong roundhouse cutbacks are his signature moves.
Photo by Randy Hufford, www.visualimpact.org

HONOLULU, OʻAHU
Dawn patrol: Less than a mile from Waikīkī, Jennifer Shim checks the breaks spread out below the Diamond Head roadside lookout. At the southernmost reach of Oʻahu, the Diamond Head reef nearly always catches swells charging in from somewhere in the Pacific.
Photo by Val Loh

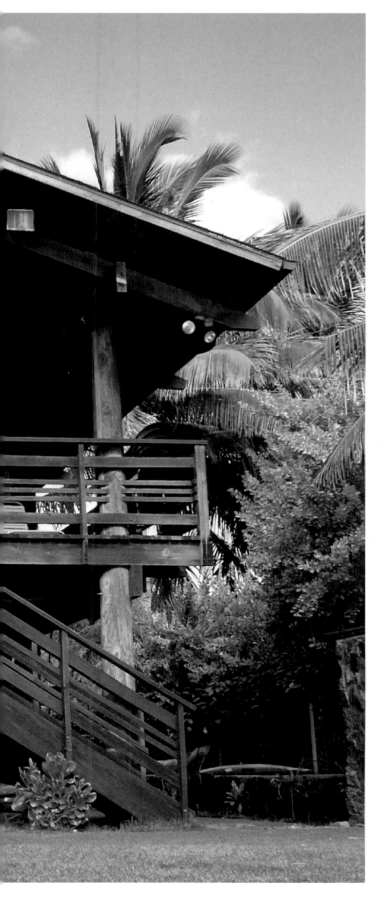

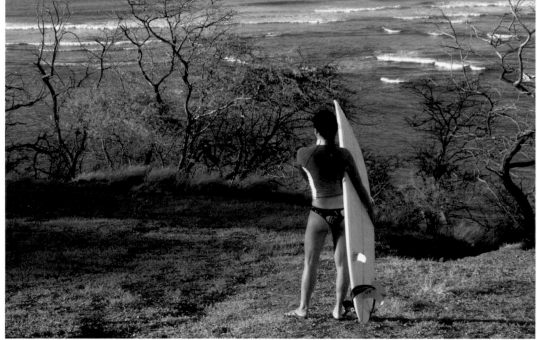

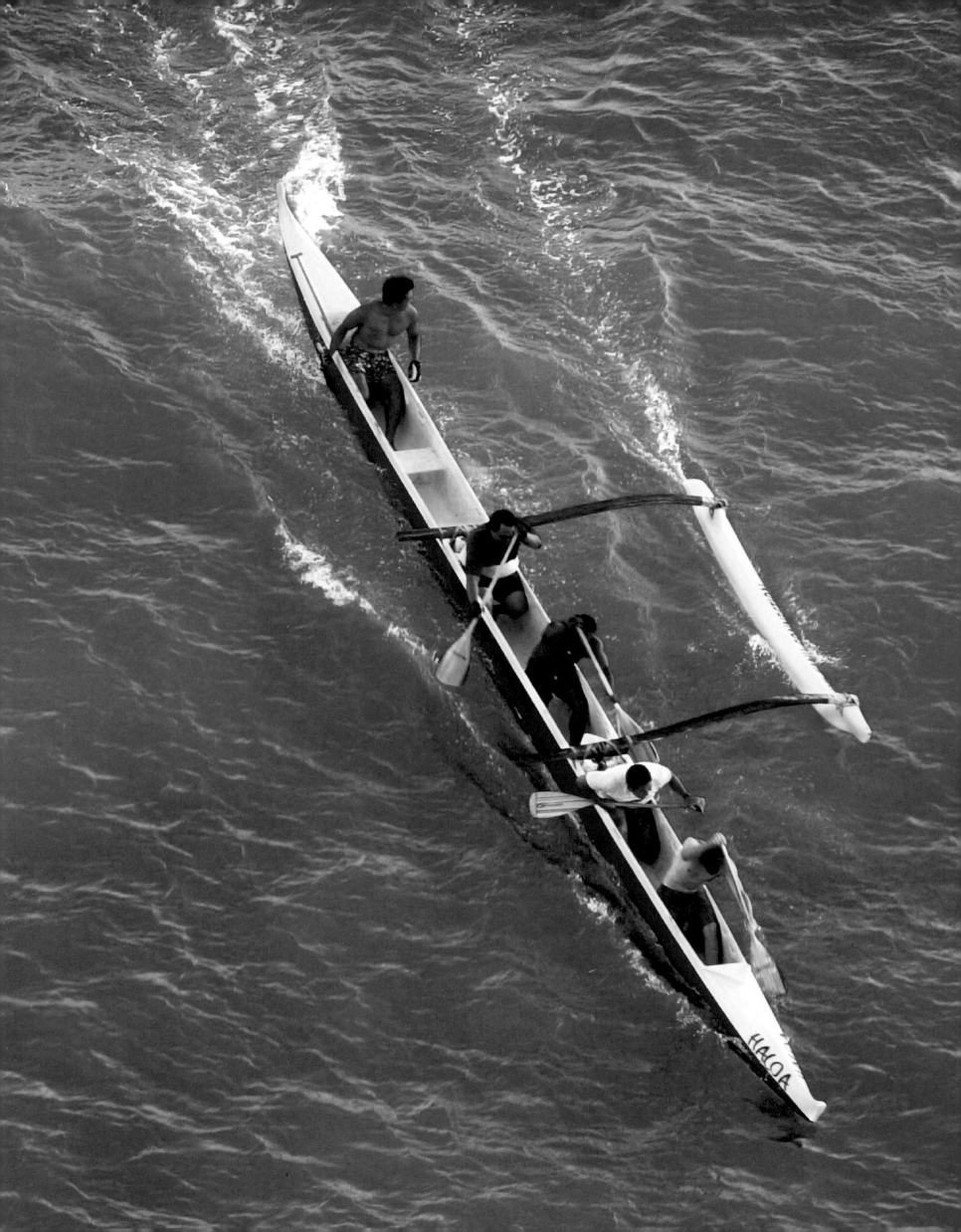

HONOLULU, OʻAHU

Paddlers cruise Māmala bay off Waikīkī. The outrigger canoe is distinguished by its stabilizer float, called an ama. The technology has been a constant throughout Asia and the Pacific ever since humans first ventured into the sea.
Photo by Deborah Booker, Honolulu Advertiser

WAILUA, KAUAʻI

Wahine crews compete at the annual Walter Smith Regatta on the broad, flat muliwai, or river-mouth, of the Wailua river. Several clubs from around Kauaʻi take part in the half-mile race. From spring through fall, thousands of paddlers throughout the islands, from keiki to old folks, participate in the outrigger canoe racing season.
Photo by David S. Boynton

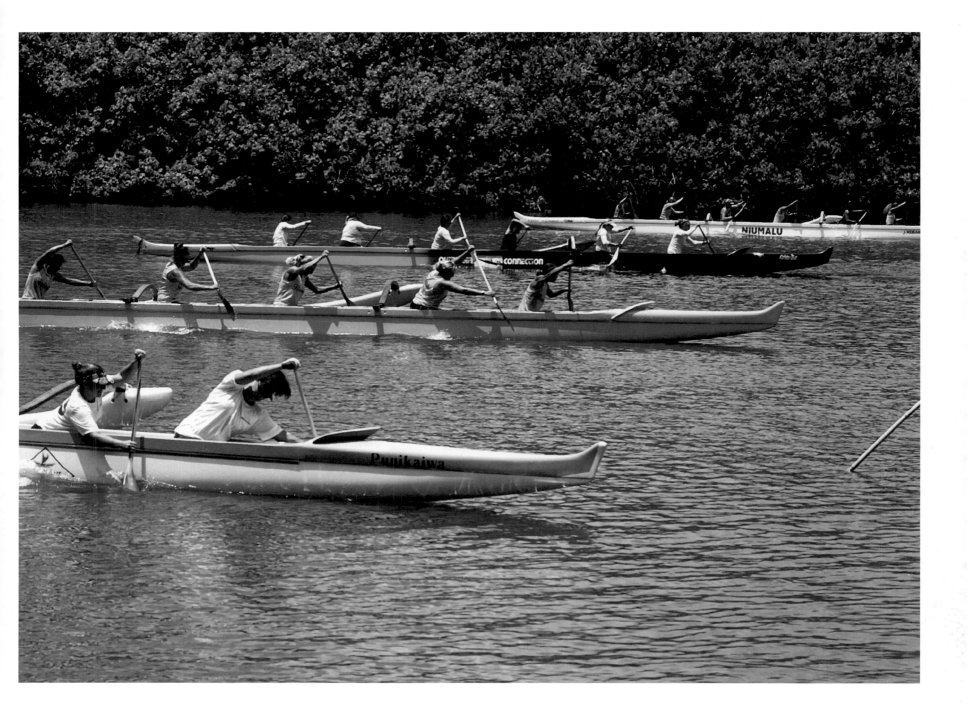

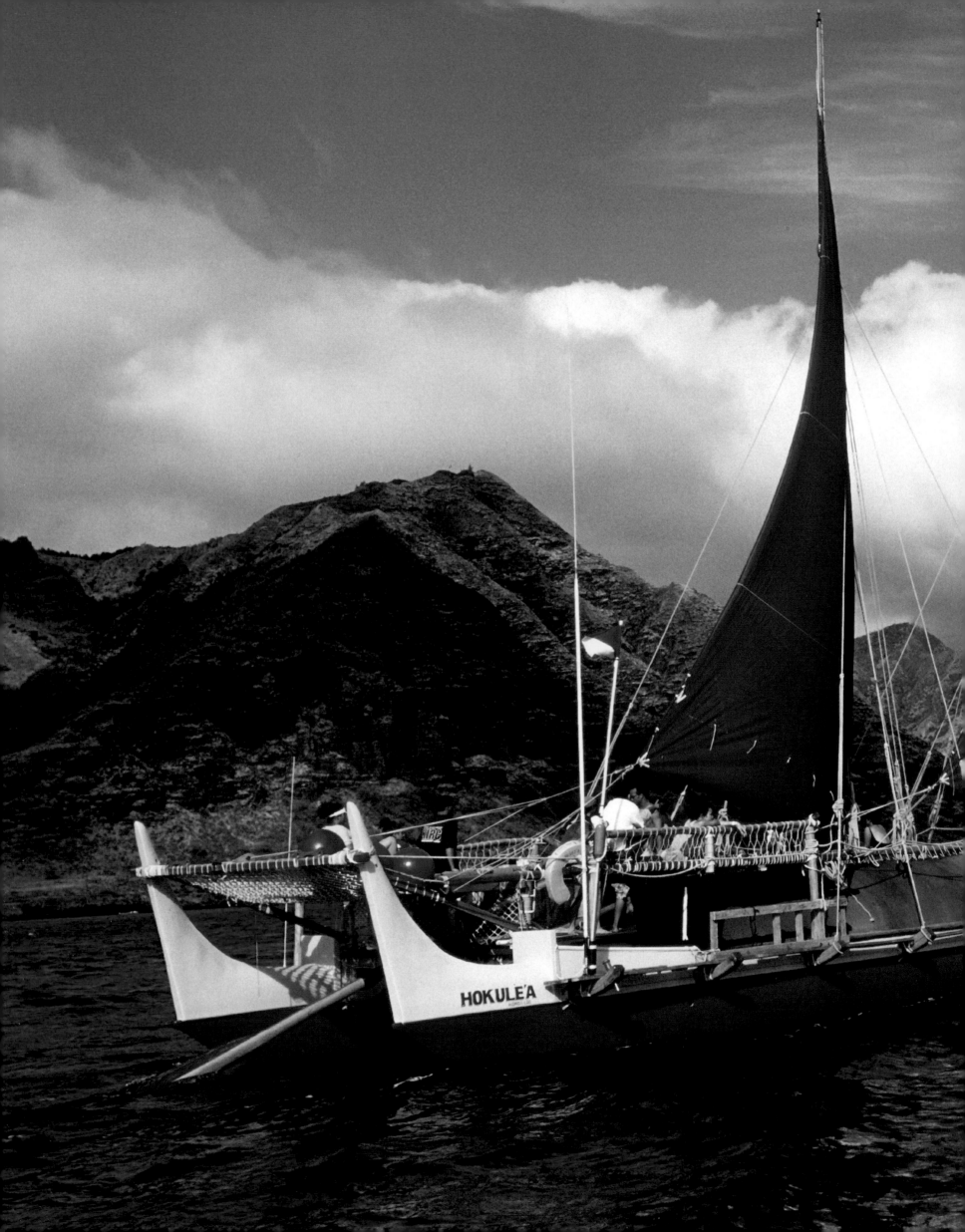

MĀKUA, OʻAHU
Hokuleʻa, a double-hulled voyaging canoe, is more than a faithful replica of the vessels Polynesian mariners used to master their watery universe: It represents the revival of Hawaiian culture. Completed in 1975, the canoe has sailed more than 100,000 miles, retracing ancient pathways. Here she is approaching Oʻahu's Mākua valley, known for its beauty—and its live-artillery training by the U.S. military.
Photo by Monte Costa

KAHUKU, O'AHU
The steering blade, or hoe uli, of the *Hokule'a*
presses the water as the canoe sails up the wind-
ward coast of O'ahu. In ancient times, the blade
would have been made of koa. This one is ply-
wood, reinforced by white and red oak.
Photo by Monte Costa

KAILUA, OʻAHU
A kayaker leaves Lanikai and heads to Moku Nui, the larger of the twin Mokulua islets, aka "da Mokes."
Photo by Deborah Booker, Honolulu Advertiser

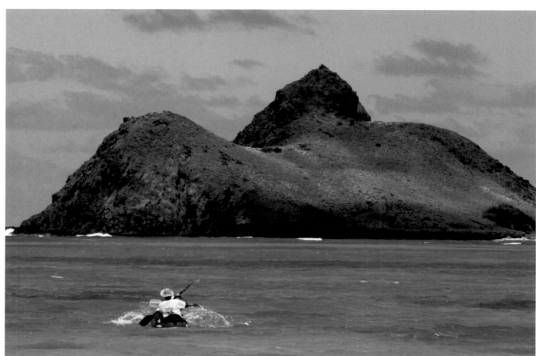

KANAHĀ, MAUI
Maui's reliable winds—and gilded lifestyle—
have made it windsurfing's world capital.
Thousands from the mainland, Europe, and
South America come to Maui to ride the
winds and live the life. A few of them stay.
Photo by Randy Hufford,
www.visualimpact.org

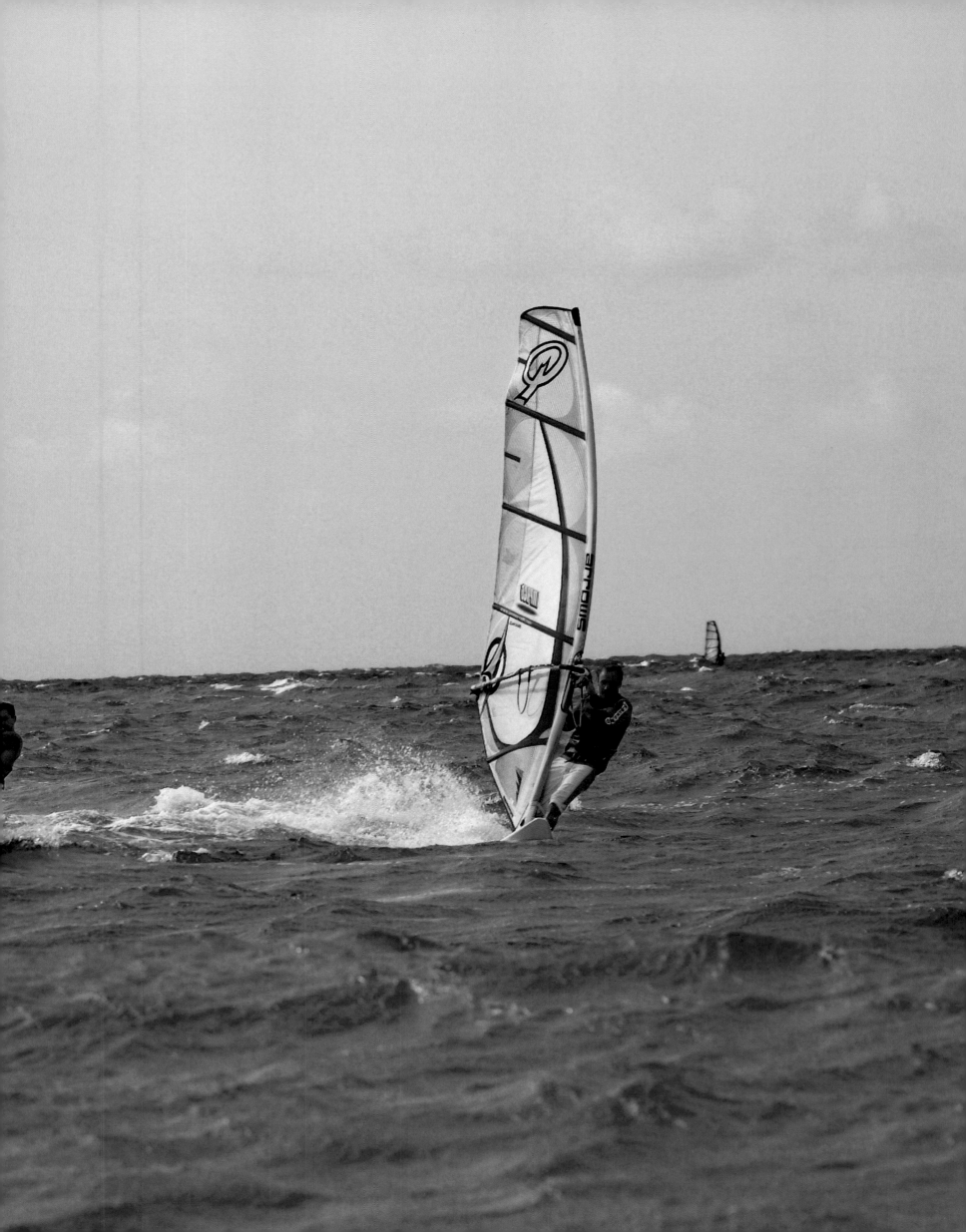

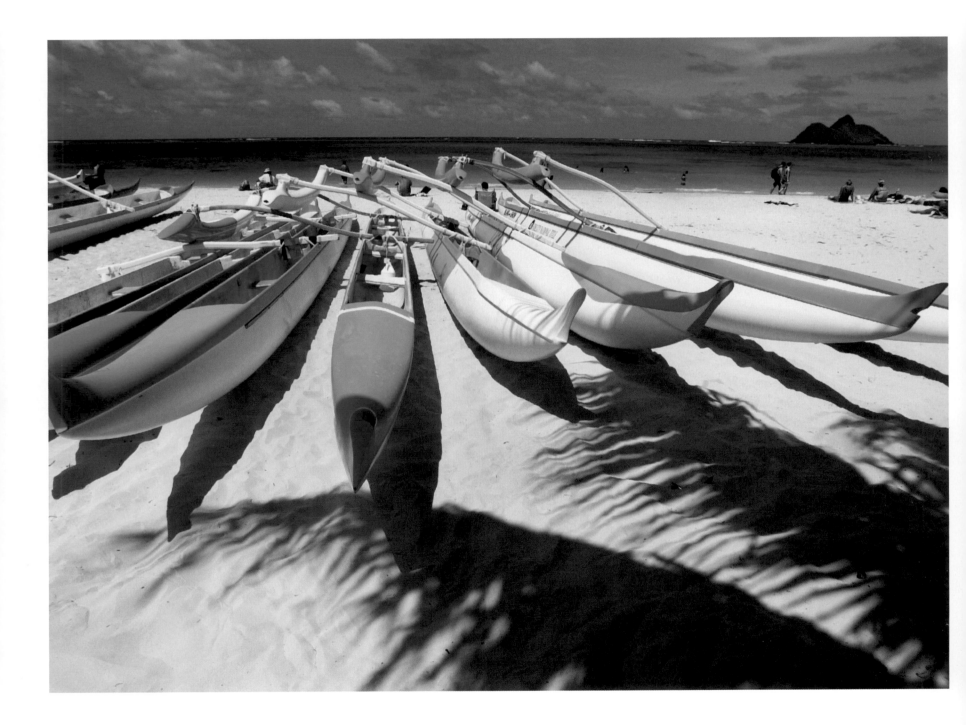

HONOLULU, O'AHU

The Ala Wai canal, which drains city streams that
would otherwise swamp Waikīkī's resort district,
is a calm and popular swath of urban water for
paddlers. A kayaker prepares for a "jog" on her
sleek fiberglass ocean kayak. Perhaps she'll ven-
ture into the Pacific to ride downwind on the
ocean's swells, the trade winds at her back.

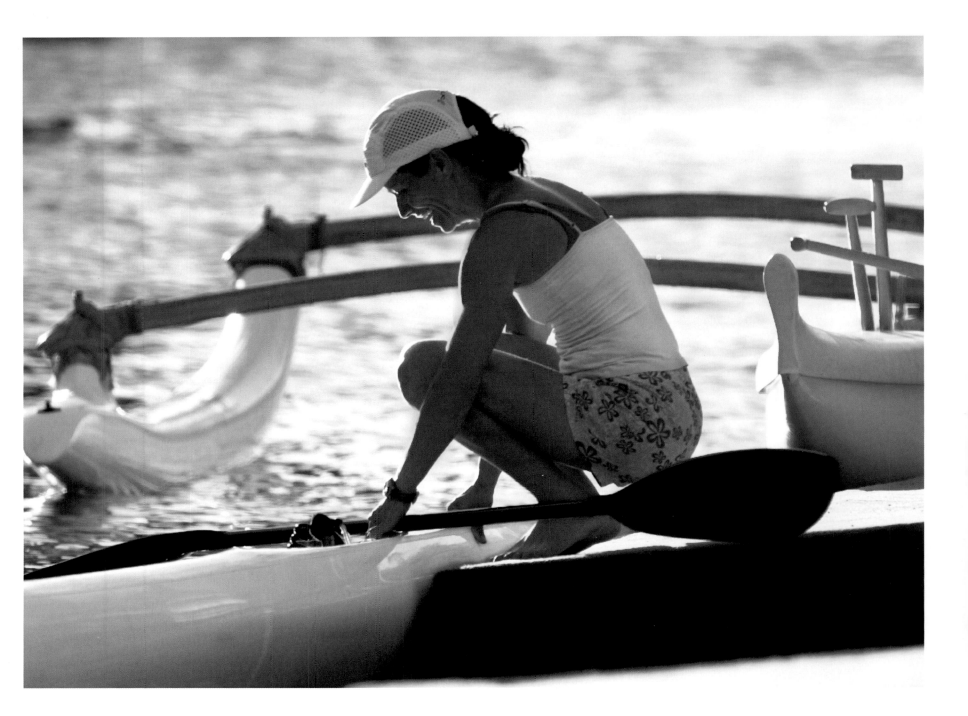

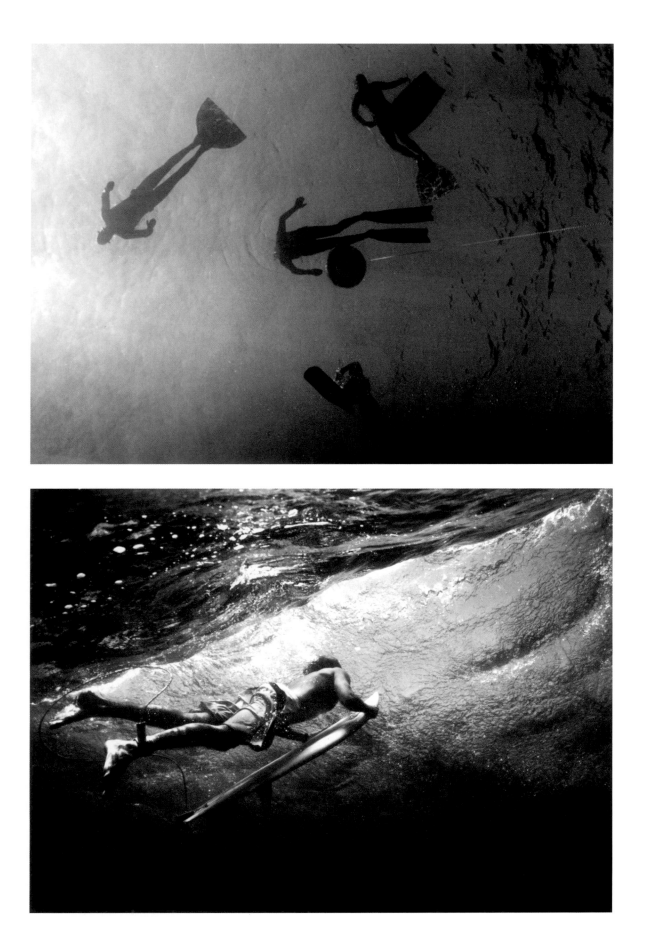

HŌNAUNAU BAY, HAWAI'I
U.S. team free divers Deron Verbeck and Annabel Briseno (in monofins) relax at the surface with their trainers. Briseno, 52, has unofficially broken the free-diving world record for women, kicking to a depth of 71 meters on a lungful of air. She trained herself to hold her breath for more than six minutes.
Photos by Wayne Levin

'EHUKAI, O'AHU
At the 'Ehukai sandbar on the North Shore, a surfer dives through a breaking wave on his way back out to the lineup.

WAIMEA, OʻAHU
At an inner point break called Pinballs, lifeguard and bodysurfing pioneer Mark Cunningham kicks under a breaking wave. Unlike many bodysurfers who slide down a wave's face, Cunningham lets himself be pulled along by the wave's suction, in the manner of dolphins and seals.

KEĀHOLE POINT, HAWAIʻI
A diver off the Kona coast communes with a school of opelu, or mackerel scad.

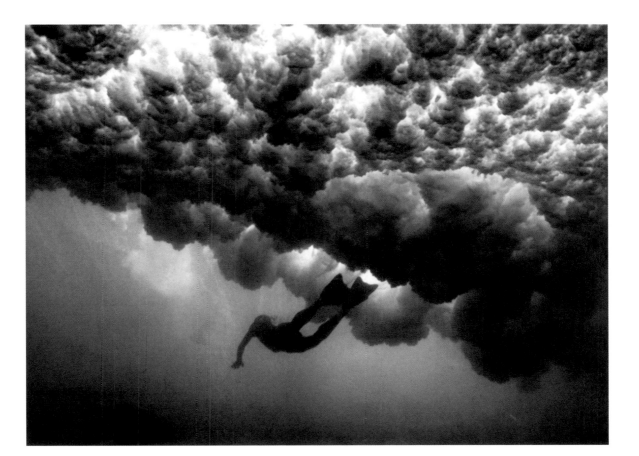

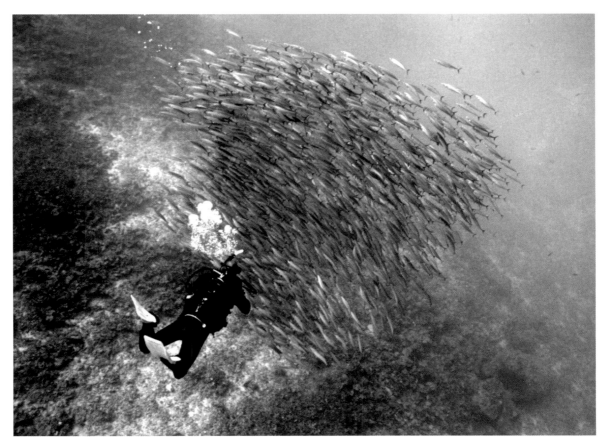

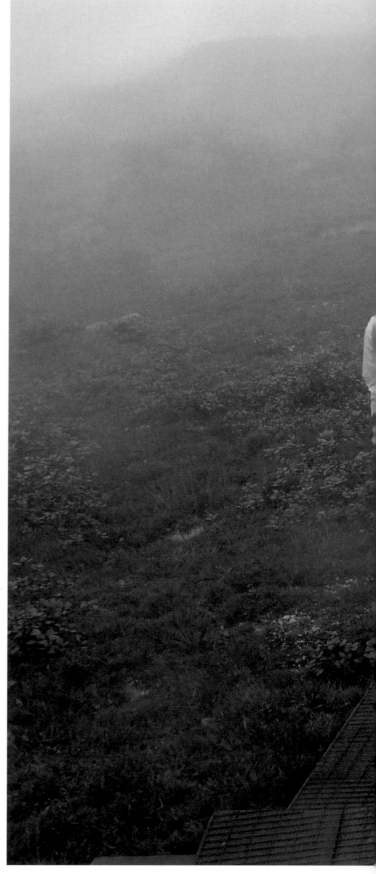

KŌKE'E STATE PARK, KAUA'I
On the Iliau Nature Loop Trail edging Waimea Canyon, fifth-graders from Kīlauea School examine a *Wilkesia gymnoxiphium*, or iliau. The plant lives for 20 to 30 years, flowers once, and then perishes. Like many plants native to Kaua'i, the iliau is unique in the world.
Photos by David S. Boynton

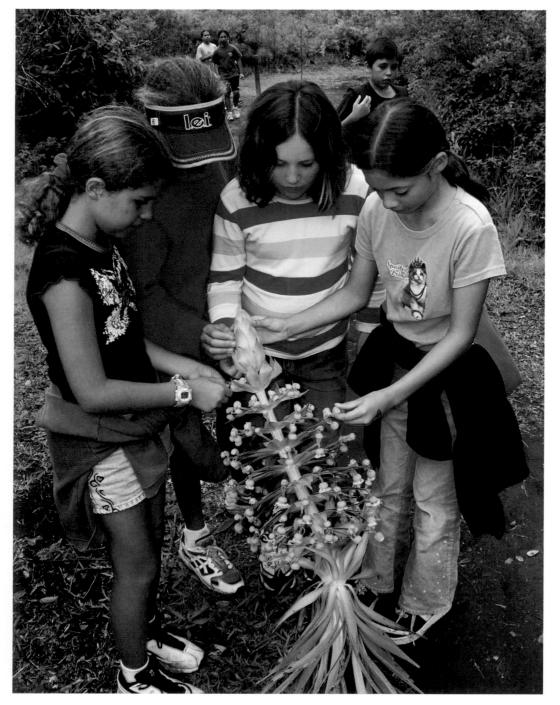

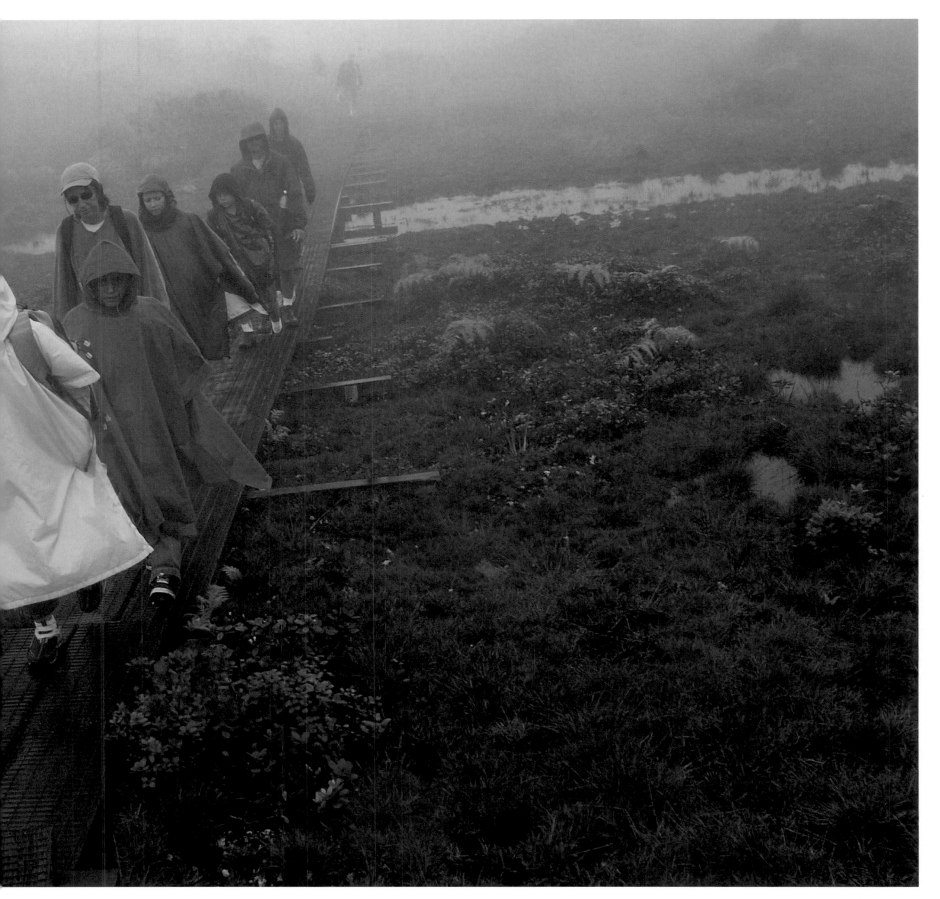

KŌKEʻE STATE PARK, KAUAʻI
Kīlauea School students tromp along the Alakaʻi
Swamp Trail. Boardwalks do double duty protect-
ing the fragile, dwarf plant life and making it
easier for hikers to navigate the muddy bog at
the crest of the Kauaʻi mountain mass. The path
accesses some of the wettest real estate on
earth, with an annual rainfall of more than 35
feet.

HUELO, MAUI

Eddie Modestini teaches hatha yoga with his wife Nicki Doane in their Maya Yoga studio on Maui's windward coast. The couple built their studio in 1997 using a special Alaskan yellow cedar to create warmth and lightness. Modestini says, "There is no electricity in the building, which keeps the energy pure and clean for yoga practice."
Photo by Ron Dahlquist

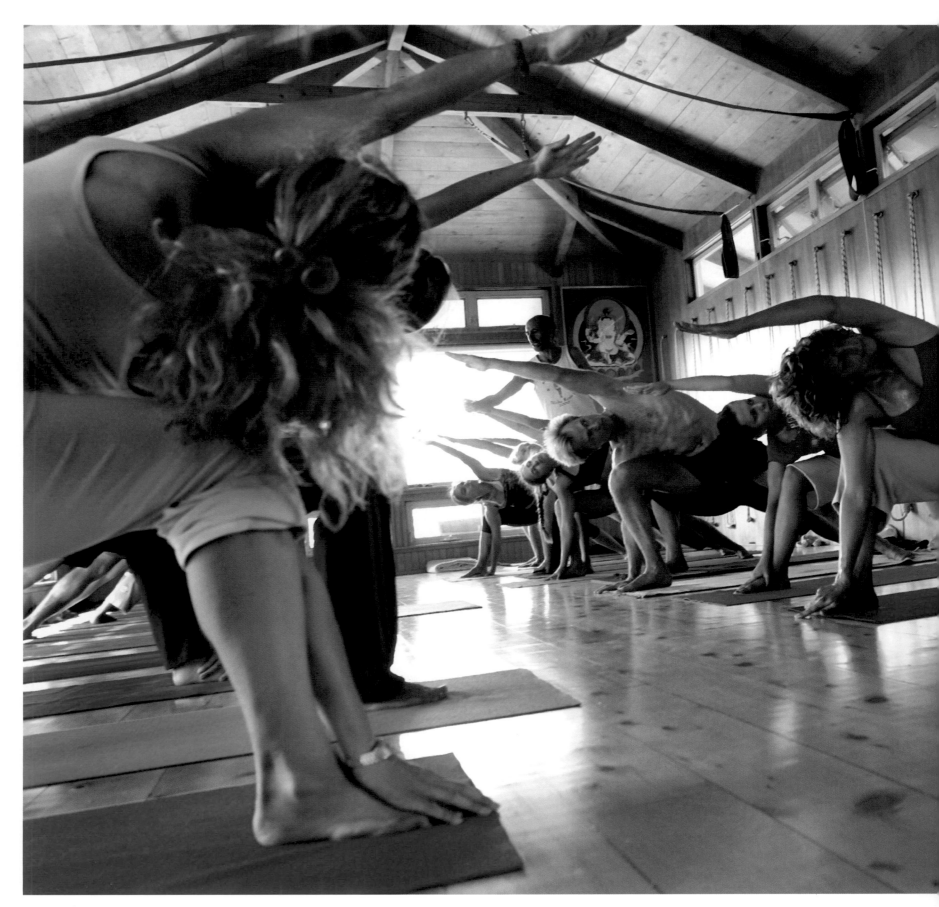

HONOLULU, O'AHU

Kari Lloyd-Jones and her son Ian demonstrate a modified version of the plough in Yoga Hawai'i's baby class. The class helps parents build the strength and tranquility they need to bring up baby—and youngsters like Ian get to enjoy their parents from a new perspective.

Photo by Sergio Goes

KAILUA, O'AHU

Kyra McGlinn-Fo, avoiding the problem of tan lines, comes to the beach with her mother Kari McGlinn whenever mom is between classes at the University of Hawai'i. Kyra's ancestry counts Japanese, Native American, and Portuguese strains, but those McGlinn genes demand SPF 30 sunscreen.

Photo by Dennis Oda, Honolulu Star-Bulletin

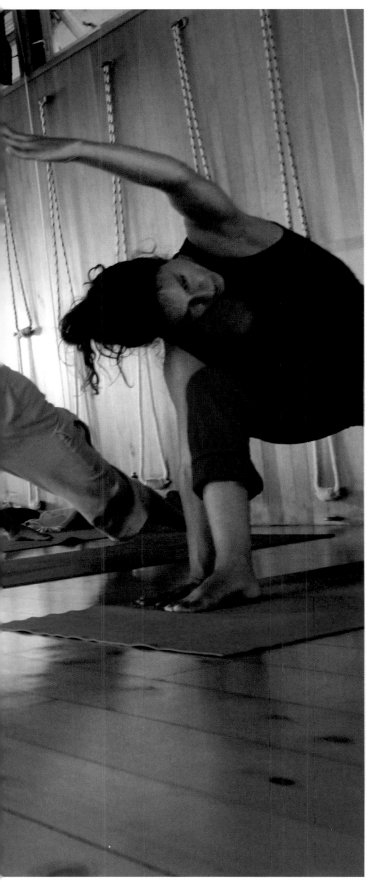

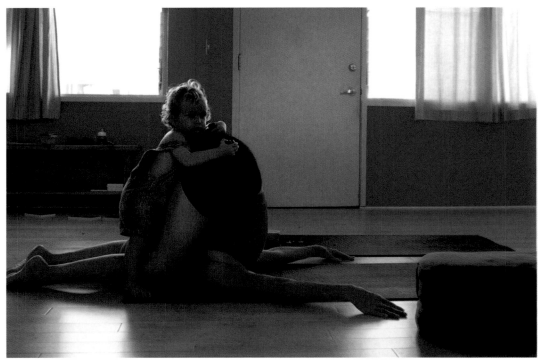

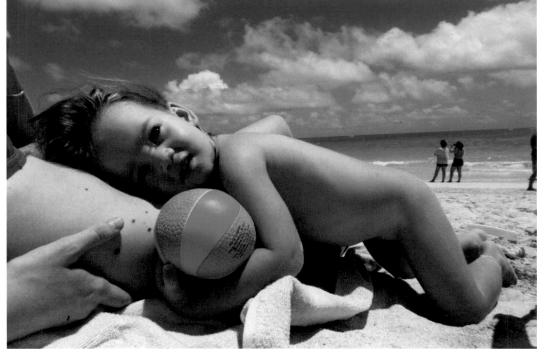

WAIALUA, O'AHU
Cockfight club: Back in the day, Filipino immigrants who worked on plantations brought fighting cocks to their camps to divert themselves with bloodsport and gambling. Despite efforts by animal-rights organizations—not to mention the police—to stamp out the illegal "sport," it continues to attract crowds in the Islands' multicultural underground.
Photo by Sergio Goes

WAI'ANAE, O'AHU
For 20 years, Sensei Takeo Fujitani, who holds a seventh-degree black belt in judo, has taught the martial art daily to kids at the Boys & Girls Clubs of Hawai'i.
Photo by Monte Costa

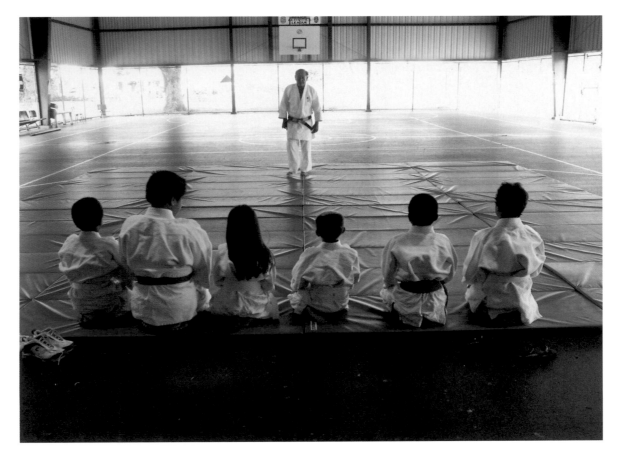

HANAPĒPĒ, KAUAʻI

Hanapēpē Cubs Coach Raphael Santo (no. 31) follows his players through the high-five line after they win the Mustang Division. Coach Ralph, as he's known, has been active in youth baseball for 33 years—and still refuses to wash his jersey until his team's first win of the season.

Photo by Sabra Kauka

KĪLAUEA, KAUAʻI

Tucked into the posh residential purlieus of the North Shore, the Kauaʻi Polo Club hosts regular matches during the spring and summer months. Teams sponsored by local businesses gather on Sundays to compete. In true island style, fans park their cars on the roadside and tailgate through the final chukker.

Photo by David S. Boynton

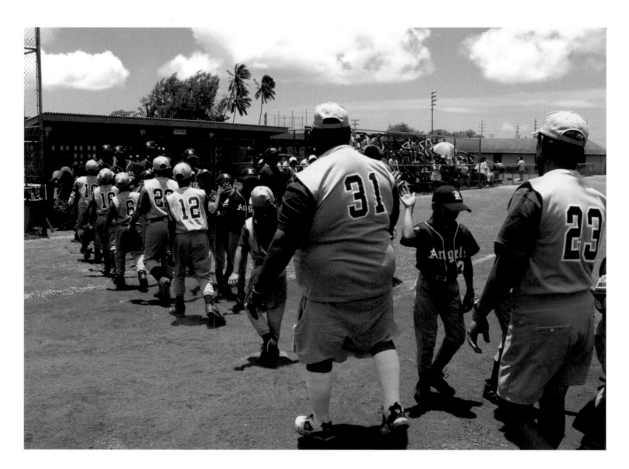

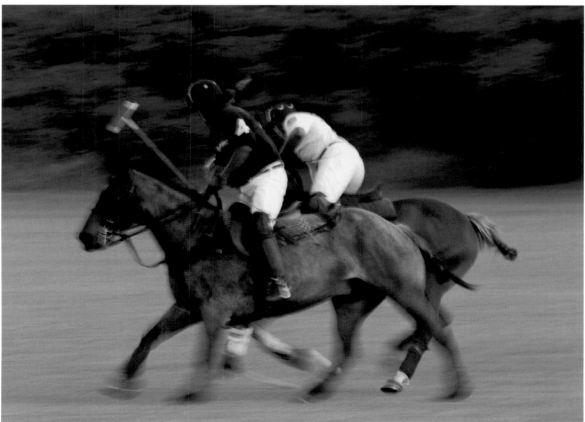

KAHULUI, MAUI
Revival island: King's Cathedral of the First
Assembly of God has become a hub of evan-
gelism over the past two decades, with
membership approaching 4,000 on Maui.
The mission of the church's pastor, James
Marocco, is to spread the word throughout
the Pacific.
Photo by Randy Hufford,
www.visualimpact.org

HONOLULU, O'AHU

Marvin Bergdahl arranges his altar in the sand of Fort DeRussy Beach. He consecrates each day to "the unity of life and the resurrection of the spirit of peace."
Photo by Sergio Goes

SPRECKELSVILLE, MAUI

Alfred Huang, 81, practices tai chi. A Taoist philosopher, Huang is also an I Ching master who published *The Complete I Ching: The Definitive Translation* in 1998. Born in China, Huang was a university professor in Shanghai and twice imprisoned. He immigrated to America at age 50 and settled on Maui, where he started the New Harmony healing institute at age 68.
Photo by Ron Dahlquist

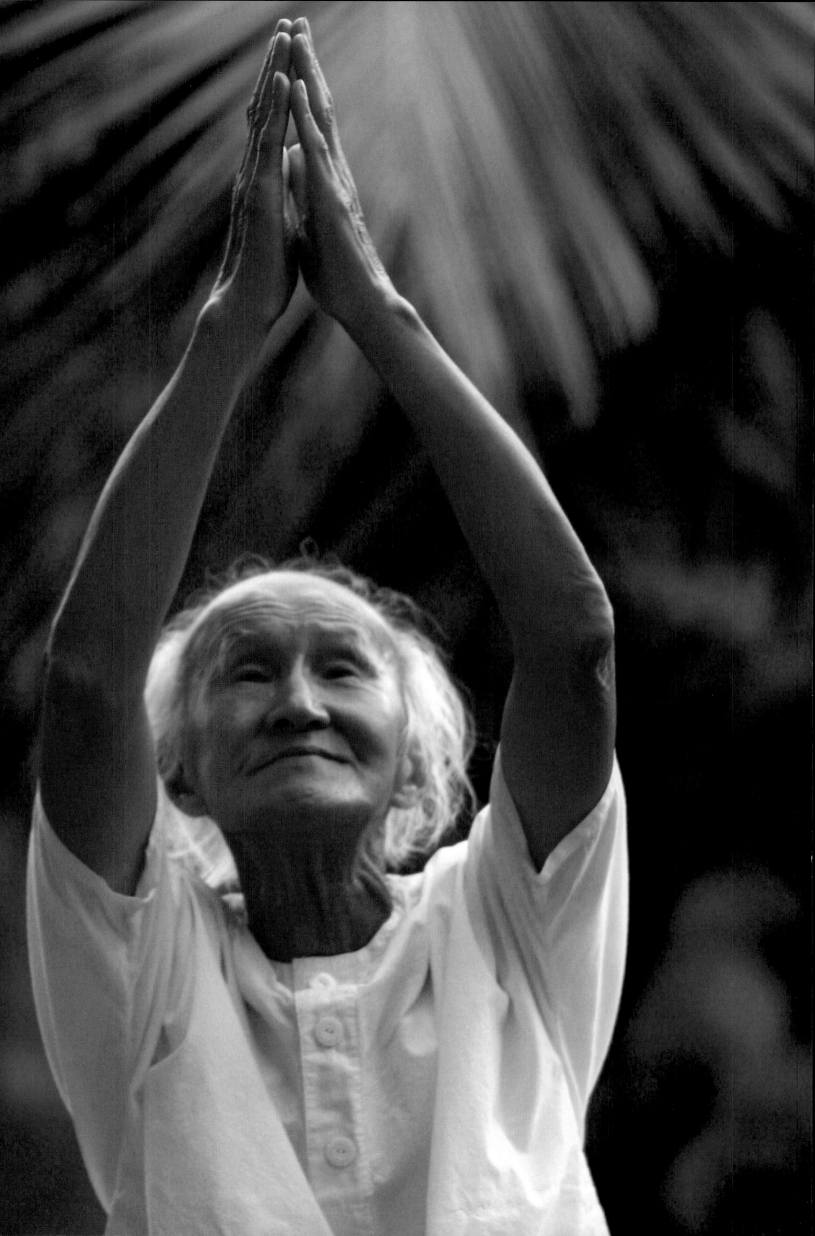

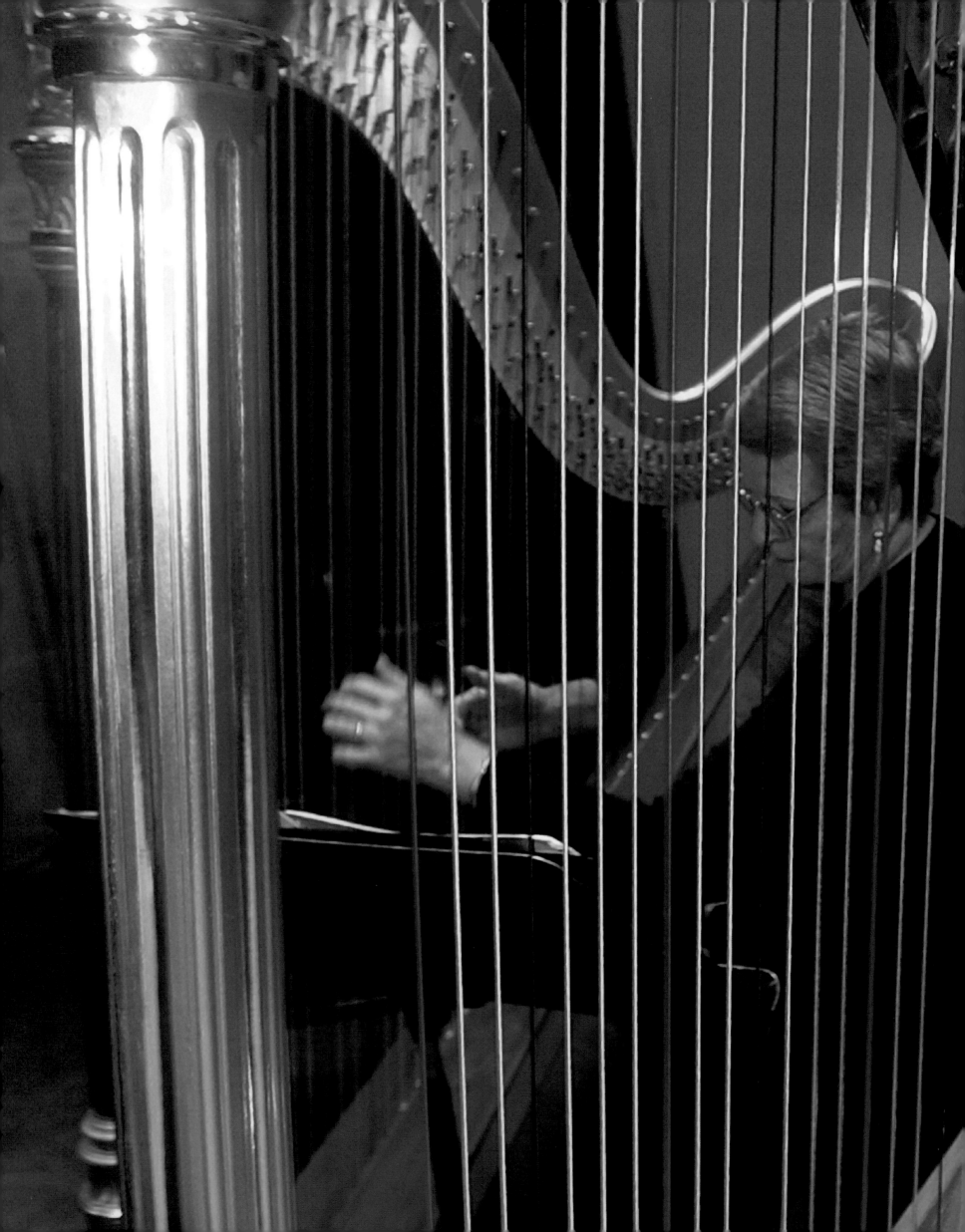

HONOLULU, O'AHU
Honolulu Symphony first harpist Constance
Uejio and, behind her, second harpist Nyle
Hallman warm up before an evening per-
formance at the Blaisdell Concert Hall. Uejio,
who has played first harp for 22 years, is
one of 63 permanent musicians with the
orchestra.
Photo by Lucy Pemoni, Associated Press

WAHIAWĀ, O'AHU

A Hindu shrine protects the Wahiawā healing stone, visible behind assistant priest Subramanyam Ramanathan. Hawaiians long revered the pōhaku as having the healing powers of the god Lono. More recently, Hindus testified that the stone gave them visions and a sense of well-being, and that it resembled the lingam, or phallus, of the god Shiva. Now they, too, venerate the stone.

Photos by Phil Spalding

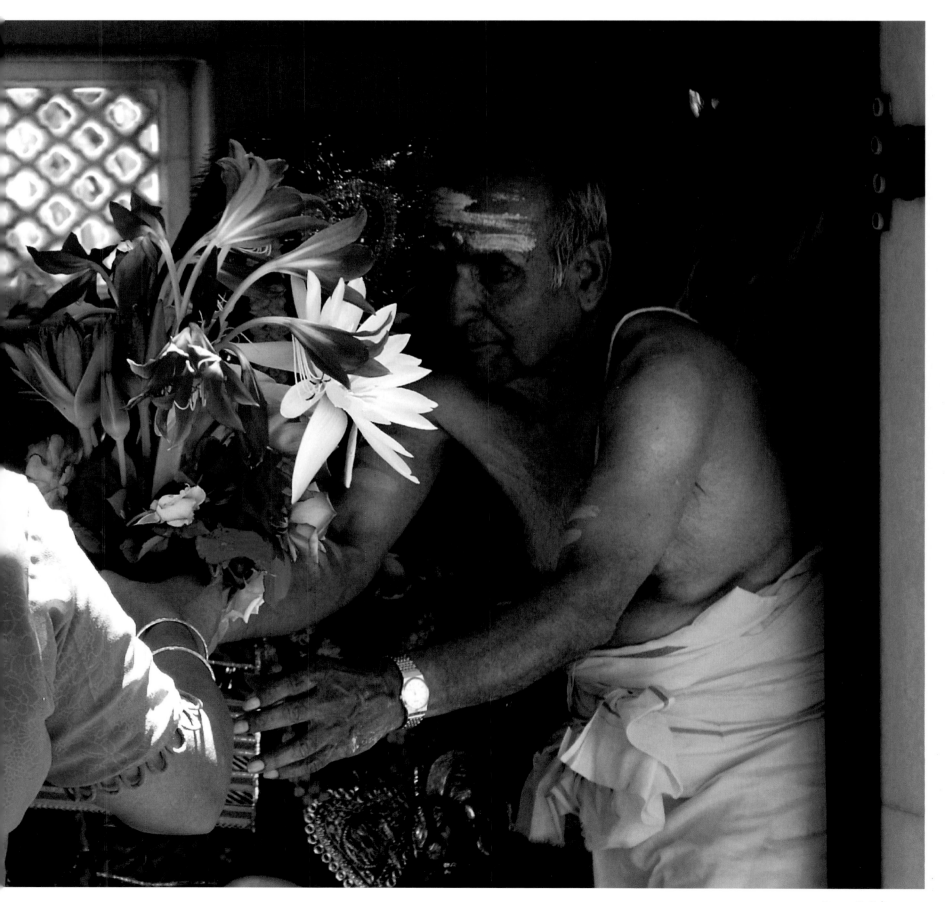

HONOLULU, O'AHU

One April evening in 2001, as Police Officer Danny Padayao placed flares on a rural stretch of Kamehameha Highway following a car crash, a drunk driver ran into him, killing him. During Police Week, Honolulu Police Department Chaplain Alex Vergara reads the names of all 38 O'ahu officers who died in the line of duty in the last hundred years.

Photo by Deborah Booker,
Honolulu Advertiser

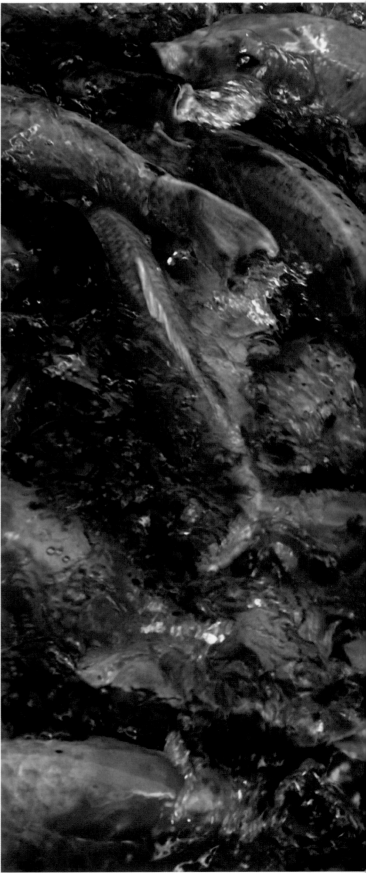

KAHALU'U, O'AHU

Byodo-In Buddhist temple, a replica of a 900-year-old temple in Uji, Japan, nestles into the rain forest in Valley of the Temples Memorial Park, at the foot of the Ko'olau pali. Built in 1986 by the Hawaiian Buddhist community, Byodo-In with its gardens and ponds is a tranquil refuge from O'ahu's suburban sprawl.
Photos by Kevin Boutwell

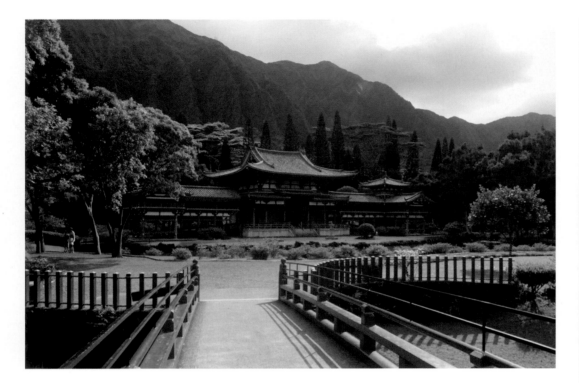

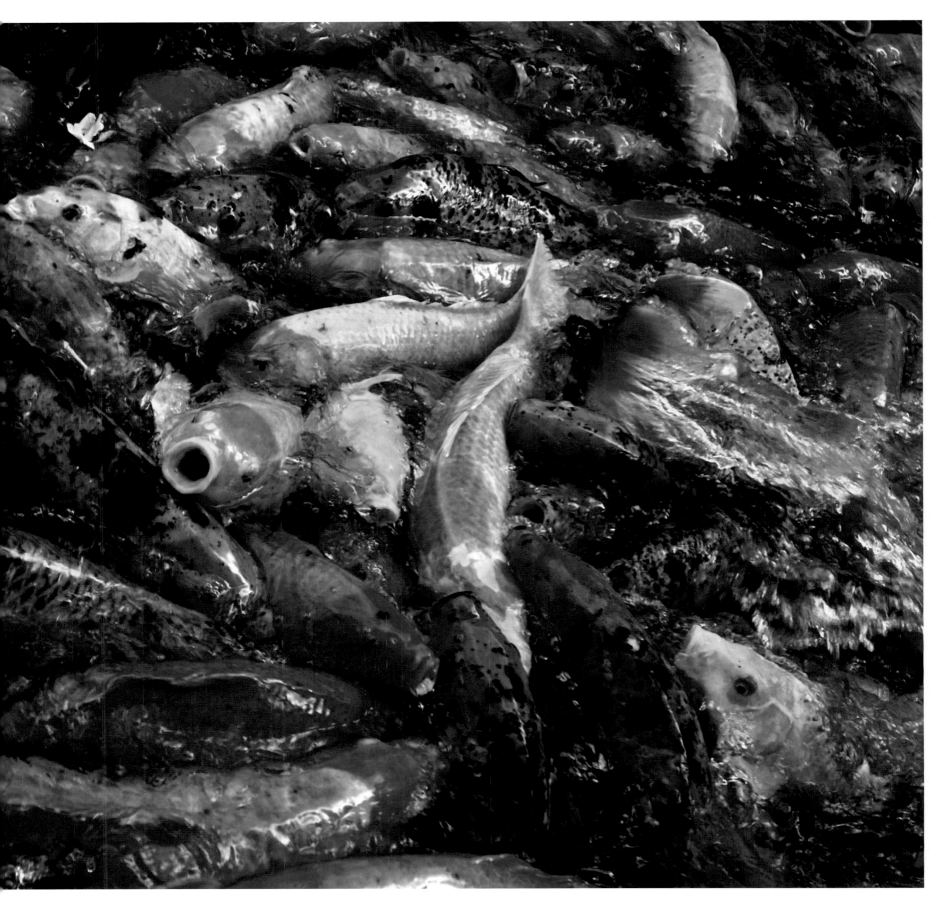

KAHALU'U, O'AHU
It's a feeding frenzy at the Byodo-In Buddhist temple's 2-acre reflecting pool, home to thousands of koi (carp). On Boys' Day, Japanese families fly paper koi on bamboo sticks, one for each male in the family. Considered the most spirited of fish, koi symbolize masculine power and energy.

KĪLAUEA, KAUAʻI

On the North Shore, friends join the Yokotake family for an ʻohana picture after Heleolani Yokotake's christening at Christ Memorial Episcopal Church. The picturesque stone church was built in 1935 under the auspices of the Kilauea Sugar Company, which deeded the land and supplied the lava rock.

Photo by David S. Boynton

HĀLAWA, OʻAHU

At an *oharai*, or purification ceremony, Shinto priest Al Takata waves a *gohei* over the owners of a new company, Aquariums Hawaiʻi. "I cleanse the building of the old karma associated with it and its former occupants," Takata explains.

Photo by Bruce Behnke, Pacific Rim Photography

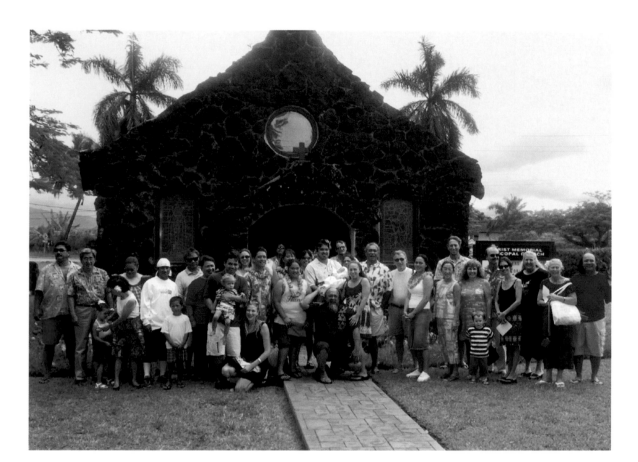

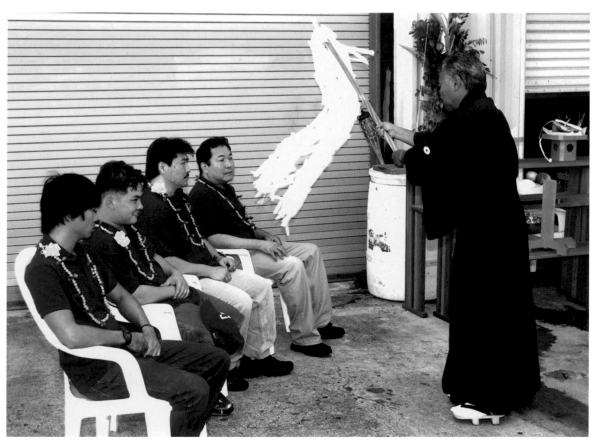

KĪLAUEA, KAUAʻI

At Christ Memorial Episcopal Church, Hoku Cabebe and Ekolu Yokotake are all smiles after the christening of their 2-month-old daughter, Heleolani Yokotake. The young family lives "off the grid" in Kauaʻi's backcountry.

Photo by David S. Boynton

WAHIAWĀ, OʻAHU

Hindus venerate the large black rock as a manifestation of the god Shiva. The stone on the left represents the bull, Shiva's chariot. The small stone is Ganesha, the popular elephant-headed son of Shiva.

Photo by Phil Spalding

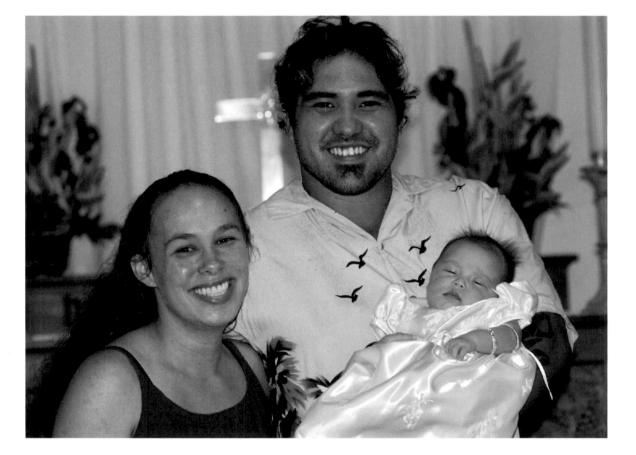

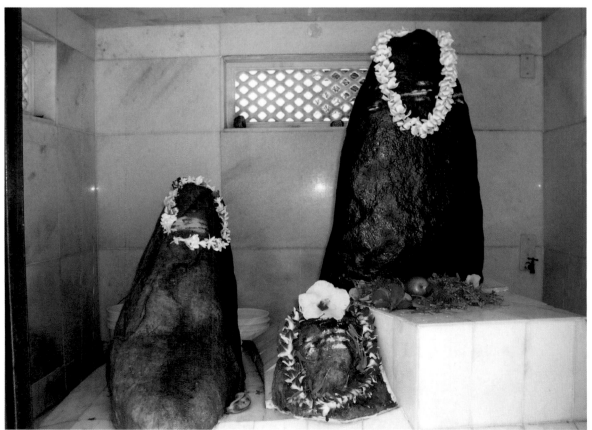

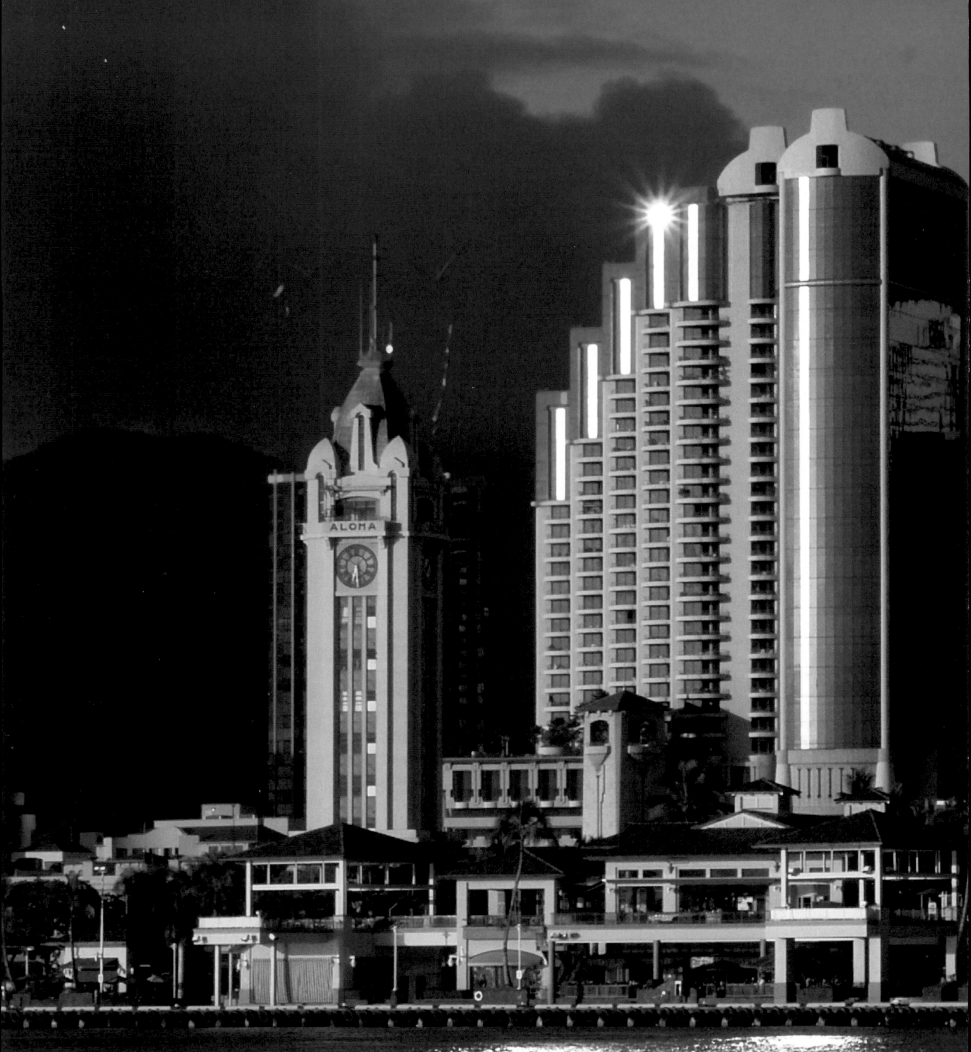

HONOLULU, O'AHU
Crossroads of the Pacific: Evolving from grass-hut fishing settlement to mid-ocean metropolis, Honolulu and its harbor have ridden the economic crests of the sandalwood trade, whaling, sugar, war, and tourism.
Photo by Wilber Bergado

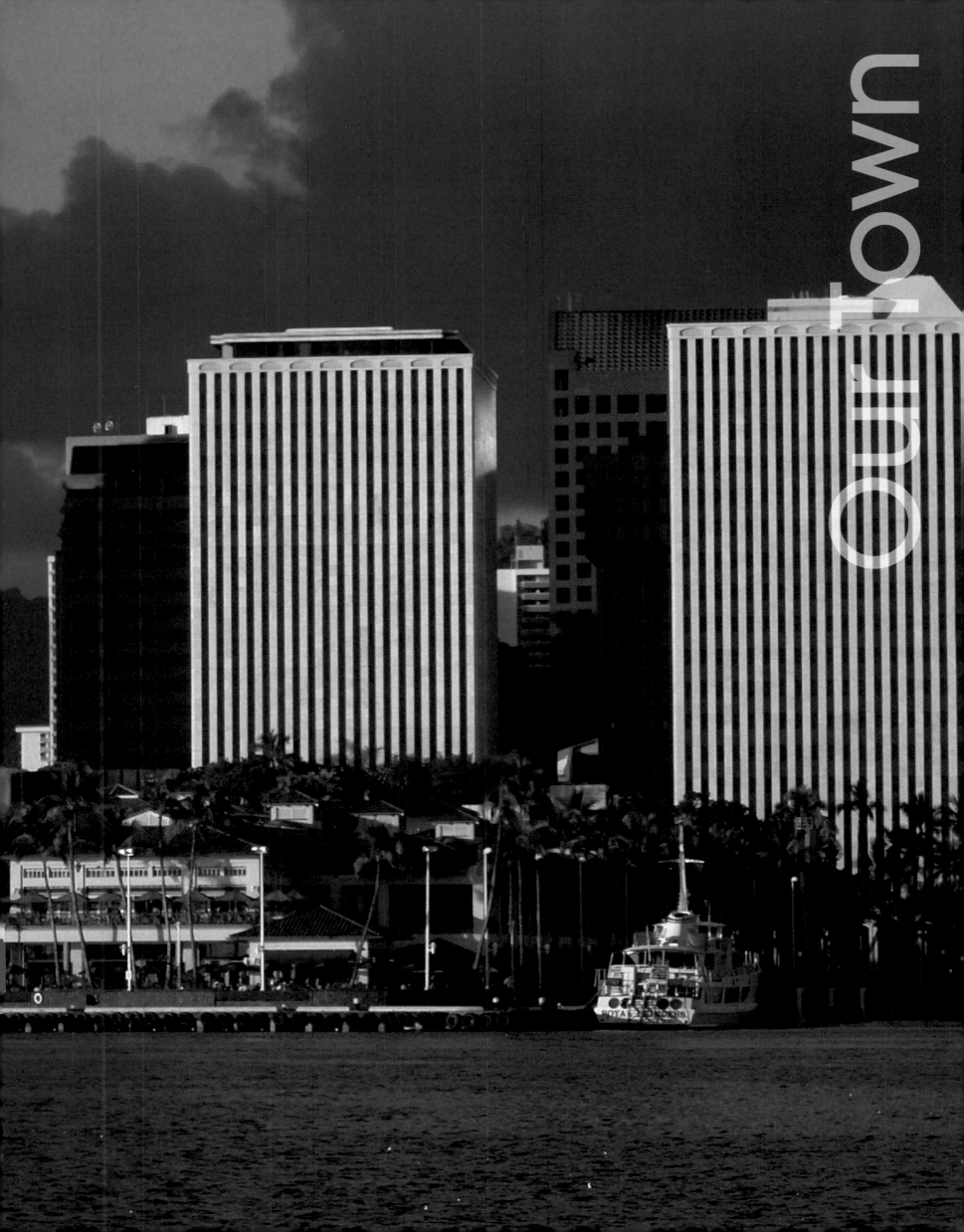

Our town

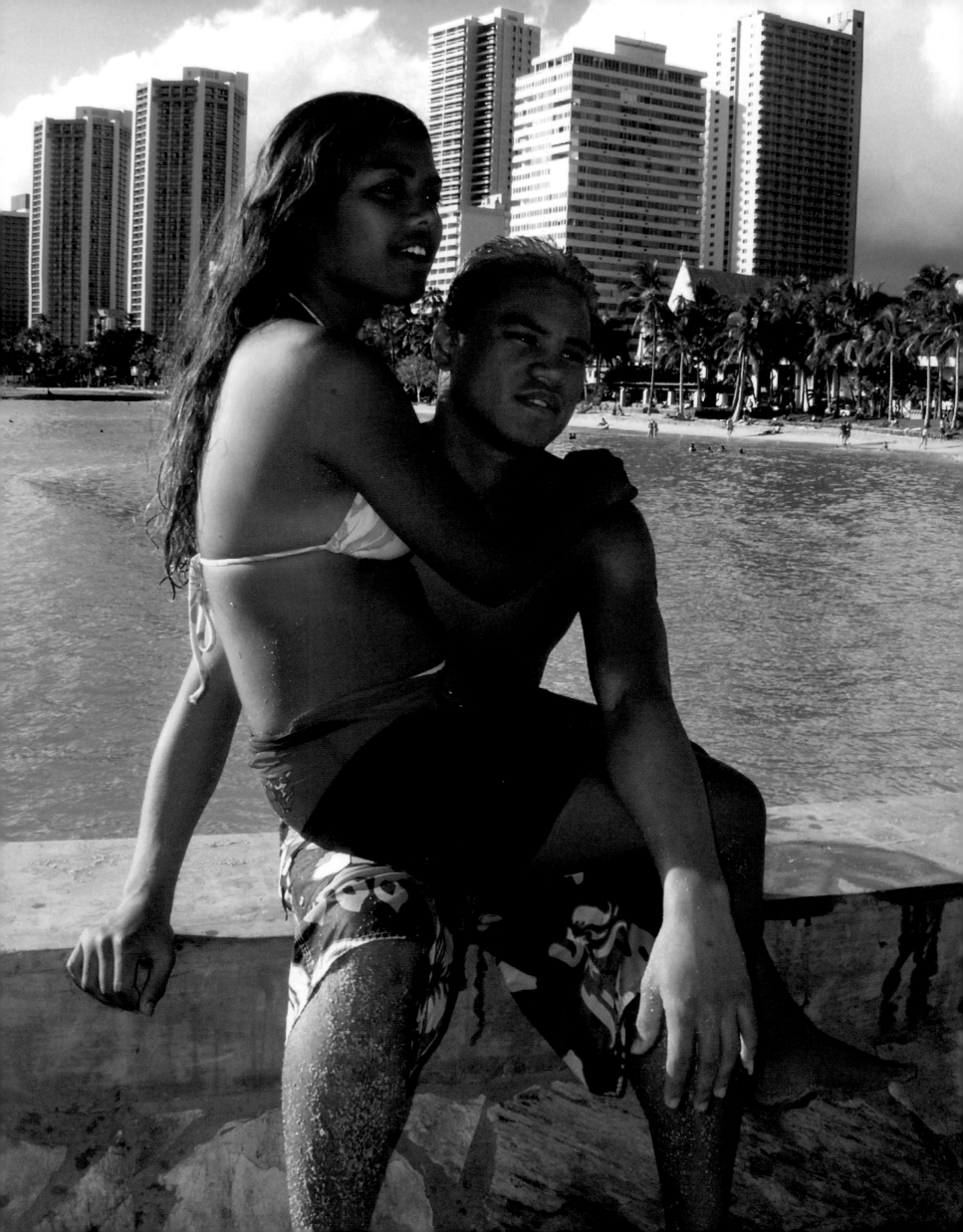

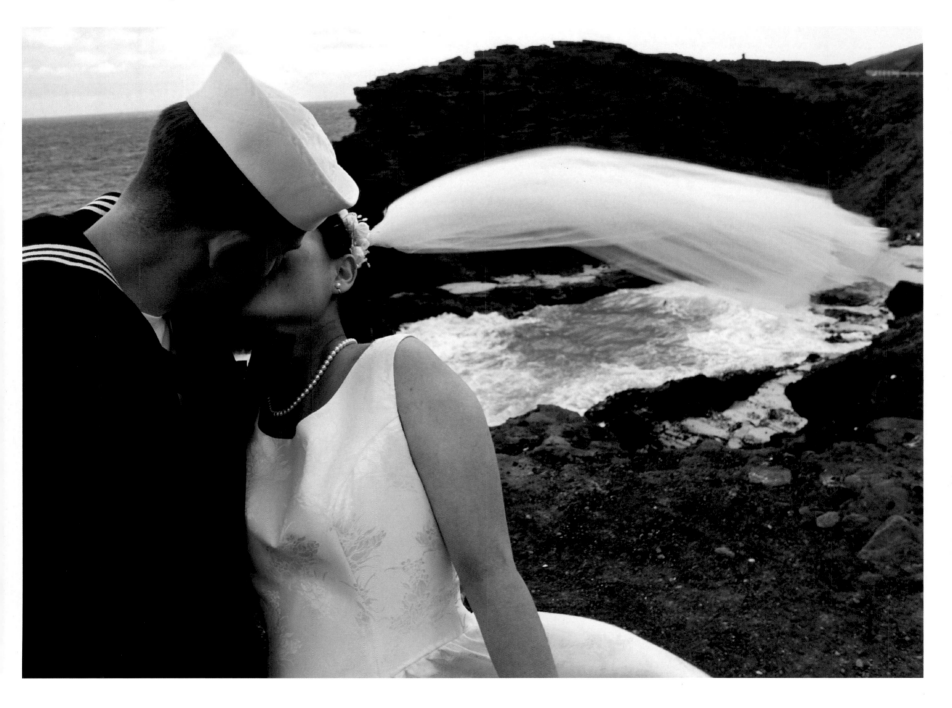

HONOLULU, O'AHU

The Sheratons, the Marriotts, the Outriggers, the Hyatts, the Hiltons...Crowded by sheer cliffs of hotel rooms, the district called Waikīkī nevertheless endures. With perhaps the most perfect microclimate in the Hawaiian Islands, gentle waters, golden sunsets, and blue moonlight, everyone loves Waikīkī —even locals. The great coconut groves and broad lawns may be long gone, but the district will always have romance.
Photo by Val Loh

HĀLONA POINT, O'AHU

At the Hālona blowhole on the spectacular Ka Iwi coast, newlyweds Matthew and Satoko Ramsey share a forever kiss. They met in Yokosuka, Japan, where Matthew, a Navy sailor, was stationed for two years. In the background: Hālona cove, aka Cockroach beach, where a wet Burt Lancaster and a wetter Deborah Kerr famously rolled around in the 1953 film *From Here to Eternity*.
Photo by Sergio Goes

HONOLULU, O'AHU

A gift to the people of Honolulu from King Kālakaua 120 years ago, 500-acre Kapi'olani Park lays out its playing fields between the mountains and the sea. On weekends, the place is busy with softball, soccer, rugby, and cricket players.
Photo by Val Loh

HONOLULU, O'AHU

Kapi'olani Park's fountain memorializes Louise Gaylord Dillingham, wife of Walter Dillingham, whose construction company paced Hawai'i's growth through most of the 20th century.
Photo by Val Loh

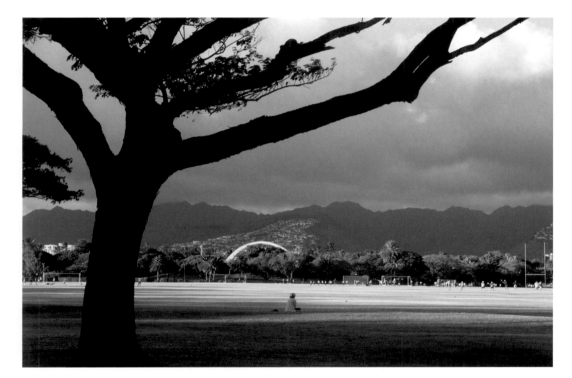

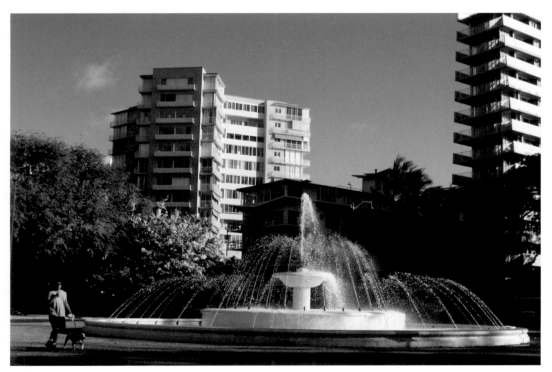

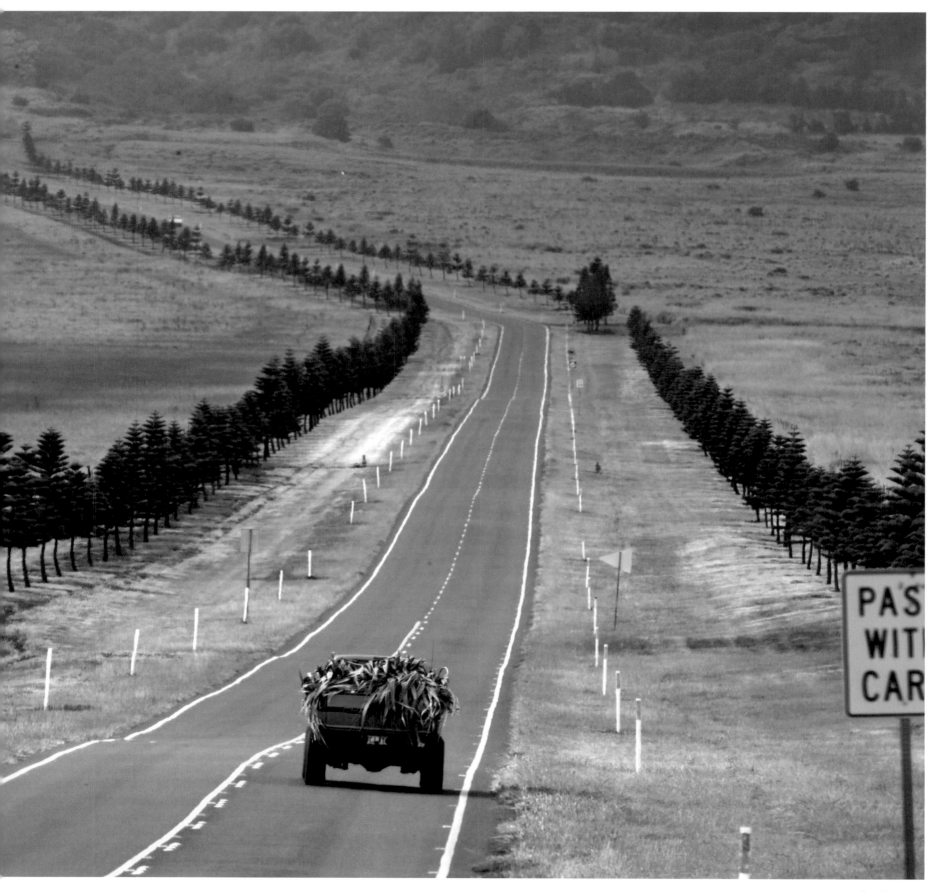

LĀNA'I CITY, LĀNA'I

Highway 440 traverses the island's flat center between Lāna'i City (pop. 3,000) and the resort district at Manele bay. First developed as a giant pineapple plantation by the Dole Company in the 1920s, the island lay low until recently, when new owners shut the plantation, built two ultra-luxury hotels, and began selling an exclusive get-away experience.

Photo by Jeff Widener

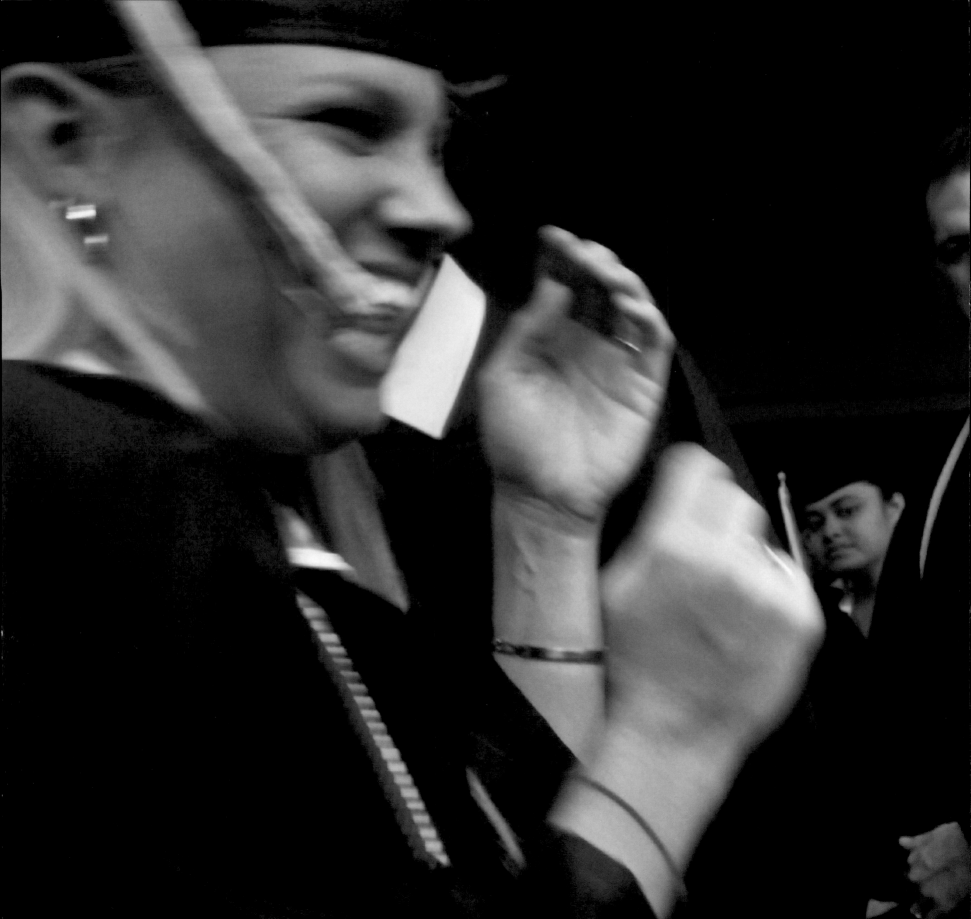

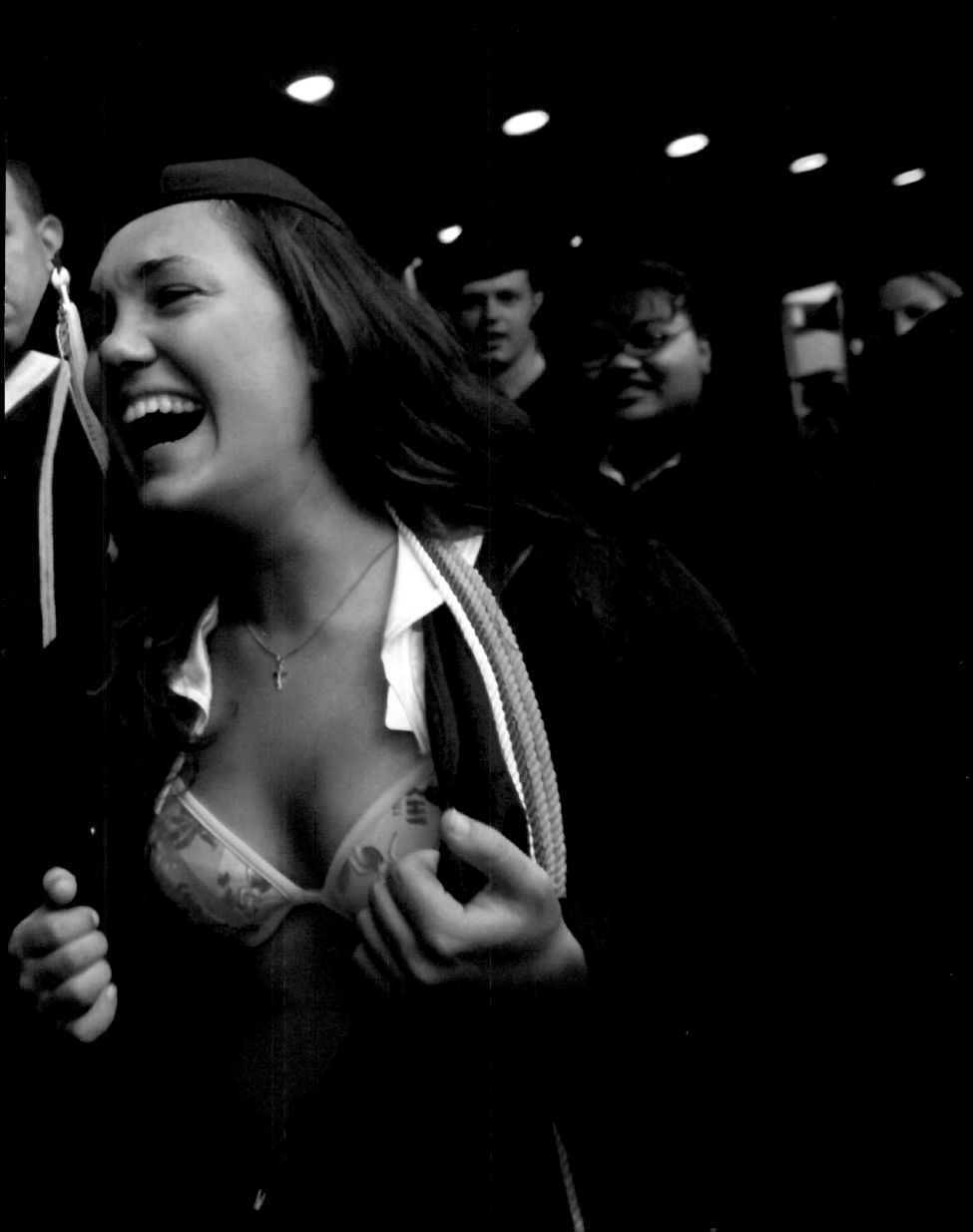

WAIKĪKĪ, OʻAHU

Save the honu! After years of overfishing, the now-protected Hawaiian green sea turtles have recovered to the point that they are a normal sight for snorkelers and swimmers. But the slow-moving and curious creatures are still in danger. A mysterious tumor called fibropalilloma is spreading quickly among the population. The honu's other deadly adversary: marine debris.
Photo by Deborah Booker, Honolulu Advertiser

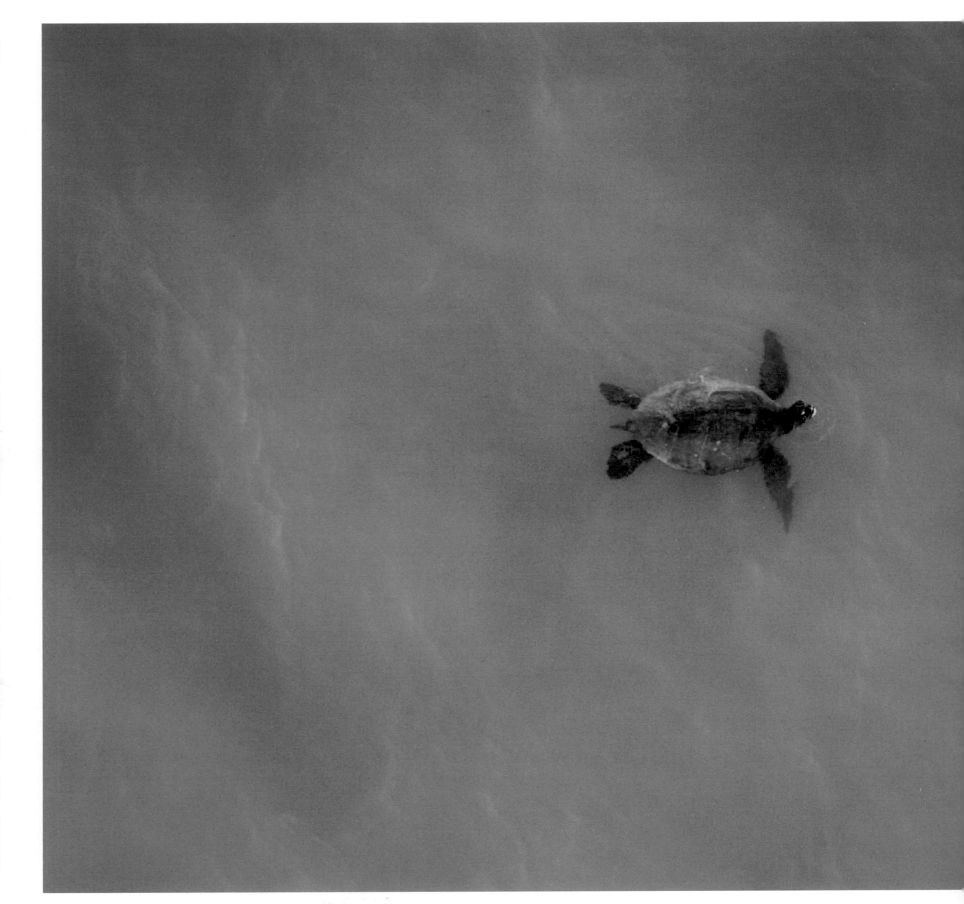

WAIMĀNALO, OʻAHU
Kailua artist Ron Artis—yes, an artist named Artis—painted *The Spirit of Waimānalo* in 1998 on the wall of Shima's Market.
Photo by Brett Uprichard,
Honolulu Publishing Company

KĀNEʻOHE, OʻAHU
Doug "Double D" Durocher takes it easy at his waterfront home after deejaying for Honolulu rock station KPOI's early morning show. For this native of Detroit, Michigan, his island life is a permanent vacation.
Photo by Daniela Stolfi

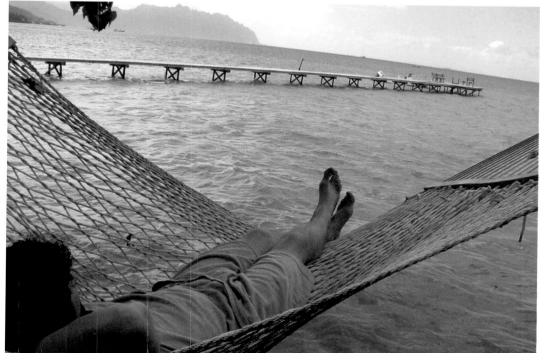

PEARL HARBOR, O'AHU
Sergeant Charity Heights reads a souvenir news-
paper after her formal re-enlistment ceremony at
the USS Arizona Memorial, committing her to an-
other three years in the army. A combat medic
stationed at Tripler Army Medical Center, Heights
says re-enlistment ceremonies can be held any-
where you want. "On top of Diamond Head, at
the beach, or in your kitchen—wherever."
Photo by Brett Uprichard,
Honolulu Publishing Company

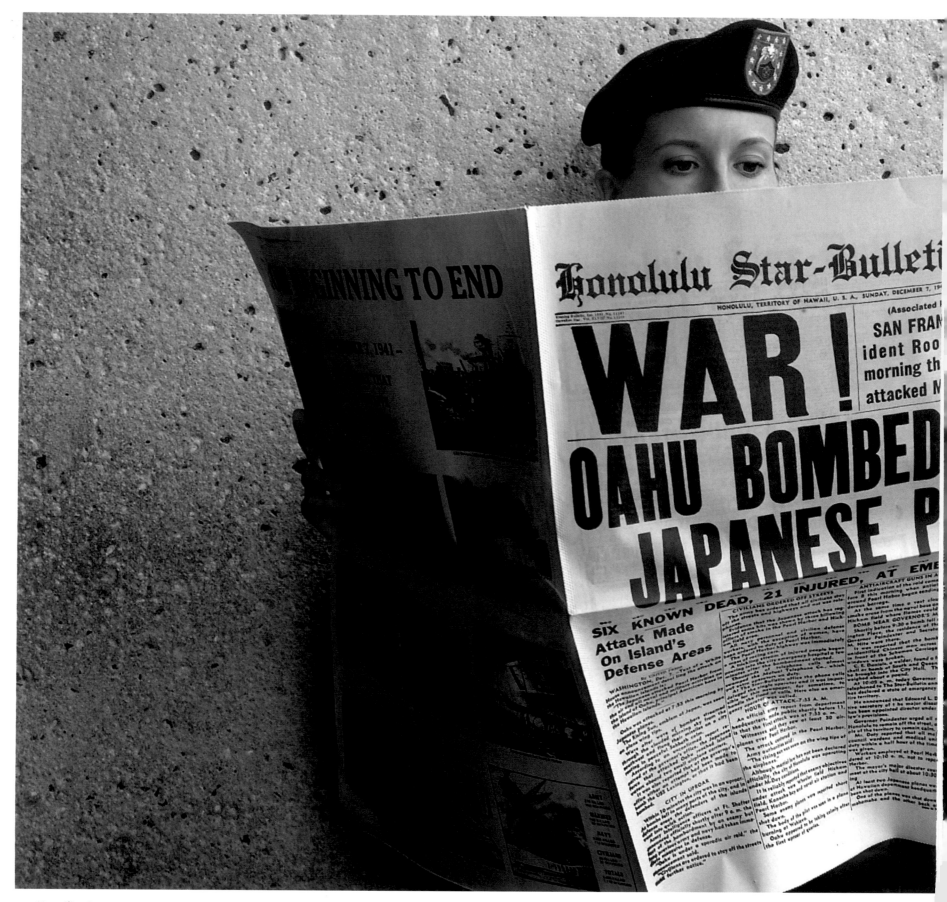

PEARL HARBOR, OʻAHU

A visitor stands silent in the memorial's shrine room. The names of the 1,177 crew members killed aboard the USS *Arizona* are engraved in the marble walls.

Photo by Bruce Behnke, Pacific Rim Photography

PEARL HARBOR, OʻAHU

An interpretive display gives memorial visitors a perspective of the sunken battleship, showing decks, turret locations, and other points of interest. Japanese tour groups make for a steady stream of visitors.

Photo by David Ulrich,
Pacific New Media, University of Hawaiʻi

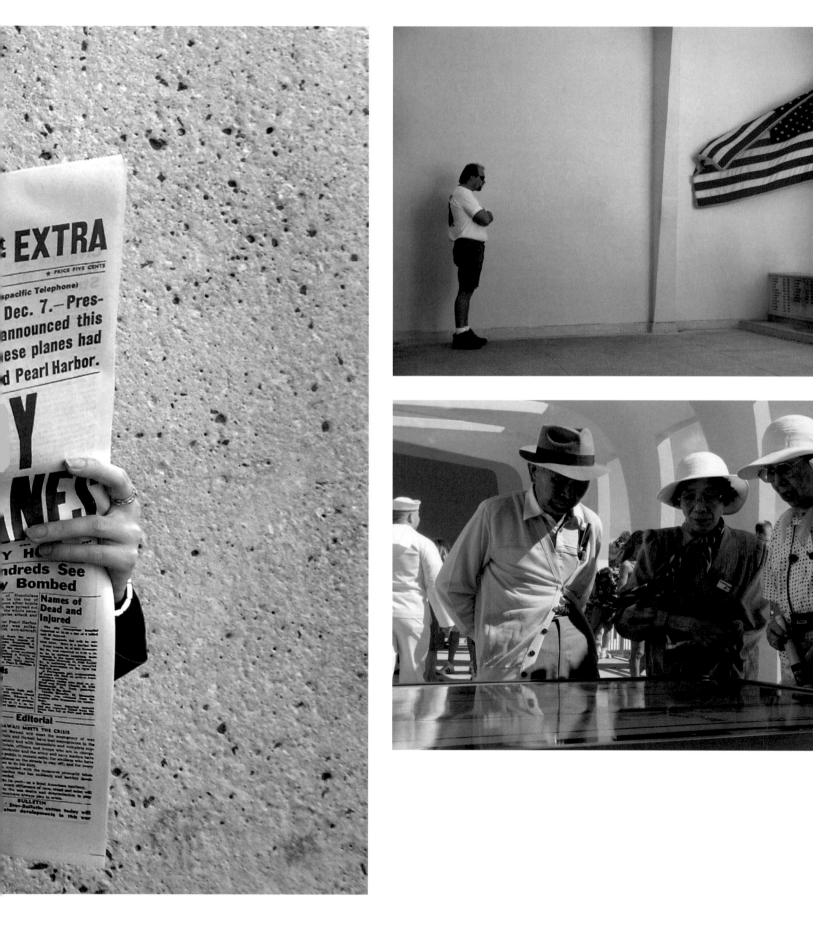

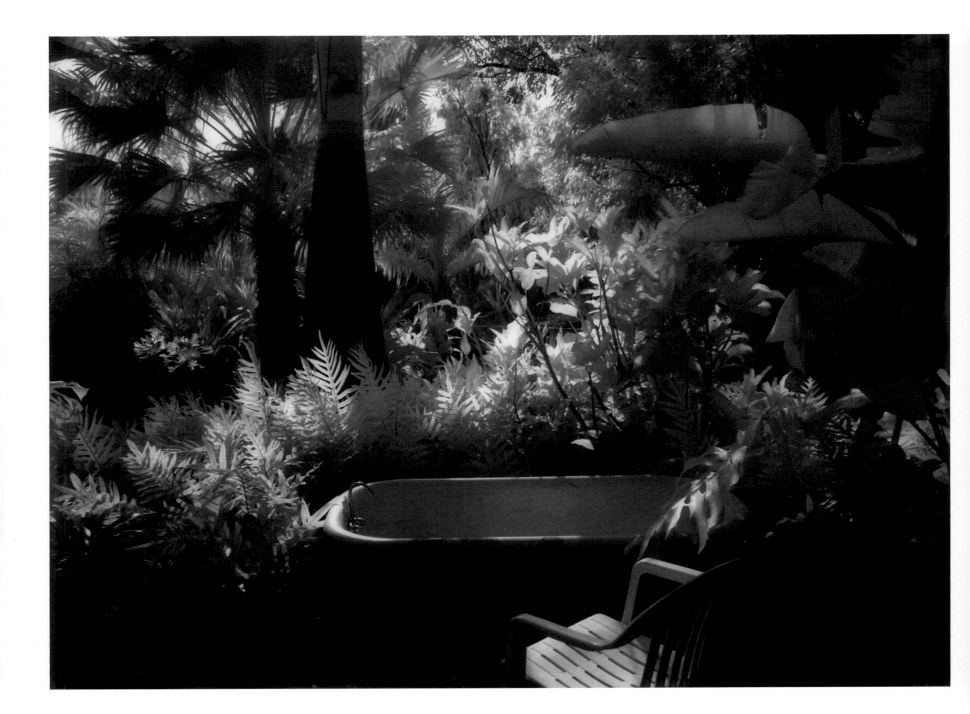

KAULUWAI, MOLOKA'I
The grounds of the Hui Ho'olana retreat take on an otherworldly glow through the lens of proprietor Richard Cooke, who used a digital camera with an infrared filter to create this effect. Describing the result, Cooke says, "What's most alive is what's most light."
Photos by Richard A. Cooke III

KAULUWAI, MOLOKA'I
Secret garden: The retreat serves organic fruits
and vegetables grown on the 77-acre property,
which is located in upcountry Moloka'i at about
1,300 feet.

KULA, MAUI

A rare pineapple field drinks the sunlight. As labor and land costs price Hawaiian pineapple products out of the market, the fields dwindle. Now, the fruit is mostly sold fresh to mainland U.S. markets. Contrary to popular belief, pine is not native to Hawai'i. Portuguese explorers discovered the succulent bromeliad in the West Indies and carried it around the globe.

Photo by Randy Hufford, www.visualimpact.org

HAWAI'I VOLCANOES NATIONAL PARK, HAWAI'I

Cooling folds of pāhoehoe lava flowing downhill from the Pu'u O'o vent put a fresh new veneer on the park's coastal plain.

Photo by G. Brad Lewis

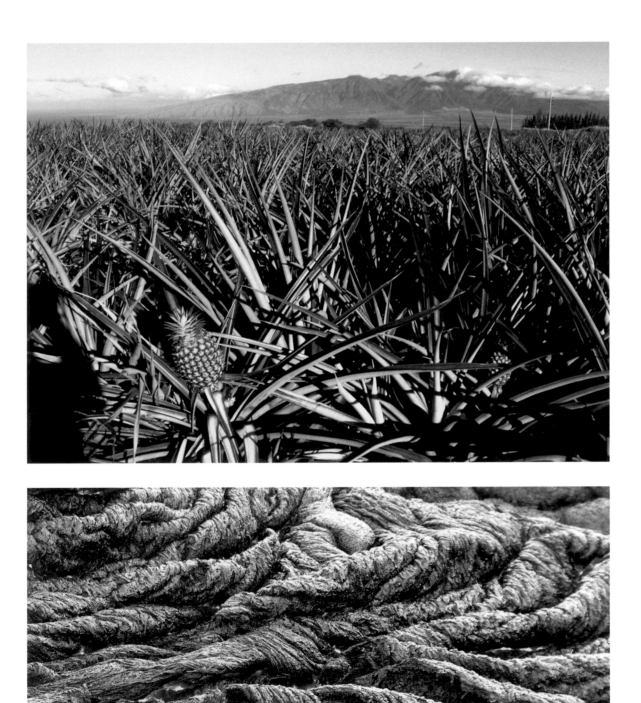

'ANAEHO'OMALU, HAWAI'I

Along an ancient footpath adjacent to the fifth hole of a resort golf course, a field of petroglyphs etched into brittle pāhoehoe lava offers a graffitti glimpse at Hawai'i's past.

Photo by Peter French, Jason Fujii

HALEAKALĀ NATIONAL PARK, MAUI

Elevation 9,324 feet: The Kalahaku Overlook accesses views of the Pu'u o Māui cinder cone, seen by almost 2 million visitors a year. Considered the world's largest dormant volcano, the mountain has been napping since 1790.

Photo by Ron Dahlquist

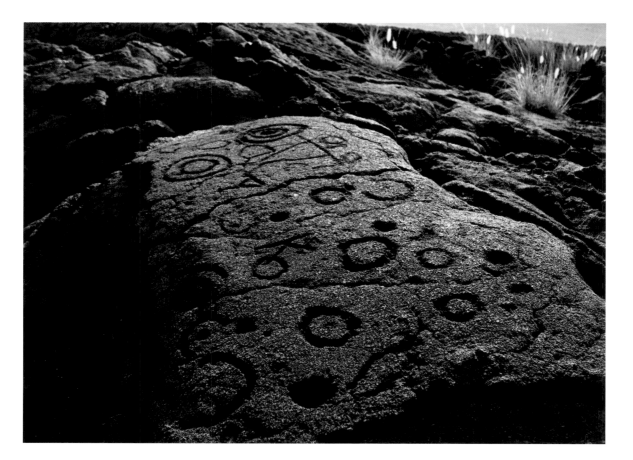

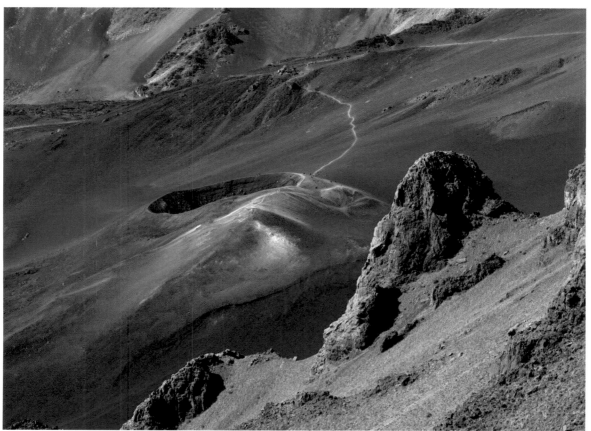

HONOLULU, O'AHU
One of the sweeter daily dilemmas is deciding where to watch the sunset. At Ala Moana Beach Park, it's clear that members of the Alvarado family have made an excellent choice. Aloha.
Photo by Dennis Oda, Honolulu Star-Bulletin

The week of May 12-18, 2003, more than 25,000 professional and amateur photographers spread out across the nation to shoot over a million digital photographs with the goal of capturing the essence of daily life in America.

The professional photographers were equipped with Adobe Photoshop and Adobe Album software, Olympus C-5050 digital cameras, and Lexar Media's high-speed compact flash cards.

The 1,000 professional contract photographers plus another 5,000 stringers and students sent their images via FTP (file transfer protocol) directly to the *America 24/7* website. Meanwhile, thousands of amateur photographers uploaded their images to Snapfish's servers.

At *America 24/7*'s Mission Control headquarters, located at CNET in San Francisco, dozens of picture editors from the nation's most prestigious publications culled the images down to 25,000 of the very best, using Photo Mechanic by Camera Bits. These photos were transferred into Webware's ActiveMedia Digital Asset Management (DAM) system, which served as a central image library and enabled the designers to track, search, distribute, and reformat the images for the creation of the 51 books, foreign language editions, web and magazine syndication, posters, and exhibitions.

Once in the DAM, images were optimized (and in some cases resampled to increase image resolution) using Adobe Photoshop. Adobe InDesign and Adobe InCopy were used to design and produce the 51 books, which were edited and reviewed in multiple locations around the world in the form of Adobe Acrobat PDFs. Epson Stylus printers were used for photo proofing and to produce large-format images for exhibitions. The companies providing support for the *America 24/7* project offer many of the essential components for anyone building a digital darkroom. We encourage you to read more on the following pages about their respective roles in making *America 24/7* possible.

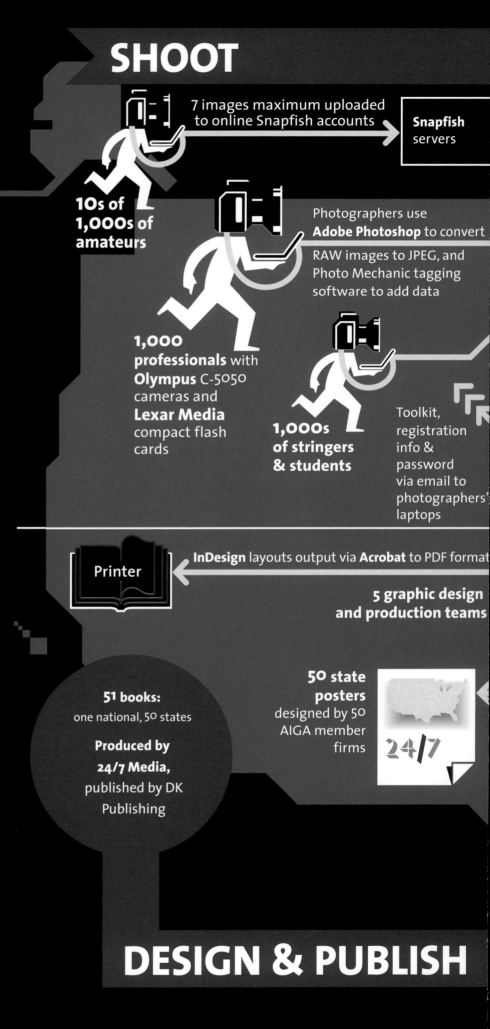

SHOOT

7 images maximum uploaded to online Snapfish accounts

Snapfish servers

10s of 1,000s of amateurs

Photographers use **Adobe Photoshop** to convert RAW images to JPEG, and Photo Mechanic tagging software to add data

1,000 professionals with **Olympus** C-5050 cameras and **Lexar Media** compact flash cards

1,000s of stringers & students

Toolkit, registration info & password via email to photographers' laptops

Printer

InDesign layouts output via **Acrobat** to PDF format

5 graphic design and production teams

51 books: one national, 50 states

Produced by 24/7 Media, published by DK Publishing

50 state posters designed by 50 AIGA member firms

24/7

DESIGN & PUBLISH

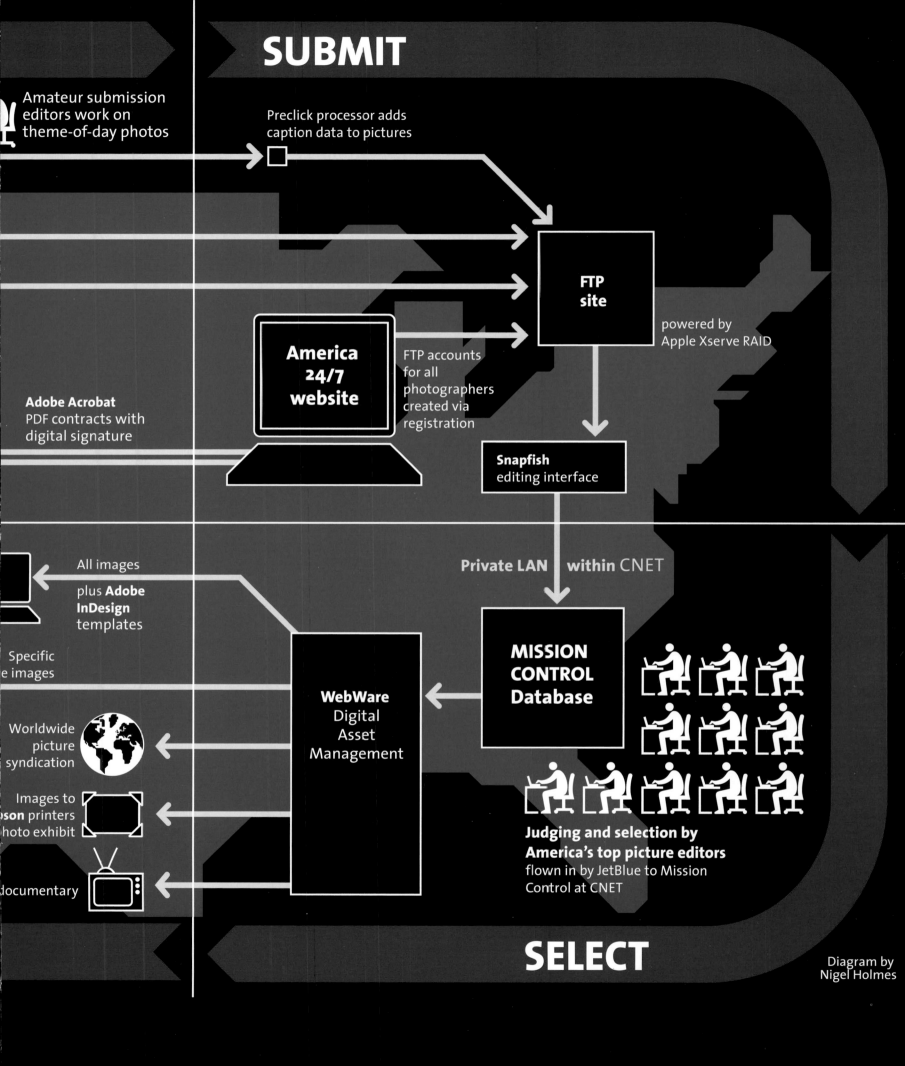

SUBMIT

Amateur submission editors work on theme-of-day photos

Preclick processor adds caption data to pictures

FTP site

powered by Apple Xserve RAID

America 24/7 website

FTP accounts for all photographers created via registration

Adobe Acrobat PDF contracts with digital signature

Snapfish editing interface

All images

plus **Adobe InDesign** templates

Specific images

Private LAN within CNET

MISSION CONTROL Database

WebWare Digital Asset Management

Worldwide picture syndication

Images to son printers photo exhibit

Judging and selection by America's top picture editors flown in by JetBlue to Mission Control at CNET

documentary

SELECT

Diagram by Nigel Holmes

Hawai'i 24/7

About Our Sponsors

America 24/7 gave digital photographers of all levels the opportunity to share their visions of what it means to live in the United States. This project was made possible by a digital photography revolution that is dramatically changing and improving picture-taking for professionals and amateurs alike. And an Adobe product, Photoshop®, has been at the center of this sea change.

Adobe's products reflect our customers' passion for the creative process, be it the photographer, graphic designer, layout artist, or printer. Adobe is the Publishing and Imaging Software Partner for *America 24/7* and products such as Adobe InDesign®, Photoshop, Acrobat®, and Illustrator® were used to produce this stunning book in a matter of weeks. We hope that our software has helped do justice to the mythic images, contributed by well-known photographers and the inspired hobbyist.

Adobe is proud to be a lead sponsor of *America 24/7*, a project that celebrates the vibrancy of the American spirit: the same spirit that helped found Adobe and inspires our employees and customers to deliver the very best.

Bruce Chizen
President and CEO
Adobe Systems Incorporated

Olympus, a global technology leader in designing precision healthcare solutions and innovative consumer electronics, is proud to be the official digital camera sponsor of *America 24/7*. The opportunity to introduce Americans from coast to coast to the thrill, excitement, and possibility of digital photography makes the vision behind this book a perfect fit for Olympus, a leader in digital cameras since 1996.

For most people, the essence of digital photography is best grasped through firsthand experience with the technology, which is precisely what *America 24/7* is about. We understand that direct experience is the pathway to inspiration, and welcome opportunities like this sponsorship to bring the power of the digital experience into the lives of people everywhere. To Olympus, *America 24/7* offers a platform to help realize a core mission: to deliver and make accessible the power of the digital experience to millions of American photographers, amateurs, and professionals alike.

The 1,000 professional photographers contracted to shoot on the America 24/7 project were all equipped with Olympus C-5050 digital cameras. Like all Olympus products, the C-5050 is offered by a company well known for designing, manufacturing, and servicing products used by professionals to perform their work, every day. Olympus is a customer-centric company committed to working one-

to-one with a diverse group of professionals. From biomedical researchers who use our clinical microscopes, to doctors who perform life-saving procedures with our endo-scopes, to professional photographers who use cameras in their daily work, Olympus is a trusted brand.

The digital imaging technology involved with *America 24/7* has enabled the soul of America to be visually conveyed, not just by professional observers, but by the American public who participated in this project—the very people who collectively breath life into this country's existence each day.

We are proud to be enabling so many photographers to capture the pictures on these pages that tell the story of who we are as a nation. From sea to shining sea, digital imagery allows us to connect to one another in ways we never dreamed possible.

At Olympus, our ideas have proliferated as rapidly as technology has evolved. We have channeled these visions into breakthrough products and solutions to meet the demands of our changing world-products like microscopes, endoscopes, and digital voice recorders, supported by the highly regarded training, educational, and consulting services we offer our customers.

Today, 83 years after we introduced our first microscope, we remain as young, as curious, and as committed as ever.

Lexar Media has grown from the digital photography revolution, which is why we are proud to have supplied the digital memory cards used in the America 24/7 project. Lexar Media's high-performance memory cards utilize our unique and patented controller coupled with high-speed flash memory from Samsung, the world's largest flash memory supplier. This powerful combination brings out the ultimate performance of any digital camera.

Photographers who demand the most from their equipment choose our products for their advanced features like write speeds up to 40X, Write Acceleration technology for enabled cameras, and Image Rescue, which recovers previously deleted or lost images. Leading camera manu-facturers bundle Lexar Media digital memory cards with their cameras because they value its performance and reliability.

Lexar Media is at the forefront of digital photography as it transforms picture-taking worldwide, and we will continue to be a leader with new and innovative solutions for profes-sionals and amateurs alike.

Snapfish, which developed the technology behind the *America 24/7* amateur photo event is a leading online photo service, with more than 5 million members and 100 million photos posted online. Snapfish enables both film and digital camera owners to share, print, and store their most important photo memories, at prices that cannot be equaled. Digital camera users upload photos into a password-protected online album for free. Users can also order film-quality prints on professional photographic paper for as low as 25¢. Film camera users get a full set of prints, plus online sharing and storage, for just $2.99 per roll.

Founded in 1995, eBay created a powerful platform for the sale of goods and services by a passionate community of individuals and businesses. On any given day, there are millions of items across thousands of categories for sale on eBay. eBay enables trade on a local, national and international basis with customized sites in markets around the world.

Through an array of services, such as its payment solution provider PayPal, eBay is enabling global e-commerce for an ever-growing online community.

JetBlue Airways is proud to be *America 24/7's* preferred carrier, flying photographers, photo editors, and organizers across the United States.

Winner of Condé Nast Traveler's Readers' Choice Awards for Best Domestic Airline 2002, JetBlue provides friendly service and low fares for travelers in 22 cities in nine states across America.

On behalf of JetBlue's 5,000 crew members, we're excited to be involved in this remarkable project, and for the opportunity to serve American travelers each and every day, coast to coast, 24/7.

DIGITAL POND.

Digital Pond has been a leading creator of large graphic displays for museums, corporations, trade shows, retail environments and fine art since 1992.

We were proud to bring together our creative, print and display capabilities to produce signage and displays for mission control, critical retouching for numerous key images for the book, and art galleries for the New York Public Library and Bryant Park.

The Pond's team and SplashPic® Online service enabled us to nimbly design, produce and install over 200 large graphic panels in two NYC locations within the truly "24/7" production schedule of less than ten days.

WebWare Corporation is pleased to be a major sponsor of the America 24/7 project. We take pride in being part of a groundbreaking adventure that is stretching the boundaries—and the imagination—in digital photography, digital asset management, publishing, news, and global events.

Our ActiveMedia Enterprise™ digital asset management software is the "nerve center" of *America 24/7,* the central repository for managing, sharing, and collaborating on the project's photographs. From photo editors and book publishers to 24/7's media relations and marketing personnel, ActiveMedia provides the application support that links all facets of the project team to the content worldwide.

WebWare helps Global 2000 firms securely manage, reuse, and distribute media assets locally or globally. Its suite of ActiveMedia software products provide powerful media services platforms for integrating rich media into content management systems marketing and communication portals; web publishing systems; and e-commerce portals.

Google's mission is to organize the world's information and make it universally accessible and useful.

With our focus on plucking just the right answer from an ocean of data, we were naturally drawn to the America 24/7 project. The book you hold is a compendium of images of American life distilled from thousands of photographs and infinite possibilities. Are you looking for emotion? Narrative? Shadows? Light? It's all here, thanks to a multitude of photographers and writers creating links between you, the reader, and a sea of wonderful stories. We celebrate the connections that constitute the human experience and are pleased to help engender them. And we're pleased to have been a small part of this project, which captures the results of that interaction so vividly, so dynamically, and so dramatically.

Special thanks to additional contributors: FileMaker, Apple, Camera Bits, LaCie, Now Software, Preclick, Outpost Digital, Xerox, Microsoft, WoodWing Software, net-linx Publishing Solutions, and Radical Media. The Savoy Hotel, San Francisco; The Pan Pacific, San Francisco; Four Seasons Hotel, San Francisco; and The Queen Anne Hotel. Photography editing facilities were generously hosted by CNET Networks, Inc.

Participating Photographers

Hawai'i Coordinator: David Ulrich, Pacific New Media, University of Hawai'i

Bruce Behnke, Pacific Rim Photography
Wilber Bergado
Warren Bolster, Getty Images
Deborah Booker, *Honolulu Advertiser*
Kevin Boutwell
David S. Boynton
Brian Bozlee
Michelle Clark
Richard A. Cooke III
Monte Costa
Ron Dahlquist
Greg Davidge
Tami Dawson, Photo Resource Hawai'i
Lisa Devlin
Brandy Dobson
Peter French, Jason Fujii
Michael Gilbert
Sergio Goes
Linda Gomez Carr
Ed Greevy
Randy Hufford, www.visualimpact.org

Warren Ishii
Sabra Kauka
George F. Lee, *Honolulu Star-Bulletin*
Wayne Levin
G. Brad Lewis
Val Loh
Linda Mascaro
Julie McBane
Dennis Oda, *Honolulu Star-Bulletin*
Lucy Pemoni, Associated Press
Eric Sawchuk
Phil Spalding
Daniela Stolfi
Bruna Stude
Peter Thourson
David Ulrich,
Pacific New Media, University of Hawai'i
Brett Uprichard,
Honolulu Publishing Company
Jeff Widener
Tim Wright

Thumbnail Picture Credits

Credits for thumbnail photographs are listed by the page number and are in order from left to right.

20–Monte Costa
Brett Uprichard, Honolulu Publishing Company
Brett Uprichard, Honolulu Publishing Company
David S. Boynton
Brett Uprichard, Honolulu Publishing Company
Garrett Burdick, Birdman Inc.
Brett Uprichard, Honolulu Publishing Company

21–Garrett Burdick, Birdman Inc.
Julie McBane
Brett Uprichard, Honolulu Publishing Company
Brett Uprichard, Honolulu Publishing Company
Monte Costa
Randy Hufford, www.visualimpact.org
Monte Costa

22–David Ulrich, Pacific New Media, University of Hawai'i
Sergio Goes
Deborah Booker, *Honolulu Advertiser*
David S. Boynton
David S. Boynton
Sergio Goes
Val Loh

23–Sergio Goes
David S. Boynton
Sergio Goes
Randy Hufford, www.visualimpact.org
Tami Dawson, Photo Resource Hawai'i
Sergio Goes
Jeff Widener

25–Sabra Kauka
Michael Gilbert
Michael Gilbert
Michael Gilbert
Sabra Kauka
Michael Gilbert
Sabra Kauka

26–Richard A. Cooke III
Brett Uprichard, Honolulu Publishing Company
Bruna Stude
Carol Ann Davis
Bruna Stude
Bruna Stude
Richard A. Cooke III

27–Richard A. Cooke III
Richard A. Cooke III
Val Loh

Sergio Goes
Val Loh
Richard A. Cooke III
Dennis Oda, *Honolulu Star-Bulletin*

28–Phil Spalding
Phil Spalding
Phil Spalding
Jeff Widener
Phil Spalding
Richard A. Cooke III
Phil Spalding

32–Brett Uprichard, Honolulu Publishing Company
G. Brad Lewis
George F. Lee, *Honolulu Star-Bulletin*
Brett Uprichard, Honolulu Publishing Company
David Ulrich, Pacific New Media, University of Hawai'i
George F. Lee, *Honolulu Star-Bulletin*
Brett Uprichard, Honolulu Publishing Company

33–Jay Garibay
Brett Uprichard, Honolulu Publishing Company
Jeff Widener
George F. Lee, *Honolulu Star-Bulletin*
Michael Gilbert
Sabra Kauka
Tami Dawson, Photo Resource Hawai'i

34–G. Brad Lewis
Deborah Booker, *Honolulu Advertiser*
Brett Uprichard, Honolulu Publishing Company
G. Brad Lewis
David S. Boynton
Garrett Burdick, Birdman Inc.
G. Brad Lewis

35–David S. Boynton
Sergio Goes
G. Brad Lewis
G. Brad Lewis
David S. Boynton
Peter French, Jason Fujii
Sergio Goes

37–Phil Spalding
Monte Costa
Phil Spalding
David Ulrich, Pacific New Media, University of Hawai'i
Garrett Burdick, Birdman Inc.
Phil Spalding
David S. Boynton

38–Brett Uprichard, Honolulu Publishing Company
Randy Hufford, www.visualimpact.org
Monte Costa
Randy Hufford, www.visualimpact.org
Dennis Oda, *Honolulu Star-Bulletin*
Randy Hufford, www.visualimpact.org
Randy Hufford, www.visualimpact.org

39–Randy Hufford, www.visualimpact.org
Monte Costa
Dennis Oda, Honolulu Star-Bulletin
Randy Hufford, www.visualimpact.org
Randy Hufford, www.visualimpact.org
Dennis Oda, *Honolulu Star-Bulletin*
Dennis Oda, *Honolulu Star-Bulletin*

46–Lucy Pemoni, Associated Press
Dennis Oda, *Honolulu Star-Bulletin*
Deborah Booker, *Honolulu Advertiser*
Dennis Oda, *Honolulu Star-Bulletin*
Sergio Goes
Deborah Booker, *Honolulu Advertiser*
Sergio Goes

47–Sabra Kauka
Richard A. Cooke III
Sabra Kauka
Dennis Oda, *Honolulu Star-Bulletin*
Deborah Booker, *Honolulu Advertiser*
Sabra Kauka
Deborah Booker, *Honolulu Advertiser*

49–Brett Uprichard, Honolulu Publishing Company
Deborah Booker, *Honolulu Advertiser*
Brett Uprichard, Honolulu Publishing Company
Brett Uprichard, Honolulu Publishing Company
Brett Uprichard, Honolulu Publishing Company
Deborah Booker, *Honolulu Advertiser*
Brett Uprichard, Honolulu Publishing Company

50–Dennis Oda, *Honolulu Star-Bulletin*
Bruce Behnke, Pacific Rim Photography
Dennis Oda, *Honolulu Star-Bulletin*
Deborah Booker, *Honolulu Advertiser*
Dennis Oda, *Honolulu Star-Bulletin*
Bruce Behnke, Pacific Rim Photography
Dennis Oda, *Honolulu Star-Bulletin*

51–Linda Gomez Carr
Dennis Oda, *Honolulu Star-Bulletin*
Tami Dawson, Photo Resource Hawai'i
Deborah Booker, *Honolulu Advertiser*
Randy Hufford, www.visualimpact.org
Deborah Booker, *Honolulu Advertiser*
Linda Gomez Carr

52–Richard A. Cooke III
Bruce Behnke, Pacific Rim Photography
Richard A. Cooke III
Brett Uprichard, Honolulu Publishing Company
Richard A. Cooke III
Wilber Bergado
Richard A. Cooke III

53–Richard A. Cooke III
Richard A. Cooke III
Richard A. Cooke III
Phil Spalding
Richard A. Cooke III
Richard A. Cooke III
Phil Spalding

54–Tami Dawson, Photo Resource Hawai'i
Lucy Pemoni, Associated Press
Richard A. Cooke III
Wilber Bergado
Richard A. Cooke III
Peter French, Jason Fujii
Jeff Widener

55–Phil Spalding
Richard A. Cooke III
Tim Wright
Tim Wright
Sergio Goes
Phil Spalding
Brett Uprichard, Honolulu Publishing Company

56–Ron Dahlquist
Richard A. Cooke III
Richard A. Cooke III
Richard A. Cooke III
Ron Dahlquist
Ron Dahlquist
Ron Dahlquist

57–Ron Dahlquist
Tim Wright
Sergio Goes
Val Loh
Ron Dahlquist
Val Loh

60–Ron Dahlquist
Ron Dahlquist
Ron Dahlquist
Ron Dahlquist
Ron Dahlquist
Ron Dahlquist
Ron Dahlquist

62–Monte Costa
Peter French, Jason Fujii
Linda Gomez Carr
Randy Hufford, www.visualimpact.org
Val Loh
Ed Greevy
Monte Costa

63–Val Loh
Sabra Kauka
Tim Wright
Monte Costa
Monte Costa
Sabra Kauka
Tim Wright

64–David Ulrich, Pacific New Media, University of Hawai'i
Dennis Oda, *Honolulu Star-Bulletin*
Sergio Goes
Dennis Oda, *Honolulu Star-Bulletin*
Sergio Goes
Dennis Oda, *Honolulu Star-Bulletin*
Dennis Oda, *Honolulu Star-Bulletin*

65–Peter French, Jason Fujii
Sergio Goes
Sergio Goes
Sergio Goes
Sergio Goes
Sergio Goes
Tim Wright

66–Dennis Oda, *Honolulu Star-Bulletin*
Lucy Pemoni, Associated Press
Deborah Booker, *Honolulu Advertiser*
Sergio Goes
Lucy Pemoni, Associated Press
Deborah Booker, *Honolulu Advertiser*
Peter French, Jason Fujii

67–Deborah Booker, *Honolulu Advertiser*
Deborah Booker, *Honolulu Advertiser*
Sergio Goes
Randy Hufford, www.visualimpact.org
Lucy Pemoni, Associated Press
Sergio Goes
Sabra Kauka

68–David Ulrich, Pacific New Media, University of Hawai'i
Peter French, Jason Fujii
Daniela Stolfi
Bruce Behnke, Pacific Rim Photography
Daniela Stolfi
Daniela Stolfi
Deborah Booker, *Honolulu Advertiser*

69–Daniela Stolfi
Peter French, Jason Fujii
Daniela Stolfi
Daniela Stolfi
Randy Hufford, www.visualimpact.org
Bruce Behnke, Pacific Rim Photography
Daniela Stolfi

70–Michael Gilbert
Jeff Widener
Brett Uprichard, Honolulu Publishing Company
Lucy Pemoni, Associated Press
Richard A. Cooke III
Michael Gilbert
Michael Gilbert

71–Michael Gilbert
Sergio Goes
Michael Gilbert
Sergio Goes
Sergio Goes
Richard A. Cooke III
Sergio Goes

74–Brett Uprichard, Honolulu Publishing Company
David Ulrich, Pacific New Media, University of Hawai'i
David Ulrich, Pacific New Media, University of Hawai'i
Michael Gilbert
Val Loh
Peter French, Jason Fujii
Peter French, Jason Fujii

75–Michael Gilbert
Deborah Booker, *Honolulu Advertiser*
Peter French, Jason Fujii
Michael Gilbert
Val Loh
Val Loh
Michael Gilbert

76–Dennis Oda, *Honolulu Star-Bulletin*
Julie McBane
Daniela Stolfi
Michael Gilbert
David S. Boynton
Linda Gomez Carr
Julie McBane

77–Warren Bolster, Getty Images
Randy Hufford, www.visualimpact.org
Michael Gilbert
Julie McBane
Randy Hufford, www.visualimpact.org
Tami Dawson, Photo Resource Hawai'i
Michael Gilbert

78–Randy Hufford, www.visualimpact.org
Val Loh
Val Loh
Sergio Goes
Randy Hufford, www.visualimpact.org
Randy Hufford, www.visualimpact.org
Randy Hufford, www.visualimpact.org

79–Val Loh
Randy Hufford, www.visualimpact.org
Randy Hufford, www.visualimpact.org
Randy Hufford, www.visualimpact.org
Ron Dahlquist
Val Loh
Randy Hufford, www.visualimpact.org

81–Richard A. Cooke III
Deborah Booker, *Honolulu Advertiser*
David S. Boynton
David Ulrich, Pacific New Media, University of Hawai'i
David S. Boynton
Val Loh
Richard A. Cooke III

84–Monte Costa
Monte Costa
Monte Costa
Monte Costa
Monte Costa
Monte Costa
Monte Costa

85–Monte Costa
Monte Costa
Monte Costa
Deborah Booker, *Honolulu Advertiser*
Monte Costa
Monte Costa
Monte Costa

88–David Ulrich, Pacific New Media, University of Hawai'i
Bruce Behnke, Pacific Rim Photography
Deborah Booker, *Honolulu Advertiser*
Michael Gilbert
David Ulrich, Pacific New Media, University of Hawai'i
Michael Gilbert
Wilber Bergado

89–Randy Hufford, www.visualimpact.org
Michael Gilbert
Monte Costa
Deborah Booker, *Honolulu Advertiser*
Tami Dawson, Photo Resource Hawai'i
Michael Gilbert
Val Loh

90–Wayne Levin
Wayne Levin
Wayne Levin
Wayne Levin
Wayne Levin
Wayne Levin
Wayne Levin

91–Wayne Levin
Wayne Levin
Wayne Levin
Wayne Levin
Wayne Levin
Wayne Levin

92–Garrett Burdick, Birdman Inc.
David S. Boynton
David S. Boynton
David S. Boynton
Garrett Burdick, Birdman Inc.
G. Brad Lewis
David S. Boynton

93–Garrett Burdick, Birdman Inc.
G. Brad Lewis
David S. Boynton
David S. Boynton
Garrett Burdick, Birdman Inc.
Randy Hufford, www.visualimpact.org
David S. Boynton

94–Carol Ann Davis
Brett Uprichard, Honolulu Publishing Company
David S. Boynton
Ron Dahlquist
Peter French, Jason Fujii
Val Loh
Wilber Bergado

95–Brett Uprichard, Honolulu Publishing Company
Sergio Goes
Ron Dahlquist
Sergio Goes
Dennis Oda, *Honolulu Star-Bulletin*
Sabra Kauka
Sergio Goes

96–Sergio Goes
Sergio Goes
David S. Boynton
Monte Costa
Monte Costa
Sergio Goes
Sergio Goes

97–Wilber Bergado
Sabra Kauka
Monte Costa
Ed Greevy
David S. Boynton
Sabra Kauka
George F. Lee, *Honolulu Star-Bulletin*

100–Ron Dahlquist
Sergio Goes
David Ulrich, Pacific New Media, University of Hawai'i
G. Brad Lewis
Ron Dahlquist
Dennis Oda, *Honolulu Star-Bulletin*
David Ulrich, Pacific New Media, University of Hawai'i

104–David Ulrich, Pacific New Media, University of Hawai'i
Phil Spalding
Phil Spalding
Deborah Booker, *Honolulu Advertiser*
Jeff Widener
Peter French, Jason Fujii
Michael Gilbert

105–Michael Gilbert
Peter French, Jason Fujii
Phil Spalding
Deborah Booker, *Honolulu Advertiser*
Monte Costa
Peter French, Jason Fujii
Phil Spalding

108–Peter French, Jason Fujii
David Ulrich, Pacific New Media, University of Hawai'i
Kevin Boutwell
Peter French, Jason Fujii
Kevin Boutwell
Jeff Widener
Michael Gilbert

109–David Ulrich, Pacific New Media, University of Hawai'i
Kevin Boutwell
Kevin Boutwell
Peter French, Jason Fujii
Randy Hufford, www.visualimpact.org
Peter French, Jason Fujii
Randy Hufford, www.visualimpact.org

110–Bruce Behnke, Pacific Rim Photography
David S. Boynton
Brett Uprichard, Honolulu Publishing Company
David Ulrich, Pacific New Media, University of Hawai'i
Bruce Behnke, Pacific Rim Photography
Val Loh
Peter French, Jason Fujii

111–Phil Spalding
David S. Boynton
Deborah Booker, *Honolulu Advertiser*
Bruce Behnke, Pacific Rim Photography
Phil Spalding
Sabra Kauka
Phil Spalding

115–Tami Dawson, Photo Resource Hawai'i
Val Loh
Val Loh
Val Loh
Sergio Goes
Val Loh
Julie McBane

116–Bruce Behnke, Pacific Rim Photography
Val Loh
Randy Hufford, www.visualimpact.org
Garrett Burdick, Birdman Inc.
Val Loh
Sabra Kauka
Wilber Bergado

117–Sabra Kauka
Randy Hufford, www.visualimpact.org
Val Loh
Jeff Widener
Val Loh
Val Loh
Michael Gilbert

120–Bruce Behnke, Pacific Rim Photography
David Ulrich, Pacific New Media, University of Hawai'i
Tami Dawson, Photo Resource Hawai'i
Deborah Booker, *Honolulu Advertiser*
Daniela Stolfi
Randy Hufford, www.visualimpact.org
Wilber Bergado

121–Randy Hufford, www.visualimpact.org
Brett Uprichard, Honolulu Publishing Company
Ron Dahlquist
David Ulrich, Pacific New Media, University of Hawai'i
Daniela Stolfi
Michael Gilbert
Val Loh

122–Michael Gilbert
Bruce Behnke, Pacific Rim Photography
Monte Costa
Bruce Behnke, Pacific Rim Photography
Wilber Bergado
Bruce Behnke, Pacific Rim Photography
David Ulrich, Pacific New Media, University of Hawai'i

123–Bruce Behnke, Pacific Rim Photography
Bruce Behnke, Pacific Rim Photography
Linda Gomez Carr
Dennis Oda, *Honolulu Star-Bulletin*
Peter French, Jason Fujii
Peter French, Jason Fujii
Michael Gilbert

124–Brett Uprichard, Honolulu Publishing Company
David Ulrich, Pacific New Media, University of Hawai'i
Brett Uprichard, Honolulu Publishing Company
David S. Boynton
Sergio Goes
Dennis Oda, *Honolulu Star-Bulletin*
Brett Uprichard, Honolulu Publishing Company

125–Wilber Bergado
Sergio Goes
David S. Boynton
Peter French, Jason Fujii
Brett Uprichard, Honolulu Publishing Company
David S. Boynton
Val Loh

126–G. Brad Lewis
G. Brad Lewis
Peter Thourson
Garrett Burdick, Birdman Inc.
Peter Thourson
Peter French, Jason Fujii
Val Loh

127–G. Brad Lewis
Phil Spalding
Phil Spalding
G. Brad Lewis
Deborah Booker, *Honolulu Advertiser*
Kevin Boutwell
Peter Thourson

128–Brett Uprichard, Honolulu Publishing Company
Brett Uprichard, Honolulu Publishing Company
David Ulrich, Pacific New Media, University of Hawai'i
Brett Uprichard, Honolulu Publishing Company
David Ulrich, Pacific New Media, University of Hawai'i
Brett Uprichard, Honolulu Publishing Company
David Ulrich, Pacific New Media, University of Hawai'i

129–David Ulrich, Pacific New Media, University of Hawai'i
Brett Uprichard, Honolulu Publishing Company
David Ulrich, Pacific New Media, University of Hawai'i
David Ulrich, Pacific New Media, University of Hawai'i
David Ulrich, Pacific New Media, University of Hawai'i
David Ulrich, Pacific New Media, University of Hawai'i
David Ulrich, Pacific New Media, University of Hawai'i

130–Brett Uprichard, Honolulu Publishing Company
Bruce Behnke, Pacific Rim Photography
Bruce Behnke, Pacific Rim Photography
Brett Uprichard, Honolulu Publishing Company
David Ulrich, Pacific New Media, University of Hawai'i
David Ulrich, Pacific New Media, University of Hawai'i
David Ulrich, Pacific New Media, University of Hawai'i

131–David Ulrich, Pacific New Media, University of Hawai'i
Bruce Behnke, Pacific Rim Photography
David Ulrich, Pacific New Media, University of Hawai'i
Bruce Behnke, Pacific Rim Photography
David Ulrich, Pacific New Media, University of Hawai'i
Deborah Booker, Honolulu Advertiser
David Ulrich, Pacific New Media, University of Hawai'i

132–Richard A. Cooke III
David Ulrich, Pacific New Media, University of Hawai'i
Kevin Boutwell
Richard A. Cooke III
Wilber Bergado
Wilber Bergado
Wilber Bergado

133–Richard A. Cooke III
Val Loh
Richard A. Cooke III
Wilber Bergado
Richard A. Cooke III
Val Loh
Bruce Behnke, Pacific Rim Photography

134–G. Brad Lewis
Randy Hufford, www.visualimpact.org
Garrett Burdick, Birdman Inc.
Peter French, Jason Fujii
G. Brad Lewis
Ron Dahlquist
Wilber Bergado

135–Ron Dahlquist
Peter French, Jason Fujii
Phil Spalding
Michael Gilbert
Ron Dahlquist
Michael Gilbert
Ron Dahlquist

Staff

The *America 24/7* series was imagined years ago by our friend Oscar Dystel, a publishing legend whose vision and enthusiasm have been a source of great inspiration.

We also wish to express our gratitude to our truly visionary publisher, DK.

Rick Smolan, Project Director
David Elliot Cohen, Project Director

Administrative
Katya Able, Operations Director
Gina Privitere, Communications Director
Chuck Gathard, Technology Director
Kim Shannon, Photographer Relations Director
Erin O'Connor, Photographer Relations Intern
Leslie Hunter, Partnership Director
Annie Polk, Publicity Manager
John McAlester, Website Manager
Alex Notides, Office Manager
C. Thomas Hardin, State Photography Coordinator

Design
Brad Zucroff, Creative Director
Karen Mullarkey, Photography Director
Judy Zimola, Production Manager
David Simoni, Production Designer
Mary Dias, Production Designer
Heidi Madison, Associate Picture Editor
Don McCartney, Production Designer
Diane Dempsey Murray, Production Designer
Jan Rogers, Associate Picture Editor
Bill Shore, Production Designer and Image Artist
Larry Nighswander, Senior Picture Editor
Bill Marr, Sarah Leen, Senior Picture Editors
Peter Truskier, Workflow Consultant
Jim Birkenseer, Workflow Consultant

Editorial
Maggie Canon, Managing Editor
Curt Sanburn, Senior Editor
Teresa L. Trego, Production Editor
Lea Aschkenas, Writer
Olivia Boler, Writer
Korey Capozza, Writer
Beverly Hanly, Writer
Bridgett Novak, Writer
Alison Owings, Writer
Fred Raker, Writer
Joe Wolff, Writer
Elise O'Keefe, Copy Chief
Daisy Hernández, Copy Editor
Jennifer Wolfe, Copy Editor

Infographic Design
Nigel Holmes

Literary Agent
Carol Mann, The Carol Mann Agency

Legal Counsel
Barry Reder, Coblentz, Patch, Duffy & Bass, LLP
Phil Feldman, Coblentz, Patch, Duffy & Bass, LLP
Gabe Perle, Ohlandt, Greeley, Ruggiero & Perle, LLP
Jon Hart, Dow, Lohnes & Albertson, PLLC
Mike Hays, Dow, Lohnes & Albertson, PLLC
Stephen Pollen, Warshaw Burstein, Cohen, Schlesinger & Kuh, LLP
Rick Pappas

Accounting and Finance
Rita Dulebohn, Accountant
Robert Powers, Calegari, Morris & Co. Accountants
Eugene Blumberg, Blumberg & Associates
Arthur Langhaus, KLS Professional Advisors Group, Inc.

Picture Editors
J. David Ake, Associated Press
Caren Alpert, formerly *Health* magazine
Simon Barnett, *Newsweek*
Caroline Couig, *San Jose Mercury News*
Mike Davis, formerly *National Geographic*
Michel duCille, *Washington Post*
Deborah Dragon, *Rolling Stone*
Victor Fisher, formerly Associated Press
Frank Folwell, *USA Today*
MaryAnne Golon, *Time*
Liz Grady, formerly *National Geographic*
Randall Greenwell, *San Francisco Chronicle*
C. Thomas Hardin, formerly *Louisville Courier-Journal*
Kathleen Hennessy, *San Francisco Chronicle*
Scot Jahn, *U.S. News & World Report*
Steve Jessmore, *Flint Journal*
John Kaplan, University of Florida
Kim Komenich, *San Francisco Chronicle*
Eliane Laffont, *Hachette Filipacchi Media*
Jean-Pierre Laffont, *Hachette Filipacchi Media*
Andrew Locke, MSNBC
Jose Lopez, *The New York Times*
Maria Mann, formerly AFP
Bill Marr, formerly *National Geographic*
Michele McNally, *Fortune*
James Merithew, *San Francisco Chronicle*
Eric Meskauskas, *New York Daily News*
Maddy Miller, *People* magazine
Michelle Molloy, *Newsweek*
Dolores Morrison, *New York Daily News*
Karen Mullarkey, formerly *Newsweek, Rolling Stone, Sports Illustrated*
Larry Nighswander, Ohio University School of Visual Communication
Jim Preston, *Baltimore Sun*
Sarah Rozen, formerly *Entertainment Weekly*
Mike Smith, *The New York Times*
Neal Ulevich, formerly Associated Press

Website and Digital Systems
Jeff Burchell, Applications Engineer

Television Documentary
Sandy Smolan, Producer/Director
Rick King, Producer/Director
Bill Medsker, Producer

Video News Release
Mike Cerre, Producer/Director

Digital Pond
Peter Hogg
Kris Knight
Roger Graham
Philip Bond
Frank De Pace
Lisa Li

Senior Advisors
Jennifer Erwitt, Strategic Advisor
Tom Walker, Creative Advisor
Megan Smith, Technology Advisor
Jon Kamen, Media and Partnership Advisor
Mark Greenberg, Partnership Advisor
Patti Richards, Publicity Advisor
Cotton Coulson, Mission Control Advisor

Executive Advisors
Sonia Land
George Craig
Carole Bidnick

Advisors
Chris Anderson
Samir Arora
Russell Brown
Craig Cline
Gayle Cline
Harlan Felt
George Fisher
Phillip Moffitt
Clement Mok
Laureen Seeger
Richard Saul Wurman

DK Publishing
Bill Barry
Joanna Bull
Therese Burke
Sarah Coltman
Christopher Davis
Todd Fries
Dick Heffernan
Jay Henry
Stuart Jackman
Stephanie Jackson
Chuck Lang
Sharon Lucas
Cathy Melnicki
Nicola Munro
Eunice Paterson
Andrew Welham

Colourscan
Jimmy Tsao
Eddie Chia
Richard Law
Josephine Yam
Paul Koh
Chee Cheng Yeong
Dan Kang

Chief Morale Officer
Goose, the dog